SPECTACULAR HOMES
of the Southwest

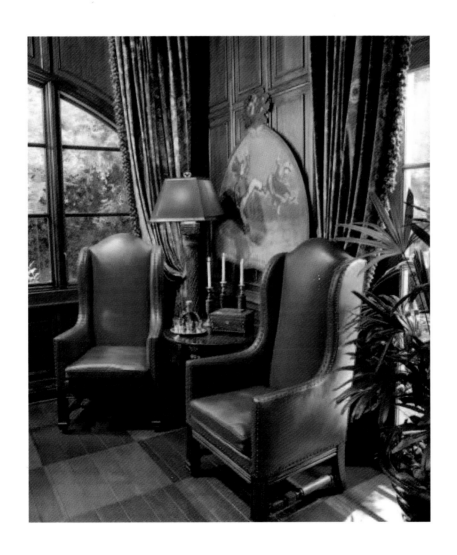

AN EXCLUSIVE SHOWCASE OF THE FINEST DESIGNERS IN ARIZONA AND NEW MEXICO

Published by

13747 Montfort Drive, Suite 100
Dallas, Texas 75240
972.661.9884
972.661.2743
www.panache.com

Publishers: Brian G. Carabet and John A. Shand

Copyright © 2006 by Panache Partners, LLC.
All rights reserved.

No part of this book may be reproduced or transmitted in any form or by
any means, electronic or mechanical, including photocopying, recording,
or by any information storage or retrieval system, except brief excerpts for
the purpose of review, without written permission of the publisher.

All images in this book have been reproduced with the knowledge and
prior consent of the designers concerned and no responsibility is accepted
by the producer, publisher, or printer for any infringement of copyright or
otherwise arising from the contents of this publication. Every effort has been
made to ensure that credits accurately comply with the information sup-
plied.

Printed in Malaysia

Distributed by Gibbs Smith, Publisher
800-748-5439

PUBLISHER'S DATA

Spectacular Homes of the Southwest

Library of Congress Control Number: 2005909011

ISBN Number: 978-1-933415-14-7

First Printing 2006

10 9 8 7 6 5 4 3 2 1

On the Cover: Paula Berg/Paula Berg Design Associates
See page 19 Photo by

Previous Page: Jana Parker Lee/Wiseman & Gale
See page 29 Photo by Dino Tonn

This Page: Designer: Rhonda Greenberg/Paradise Interiors Inc.
See page 79 Photo by Dino Tonn

This publication is intended to showcase the work of extremely talented interior
designers, designers and decorators. The Publisher does not require, warrant,
endorse, or verify any professional accreditations, educational backgrounds or
professional affiliations of the individuals or firms included herein. All copy and
photography published herein has been reviewed and approved as free of any usage
fees or rights and accurate by the individuals and/or firms included herein.

SPECTACULAR HOMES

of the Southwest

AN EXCLUSIVE SHOWCASE OF THE FINEST DESIGNERS IN ARIZONA AND NEW MEXICO

DESIGNER Photograph, Gail Carson Guest Interior Design, page 43

Land of extremes. Land of contrasts. Land of surprises.

—Federal Writers' Project, Arizona, 1956

The Southwest is the place everyone finds in dreams — and to which many follow in cars. For centuries, settlers have also arrived by foot, on horse and wagon train — a pilgrimage of Native Indian, Spanish colonial, trapper, frontiersman, territorial pioneer, Rust Belt emigrant and snowbird. To this mystical land of sun, saguaro and opportunity, these diverse groups have not only brought their lifestyle visions but also their crafts, possessions and materials, incorporating them into hogan, hacienda and home.

In Spectacular Homes of the Southwest, this theme resonates: The Southwest Style mixes styles and influences and includes crossovers, hybridizations, syntheses and juxtapositions — a mirror of local history. The 34 interior designers and firms who display their work here offer a diversity that will excite those who yearn for the adventure of the Santa Fe Trail, for the heterogeneous, the always-changing. Their style, taken as a whole, is eclectic, a blend, a distillation, constantly redefining itself away from trendiness and quick-buck solutions. The effect is, as you will see, uplifting and joyful and, most importantly, livable.

On these, indeed, spectacular pages, you will find Spanish Hacienda and Mediterranean Hacienda; Spanish Colonial, Arizona Territorial and Santa Fe; and Contemporary Southwestern, fusing clean modern lines with more traditional furnishings, crafts and textures. Here, also, you will enjoy the curves and multi-layers of French/English designs but comparatively minimalist approaches, too, as well as styles bearing influences from Morocco and Africa to Scandinavia, from kiva and pueblo to Mies and Frank Lloyd Wright. What's more, these artists of the interior don't forget a soupcon of whimsy, humor, the surprise of the unexpected, the funky and the fun.

Materials and color palettes are various, too: granite, mesquite, ochres and earthtones — ruggedly beautiful like the land itself. But the work also includes natural linens and fine cottons and imported marble as well as the patinas of layered wood, aged plaster and faded fabrics. In their wonderfully crafted spaces, too, are fossils and artifacts; treasures and trinkets; mementos from travels; gifts from loved ones; and the faded, but unfading, image of father or friend.

The designers and firms themselves reiterate the colorful history of the Southwest: sister partners; serendipitous friends who meld talents; a muralist; a remodeler; professionals with contracting and homebuilding backgrounds; professionals who design their own furniture and rugs; a South American who joins the influences of contemporary architect Cesar Pelli with those of his Old World family heritage.

The central figures here, though, are the clients, the people who bring to the Southwest their visions for primary homes, for desert retreats, even underground garages for vintage cars. The designers' approaches for them differ, of course: One works from the furnishings out, another starts with art. But all work in canvases that, while unmistakably bearing their strokes and styles, are, ultimately, the art of the clients, whose dreams they realize uniquely and so well.

Warmest regards,

David M. Brown

TABLE OF CONTENTS

BRENDA B. AGEE...11
Èlan Interiors Inc.

MARTHA ANDRIGHETTI..17
Andrighetti Design Associates, Inc.

PAULA BERG...19
Paula Berg Design Associates

JANET BROOKS..25
Janet Brooks Design

PATTY BURDICK, SUE CALVIN & JANA PARKER LEE.......29
Wiseman & Gale

CAROL BUTO...35
Carol Buto Designs

LORI CARROLL..37
Lori Carroll & Associates

CHRISTOPHER K. COFFIN..43
Christopher K. Coffin Design

KIMBERLY COLLETTI...49
Tre'ken Interiors

SARAH DEWITT...53
DeWitt Designs

JANICE DONALD...59
Eren Design & Remodeling Company

JUDY FOX...63
Judy Fox Interiors

ERNESTO GARCIA...69
Ernesto Garcia Interior Design

ROBIN GRANT..73
Grant Designs LLC

MARIEANN GREEN...77
Marieann Green Interior Design, Inc.

RHONDA GREENBERG & SHARON FAIRCLOTH.........79
Paradise Interiors Inc.

ELLEN BETH HARPER..83
Harper Studio of Interior Design

SHERRY HAUSER...85
Sherry Hauser Designs

DEBRA MAY HIMES..87
Debra May Himes Interior Design & Associates

BEVERLY S. HOGSHIRE...93
Interiors By Design

MARY ANN HOPKINS...97
Room Service LLC

SANDRA KUSH...99
Devon Design Ltd.

CHRISTY MARTIN..103
Studio Encanto

DAVID MICHAEL MILLER...107
David Michael Miller Associates

CHARLEY MORROW..111
European Traditions

ANITA LANG MUELLER...115
Interior Motives

TERESA NELSON & KIM BARNUM..................................119
Nelson Barnum Interiors

DEENA PERRY..123
Deena Perry Interior Design & Collections

ROBYN RANDALL..129
Robyn Randall Interior Design

LIZ RYAN..131
Liz Ryan Interior Design

CAROL SMITH & SANDRA DANA....................................135
Smith & Dana Associates, LLC

TONY SUTTON...139
Est Est, Inc.

JO TAULBEE..143
Taulbee Design Group

DONNA S. VALLONE...147
Vallone Design

GIA VENTURI...153
Gia Venturi Interiors

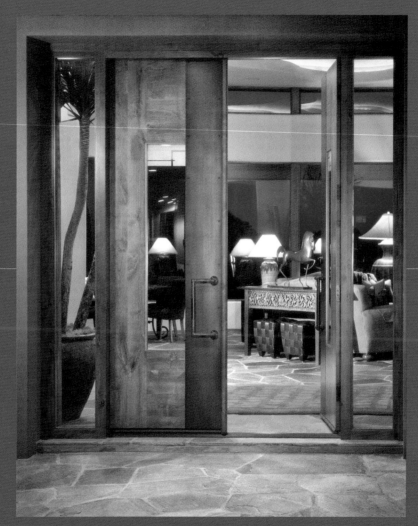

DESIGNER Lori Carroll/Lori Carroll and Associates, page **37**

Southwest

AN EXCLUSIVE SHOWCASE OF THE FINEST DESIGNERS IN ARIZONA AND NEW MEXICO

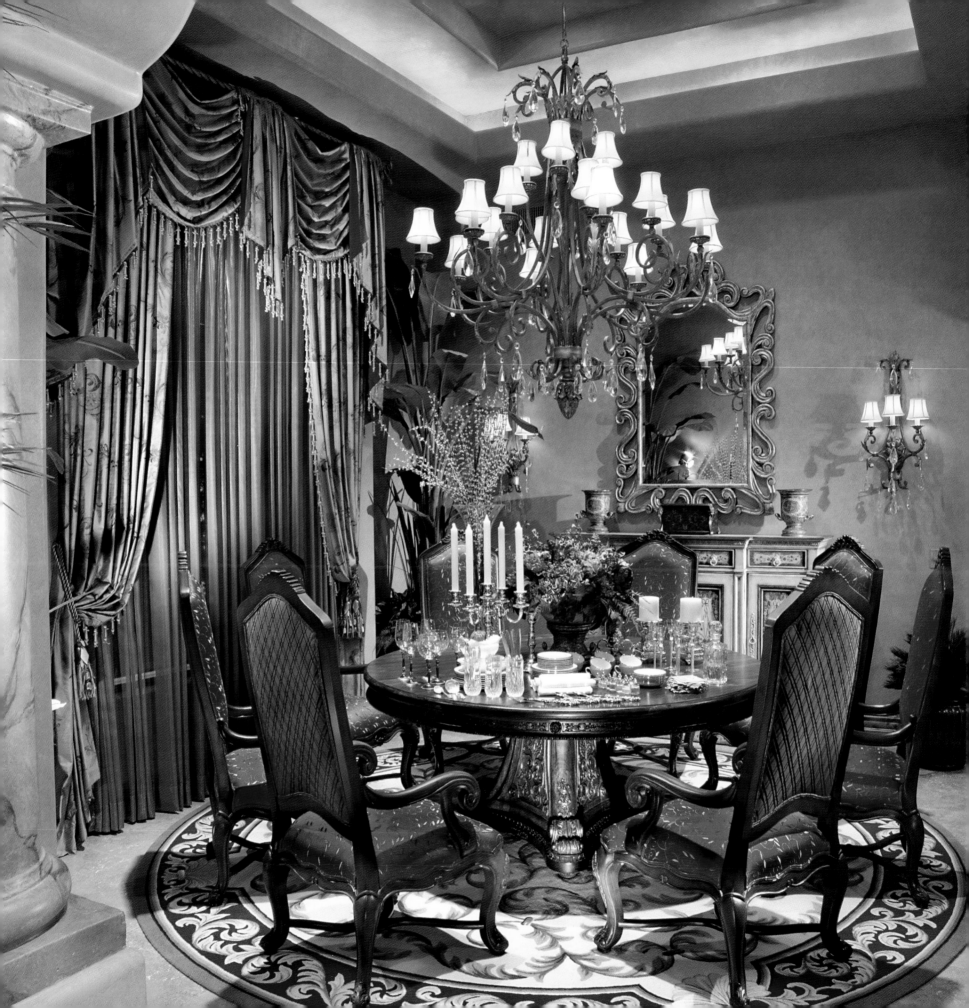

Brenda B. Agee
Élan Interiors Inc.

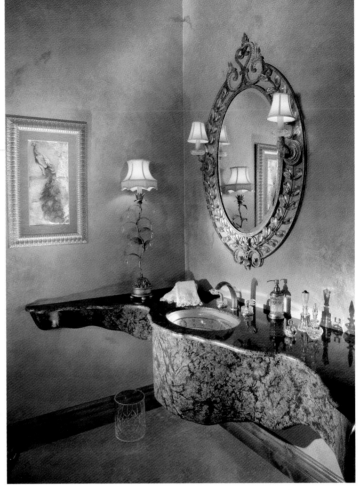

LEFT
A round tapis-weave custom-designed area rug, beautifully hand woven by Edward Fields, influenced the design, style and color of this magnificent dining area. Accompanied with gold and burgundy silk fabrics, the lush window dressings are tiered with shimmering sheers, trims and tassels, announcing a grand appearance: an Élan Interiors hallmark.

RIGHT
This lavishly designed space transcends the boundaries of ordinary powder rooms. As you come around the corner into the room, you find yourself delightedly surprised as light dances from the crystal trappings. The Rio Verde-green granite countertop leads into the room with a supple flow and directs the shape of the countertop apron with its exquisite faux-painted facade.

Interior design for Brenda B. Agee began with doll houses.

While growing up, Brenda's dad, with two doctorates from MIT in metallurgy and crystallography, would make models of the family home he planned to build on a lot looking into the Chesapeake Bay. "I'd take those models and make them into doll houses," recalls Brenda, a native of Kingston, Ontario, Canada. He wasn't so pleased, but Brenda was learning as well as playing: "Dad taught me about scale, proportion and good design."

The family never built on the Bay. Her dad, a professor at Annapolis, was transferred by the Navy to its post-graduate school in Monterey, California. There the family purchased five acres in Pebble Beach, overlooking the cypresses. It was at this time Brenda transitioned from doll houses to real houses.

"Dad could do anything; he was my inspiration," she says. Her brother, Chip (today a well-known home builder in Austin, Texas), helped their dad fell the pines. Once the foundation was poured, the four family members built their home, including plumbing, electrical and framing. "From the subflooring to the shingles on the roof, we did it all. Mom and I mixed the mortar, and the men laid the brick," she adds.

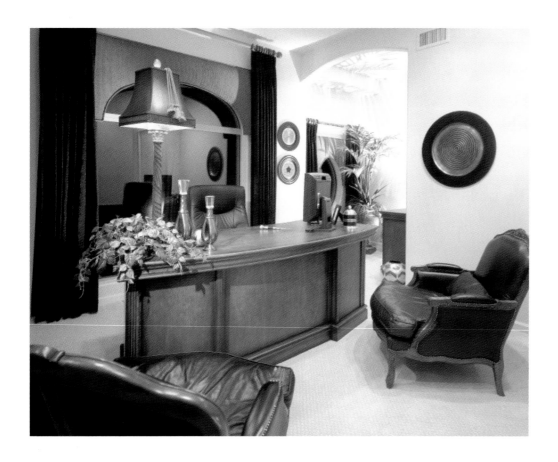

During the mid '70s, Brenda and her mom, a professional interior designer, opened an interior design studio in Laguna Niguel. "She taught me the love of the finer things in life, such as antiques, rare fabrics and artwork." After 10 years in California, Brenda, her husband, Bill, a former commercial airline captain, and their two children moved to Houston, Texas, where she had her design studio in the Galleria.

In 1986, Brenda and Bill then made Arizona their home. She established her studio, Élan Interiors, within two years and later relocated to the heart of Old Town Scottsdale, opening her showroom/gallery and new design studio. Here, she offers a "living portfolio" of art, wall treatments, furnishings, lamps and chandeliers. Brenda describes the elements of her style as casual elegance, lending a touch of European and Mediterranean influences.

Élan Interiors Inc. comes with excellence, style and vision as one of the top 10 highly acclaimed Valley design firms. The firm's distinguished client base includes CEOs, major sports figures, and celebrities—those accustomed to a refined style of living. Known

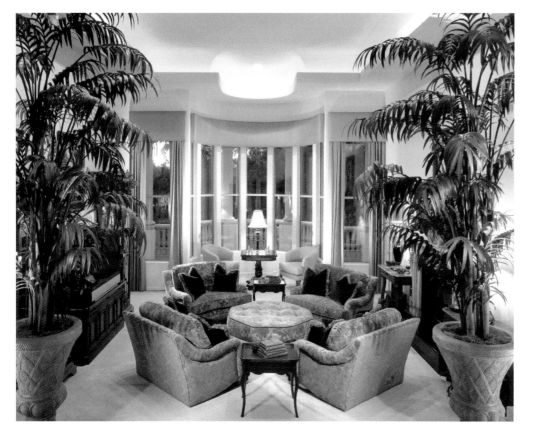

ABOVE
The ultimate in functionality, this handsome office is equipped with every essential of high-speed technology, and everything has been discreetly placed and has a low-profile appearance. The classic, warm, rich atmosphere creates ease in conducting daily business.

LEFT
This luxurious living room lends itself to put-your-feet-up comfort. Walking in, you are greeted with the presence of metropolitan architecture; subtle amenities and secluded features offer a place that is clean, neat and sophisticated.

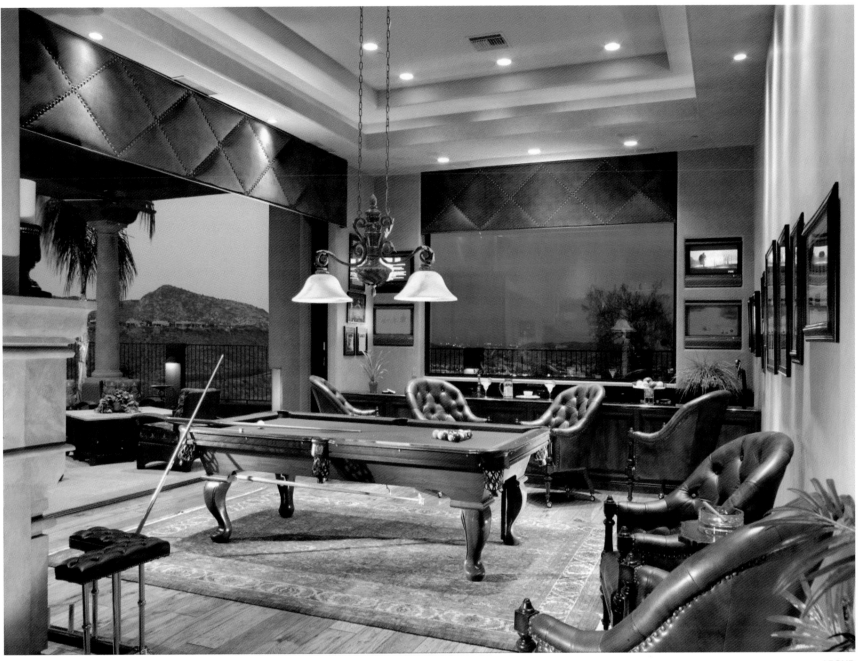

Sportsbar: It's just that, as the owners are known for their love of entertaining and frequent the room in the evenings. Six Old World leather chairs, imported from Europe, provide comfy places to await your turn to play pool, as does a tufted leather and brass fender from England, surrounding the hand-carved Cantera fireplace.

for her drama and sophisticated sensibility of style, Brenda strives to transform projects into dramatic, expressive living spaces with a rich diversity of elements—areas that combine functionality, aesthetics and unmatched artistry.

Brenda instills in her team the concept that design expertise comes from accumulated exposure and experience. As a result, their projects extend from New York to Chicago, as well as Houston, Newport Beach,

Palm Springs, Laguna Niguel and the Phoenix metropolitan area. She and her team have won a number of IIDA awards and have been widely published locally and nationally.

Their emphasis is on scale, details and planning to ensure client satisfaction. For scale: "I interact with the architects and observe the rule that form follows function." For detail: "My attention to detail can be exasperating at times. But when clients see the space and witness

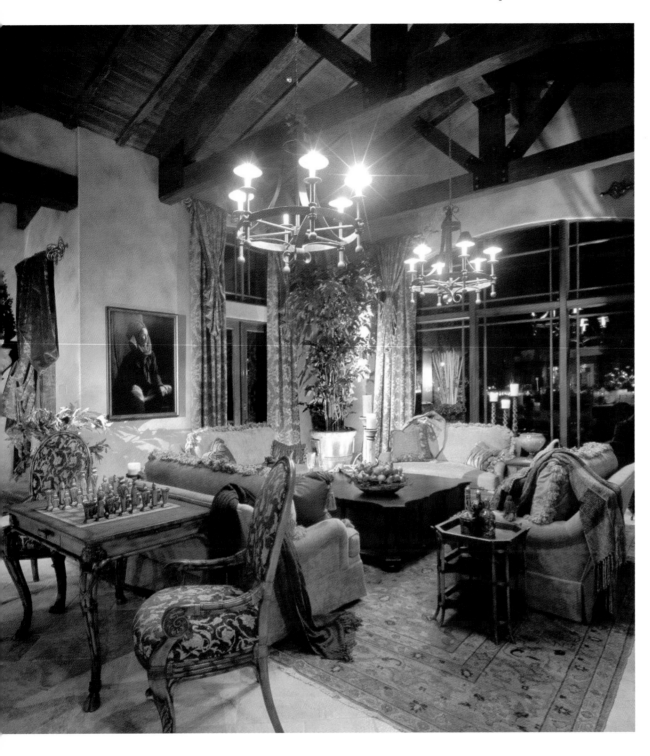

the details created, there is a definite 'WOW' factor that makes the effort all worthwhile." For planning: "My dad taught me scale and plumb lines. I follow the rule of: 'measure twice and cut once.'" For clients: "With my guidance, I follow each client's directions to bring out and incorporate their individual personalities. We believe in our vision of style to meet or exceed their expectations. 'Élan' is French for passion, great warmth of feeling, fervor and zeal, which represents my feeling of bringing the client all I have to give. Focusing on one client at a time, I believe, is what sets us apart from other design firms. 'Service, service, service': That's what has brought me to where I am today."

Honored as a professional in the International Interior Design Association and certified as a designer in New Mexico, Brenda is a member of today's *Arizona Woman's* Million Dollar Club and Who's Who of World Wide Business Leaders.

ABOVE
Four custom upholstered love seats surround a 62-inch fruitwood hand-carved coffee table with two large slide-out drawers for family treasures. A leather chess board table and matching upholstered chairs make this a perfect setting for a couple to end the evening: playing games!

NEAR RIGHT
Locally created, this masterful hand-painted groin ceiling recalls 16th-century ceiling frescos. The custom dining table, Kingsbridge custom-upholstered chairs, the drapery and the lighting also add to the Old World theme.

FAR RIGHT
You enter this bathroom through a rock arch to an elegant, draped Jacuzzi marble tub. The tête-à-tête in the middle of the room adds a sense of style dating back to nineteenth-century France.

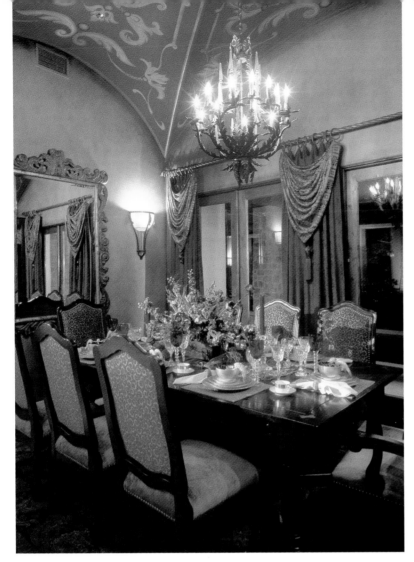

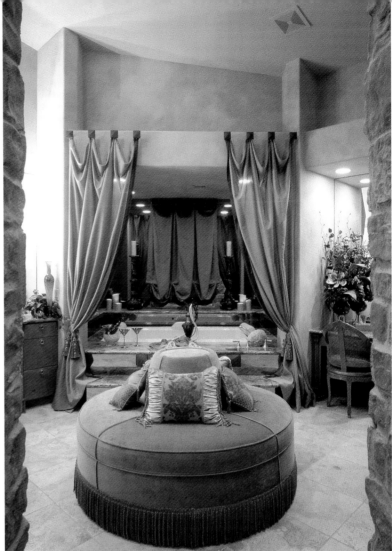

More about Brenda…

WHAT WAS THE MOST UNUSUAL/EXPENSIVE/DIFFICULT DESIGN OR TECHNIQUE YOU'VE USED IN ONE OF YOUR PROJECTS?

The most trying was an exquisitely faux-painted façade countertop apron that followed the lead from a supple, flowing, curved, Rio Verde green granite countertop. There were many go-rounds as to how we would realistically accomplish the structure of the apron. This lavish powder room beams with a softly illuminated etched crystal sink and faucet, so it was with great effort that we made sure the apron was in standing with the crystal trappings.

WHAT IS THE BEST PART OF BEING A DESIGNER?

I'm living my dream, design is my passion, I am what I do…Design!

WHAT IS YOUR SECRET TO SHOPPING AT MARKETS?

I purchase items that are unique, one-of-a-kind treasures; even if I don't have a particular project for it, I know I will be able to place it.

Élan Interiors Inc.
Brenda B. Agee
Professional Member IIDA
7020 E. First Avenue
Suite A
Scottsdale, AZ 85251
480.970.8282
www.elaninteriorsinc.com

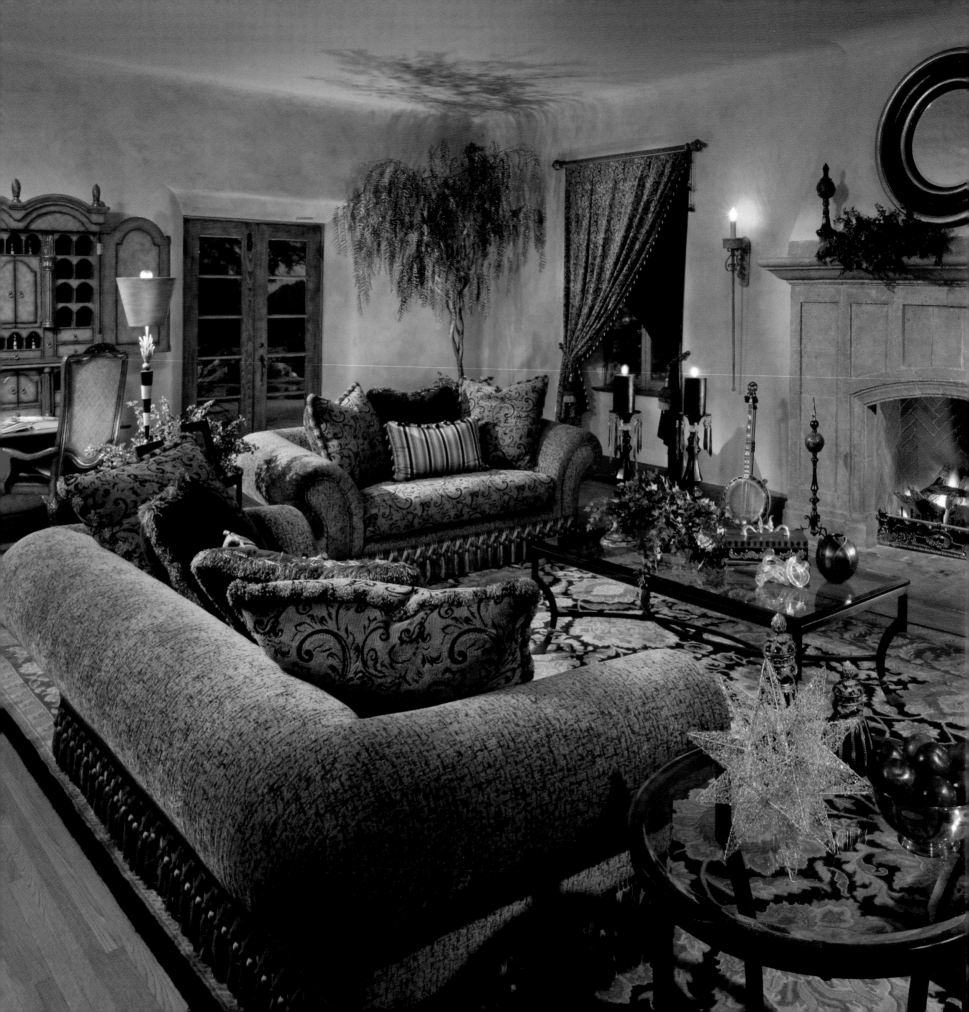

Martha Andrighetti
Andrighetti Design Associates, Inc.

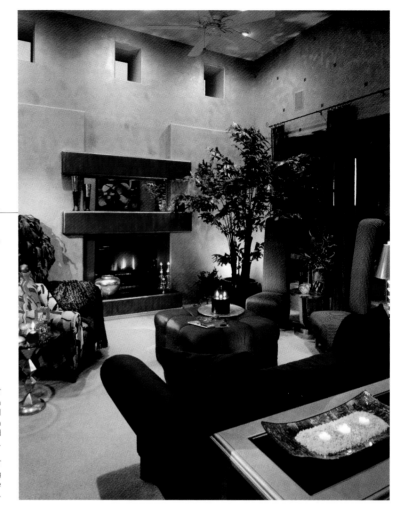

LEFT
In Phoenix, the Rancho Joaquina House is the earliest-known two-story Adobe Revival. Built in 1924 and on the National Register of Historic Places, the home features a living room which beckons with refined tones of caramels and blacks and accents of golden tobacco.

RIGHT
In a home in Scottsdale's Ancala Country Club, this living room, with silver-leaf walls, copper accents and blue overtones, is an invitation for conversation.

After 25 years in the business, Martha Andrighetti can relate to the challenges of interior design.

"My business is about relationships and understanding the clients' visions, while meeting their expectations and blending their personalities," Martha explains.

The West Virginia native lives and works out of Fountain Hills, the community just east of Scottsdale. Before moving to Arizona, Martha studied at Kendall School of Design in Grand Rapids, Michigan, and then lived and worked in Oklahoma, Maryland and Virginia, accommodating many diverse and discerning clients.

"My design palette is varied and allows the client to dictate the direction of the project," she explains. "I evaluate their lifestyle, personality and desire for change, and then pull that vision into their home."

Regardless of when she becomes integrated into the project, Martha is always very involved: "Ideally, that's at the very beginning, the preliminary stage of reworking the blueprints, space planning, creating and making aesthetic changes along with interior and exterior design selections." In this way, the plan is right before the home goes out for bid. "Ultimately, the results are aesthetically pleasing."

Whatever the style of the home, or size of its rooms, she ensures that the finished environment reflects an atmosphere of tranquility, warmth and charm while portraying a sense of subtle refinement and drama. "A room should have harmony and comfort" Martha says, "speaking to one's spirit and creating rest for one's soul."

Andrighetti Design Associates, Inc.
Martha Andrighetti
16430 East Glenbrook Blvd.
Fountain Hills, AZ 85268
480.837.4879
www.andrighettidesigns.com

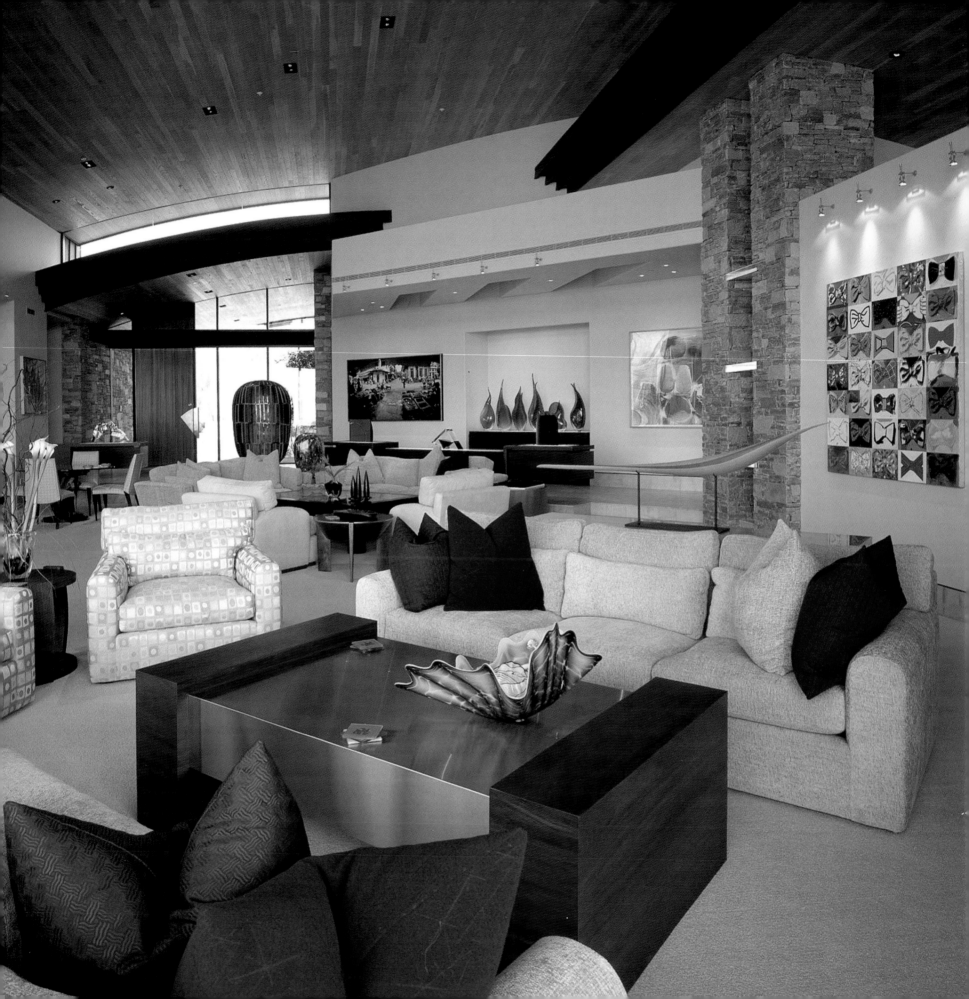

Paula Berg
Paula Berg Design Associates

LEFT
The monochromatic palette of this Arizona living room, finished with limestone, walnut And stainless-steel accents lets the owners art collection be the star attraction.

RIGHT
An eclectic blend of marble, etched glass and Eucylphus veneer highlight this contemporary Southwest design in the desert.

"'Paulatize' our home"—That's how one appreciative client offered Paula what she describes as her highest compliment during a stellar 30-year design career.

But that's the reputation she has been able to build with her dual-office firm. "The clients trust me thoroughly to meet their expectations," says Paula, a Southwest resident for 27 years.

Her combined staff 14 serves these clients in a variety of locations: Hawaii, Chicago, Beverly Hills, South Beach, Florida, Utah and throughout Arizona. The projects are as diverse as her clientele: a Chicago Lakeshore Drive home in a 1920s Beaux Arts building; an Art Deco condo in South Beach, Florida; a Tuscan retreat in Montecito, California; a 33,000-square-foot log-inspired spec home in Park City, Utah; and an Indonesian-inspired home on the big island in Hawaii. "You can't look at my portfolio and think that the same person did all of the projects," Paula says. "Our style is very eclectic."

Born in Cleveland, Ohio, Paula attended Ohio University, training as a concert organist. "I was going to be a teacher and taught drama for a short time," she recalls. Her arts passion led to travel and eventually to work as a flight attendant for Pan Am and then as a convention director.

"I like to say that all of this was by design," she says, with a chuckle. "The arts passion has helped make me a particularly sensitive designer, not only to artworks but also to materials, colors and overall planning. And all of that tourism experience has kept me broad-minded, willing to draw on many traditions and many opportunities to complete a job to my clients' needs and desires."

Meanwhile, she had decorated her first home in Atlanta. Her friends told her, "You have talent. You missed your calling." But she didn't miss it: She went back to school, in Atlanta, to Georgia State University, where she completed the interior design program and graduated with a master's of fine arts degree. After doing some design work, she and her husband moved to Phoenix where, while raising her children, she opened Beyond Horizons, an interior design store that offered both high-quality product, such as designer furnishings, and high-quality service.

That work through the store, begun more than 25 years ago, brought her a "Master of the Southwest" accolade from *Phoenix Home & Garden* magazine— making her one of the first professionals to be so named. During the last few years, Paula Berg Design Associates has also won a number of other awards, including two "Best of American Living Awards" for the Home of the Year competition. In addition, she and her team have won multiple ASID awards during the local chapter's annual design competition.

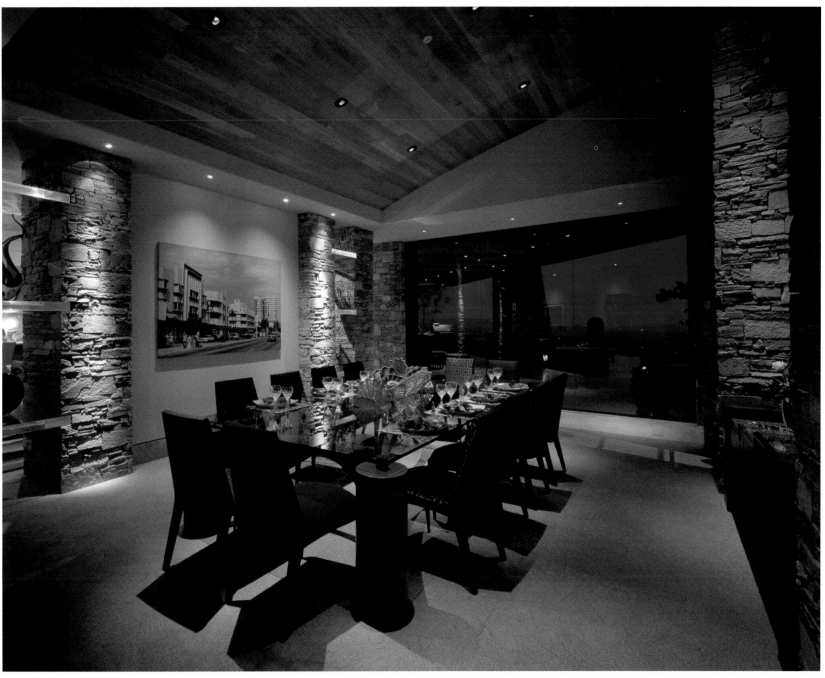

FAR LEFT
Desert earth tones with venetian plaster walls and a whimsical
contemporary rug.

NEAR LEFT
Diamond patterns in floors and venetian plaster walls make this open
living room appear even grander; a large area rug helps to ground
the intimate conversations area

ABOVE
Graceful arched walnut elements spanning between steel columns
on the dining table compliment the Chihuly.

Paula attributes this success to a variety of factors. At the foundation is old-fashioned tenacity:

"elbow grease." Then, too, she designs specifically for the Southwest environment and honors

the natural materials she works with; she loves textures and patinas and surface contrasts.

Paula is innovative as well: She was one of the first locally to use materials such as stained

concrete and bamboo flooring, etched metal or glass facings as well as unconventional

combinations of exotic woods in millwork and cabinetry. Furthermore, she respects the style

that the architect has selected. "The best scenario is to start simultaneously with the clients'

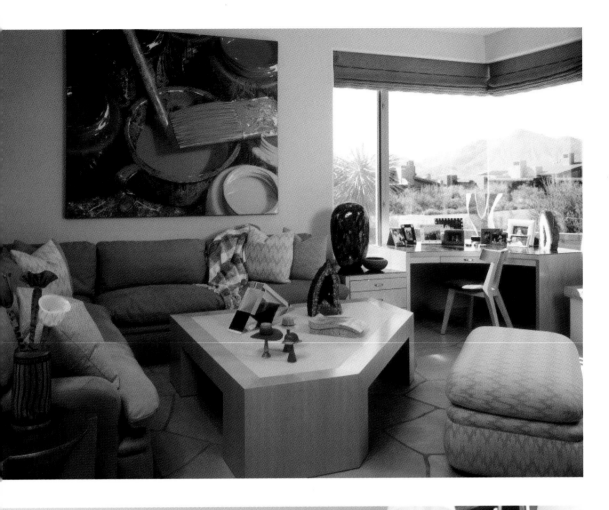

hiring the architect," she says. In this way, I can ensure that the spaces themselves are adequate for the client's conception. I like to say that by working with the architect at this stage, I become another set of ears for the client."

Details count, too. Her offices design architectural detailing to stylize the space to the customer's program, including built-ins, vanities and fireplaces. They also do turnkey furniture design. And, her infusion of art into nearly every facet of an interior, for example, often takes the form of signature tongue-in-cheek plays—which add fun and pizzazz to her interiors.

Finally, and most importantly, is her and her staff's flexibility with clients' personalities and visions. "What makes me different is my ability to adapt to the client's personality," Paula says. "I am a great listener. And because I am very interested in detail, I will go that 'extra mile' to provide interiors that are both timeless and trendsetting."

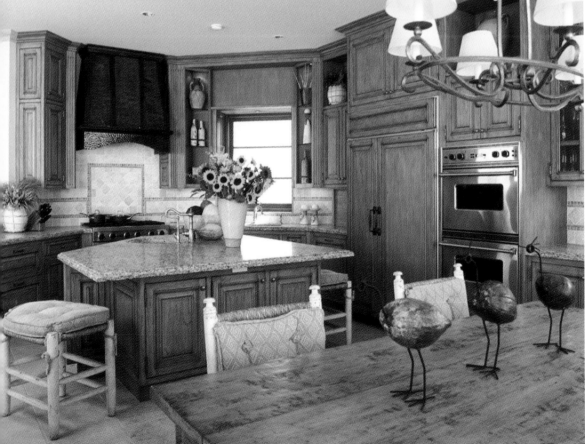

ABOVE
A monochromatic scheme in the fabrics accented by bold contemporary art.

LEFT
A California kitchen featuring distressed Alderwood and a Pewter Patina on the kitchen hood.

NEAR RIGHT
Reclaimed Beechwood cabinets and oak floors set the tone for this rustic kitchen, which features a free-form bronze cast chandelier designed by a local artisan to resemble tree branches.

FAR RIGHT
A local Artisan designed the log bunk beds in the cozy western inspired bedroom.

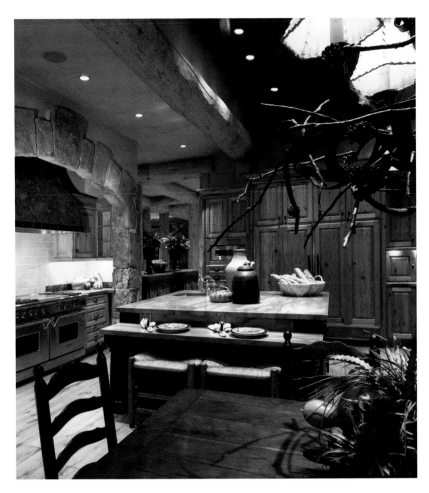

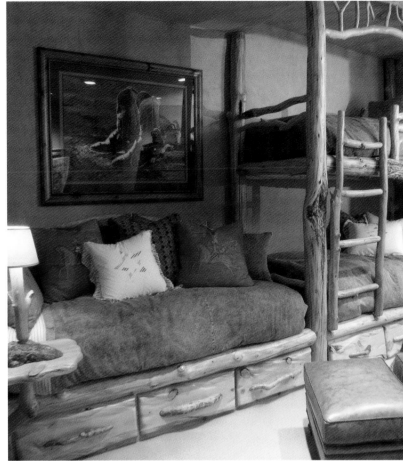

More about Paula ...

WHAT IS THE BEST PART OF BEING AN INTERIOR DESIGNER?

Always being at the cutting edge of what is new and fresh.

WHAT IS THE MOST UNIQUE/IMPRESSIVE/BEAUTIFUL HOME YOU'VE SEEN IN THE SOUTHWEST? WHY?

A home I completed in Paradise Valley, Arizona, because the client allowed me total freedom to use materials that would complement the design.

IS THERE ANYTHING YOU WOULD LIKE TO MENTION ABOUT YOURSELF OR YOUR BUSINESS?

I have a tremendous passion for my work and I always go beyond the expected to search for new inspiration and sources.

YOU WOULDN'T KNOW IT, BUT MY FRIENDS WOULD TELL YOU I WAS . . .

A "homebody." I enjoy my private time at home. I am very family oriented—my children and husband are what truly sustain me and bring me peace.

Paula Berg Design Associates
Paula Berg, Allied Member ASID
7522 E. McDonald Drive
Scottsdale, AZ 85250
480.988.2344

1816 Prospector Ave. Suite 200
Park City, UT 84060
435.655.9443

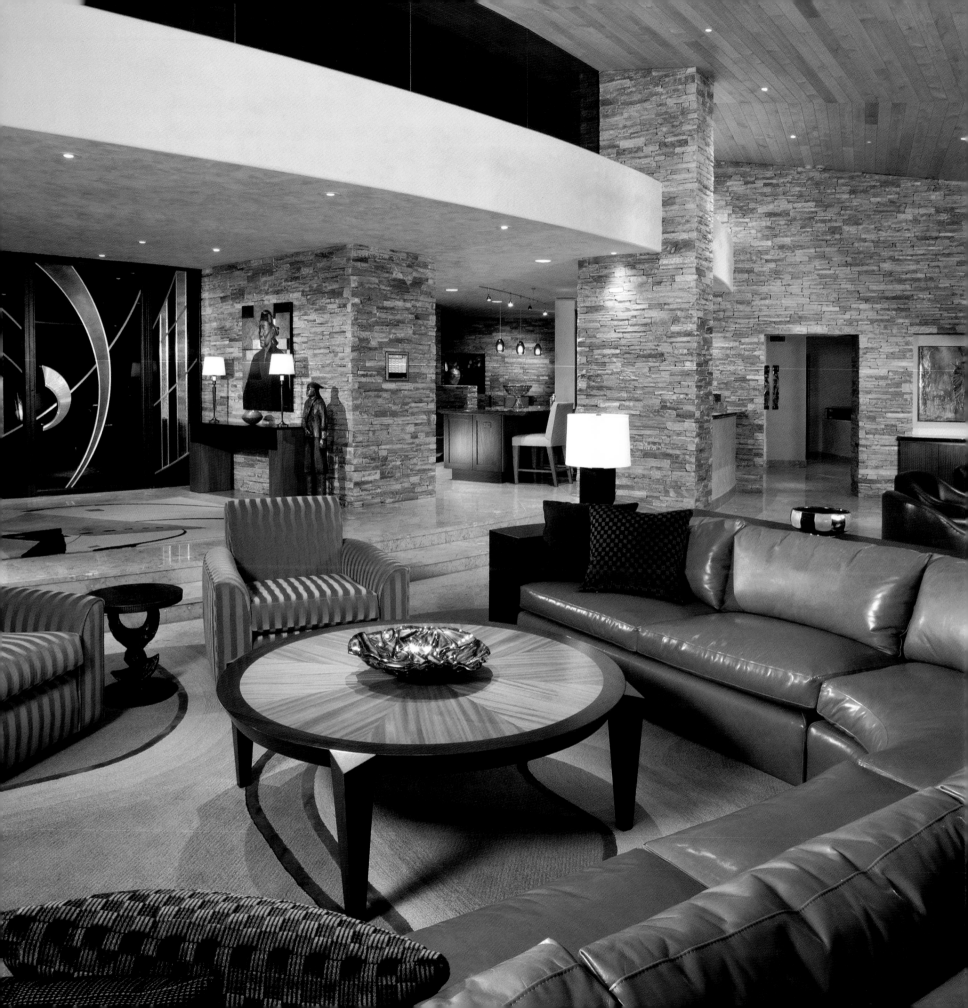

Janet Brooks
Janet Brooks Design

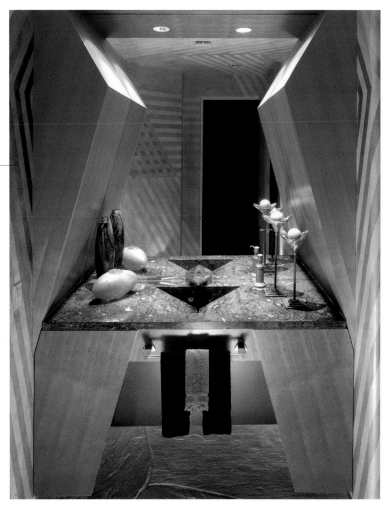

LEFT
Curves are the theme of this beautiful desert home, from the architectural shapes to the front door design, to the shapes in the custom Edward Fields area rugs. Floors throughout are 24x24-inch Napolina limestone.

RIGHT
Powder rooms should have pizzazz! This one shows that imagination by way of classy contemporary styling, with vertical-grain cherry wood, fossils and hand-painted wall graphics.

"It's all in the details," says Janet Brooks, who wrote a significant biographical detail in 1987 by moving to Scottsdale from Durango, Colorado.

Today, she and the staff at Janet Brooks Design offer interior designs that affirm the company's continuing attention to the small stuff. "Our talented designers and associates all have creative visions and expert knowledge of materials and their applications, but there is no substitute for detail." She adds "We are responsible for delivering an incredible amount of accurate information in a timely manner—or the project will fall behind schedule or be built wrong!"

"Quite often clients say they know they need our services, but their first question is, 'What, exactly, do designers do?'" She answers, "We explain that the full scope of our services includes designing and specifying materials for every surface that can be seen or touched in their homes." When the challenge of making so many important decisions is separated into categories and put on a time line, it becomes more manageable. "All of us make it a point to get into our clients' heads and see the project from their point of view, so we are able to give professional advice but keep the design authentically theirs," Janet explains.

As a result, clients continue to return to Janet Brooks Design, trusting the firm to create exactly what they want, whatever style they've chosen. "Each project has given our clients real joy and resonates with their interests at that particular time in their lives," she says, "and the successful completion of each new commission gives all of us, in turn, great joy."

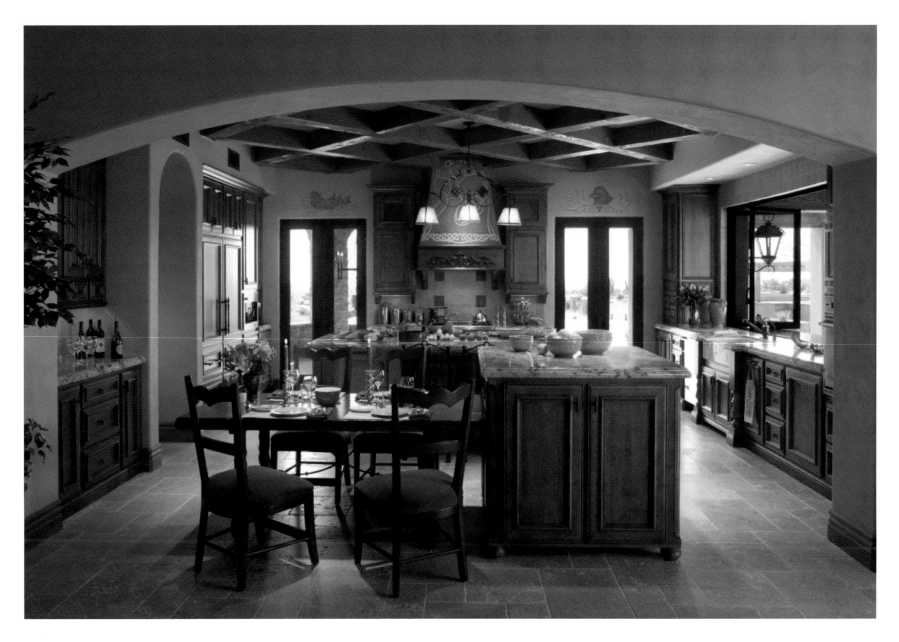

Just as importantly, multiple ASID awards haven't stopped the firm from learning. "There is never a day that we don't learn something new. We learn from the architects on each project, from the various tradesmen on the job sites, from clients, who come from so many different professions and backgrounds, and from the myriad design resources we use constantly for research."

The result: fresh, colorful, inviting designs, unlike any other design for that, or any other, client. "Comfort and appropriateness to clients' sensibilities underlie all aspects of our practice," Janet says. Relatedly, the firm avoids design clichés— and especially unauthentic knock-offs of any style or material. "The home ends up looking like a caricature," she explains. "When

someone tries to make a home look 'important,' it usually does not blend with its environment and calls attention to itself in a most unflattering way."

The motto for the firm: "Keep it real!" An example: A few years ago, Janet and her husband celebrated the New Year in a tiny cabin in Sedona abutting Oak Creek. "The home was very simply furnished and basic in its amenities, but it offered phenomenal views and the sounds of the rushing water. The architectural style blended with the forest, so whether we were inside enjoying the crackling fire in the old stone fireplace or outside on the deck in the snow, the structure was in perfect balance with its surroundings. It wasn't a Five Star resort; it was small and unassuming. But it reminded me that beauty, in its many forms, is always appropriate."

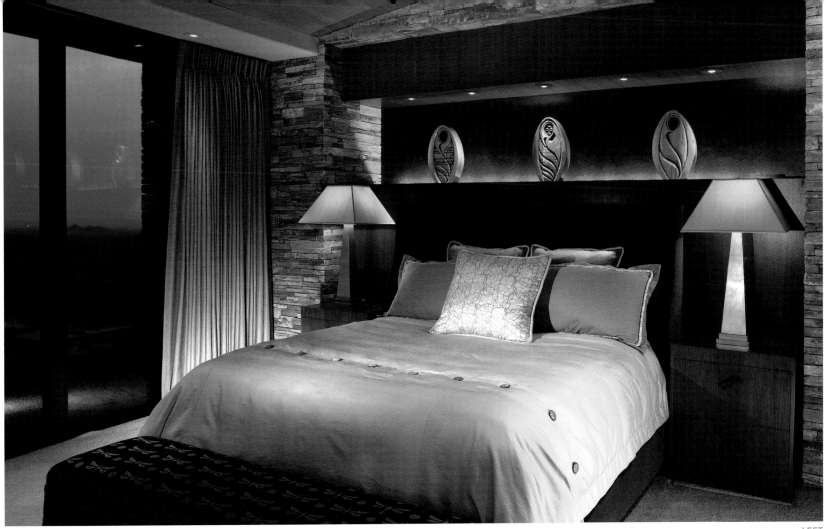

LEFT

This ultimate gourmet entertaining kitchen features the latest appliances, abundant counter space, storage that never ends, and a window wall that opens up to a patio with unbelievable views of the Superstition Mountains.

ABOVE

This romantic, elegant bedroom provides comfort, a beautiful view and a lighted niche to display a collection of carved wooden Navajo women by artist Luis Fairfield.

More about Janet…

ANY SCHOOLING, ACCREDITATION OR ASSOCIATION MEMBERSHIPS?

I am a Professional member of ASID, which works to promote education and professionalism in the interior design industry. In order to become a professional member, a designer must satisfy the eligibility requirements of the National Council for Interior Design Qualification by successfully passing a two-day exam.

WHAT IS THE MOST UNUSUAL/EXPENSIVE/DIFFICULT DESIGN OR TECHNIQUE YOU'VE USED IN ONE OF YOUR PROJECTS?

I did an unusual treatment in an ASID Designer Showhouse dining room. My design scheme was very formal and luxurious, but I used corrugated tin on the ceiling, which I found on a horse shed that was being torn down in Paradise Valley. We cleaned it up, used some acid on it to give it an interesting patina, and it made a wonderful and surprisingly elegant ceiling!

WHAT IS A SINGLE THING YOU WOULD DO TO BRING A DULL HOUSE TO LIFE?

I would adjust the light, to bring out the best of the room. It's amazing how dull even a well-designed space can look when the lighting is not working to bring it to life! I would start by adding or subtracting window treatments to achieve the best possible levels of natural light coming in from the outdoors. Then, I would use multiple levels of high- and low-voltage lighting, along with fiber-optics, to add emotion, depth, surprise and drama. Lighting is everything.

Janet Brooks Design
Janet Brooks, Allied Member, ASID
8701 E. Vista Bonita Drive
Suite 115
Scottsdale, AZ 85255
480.776.2700

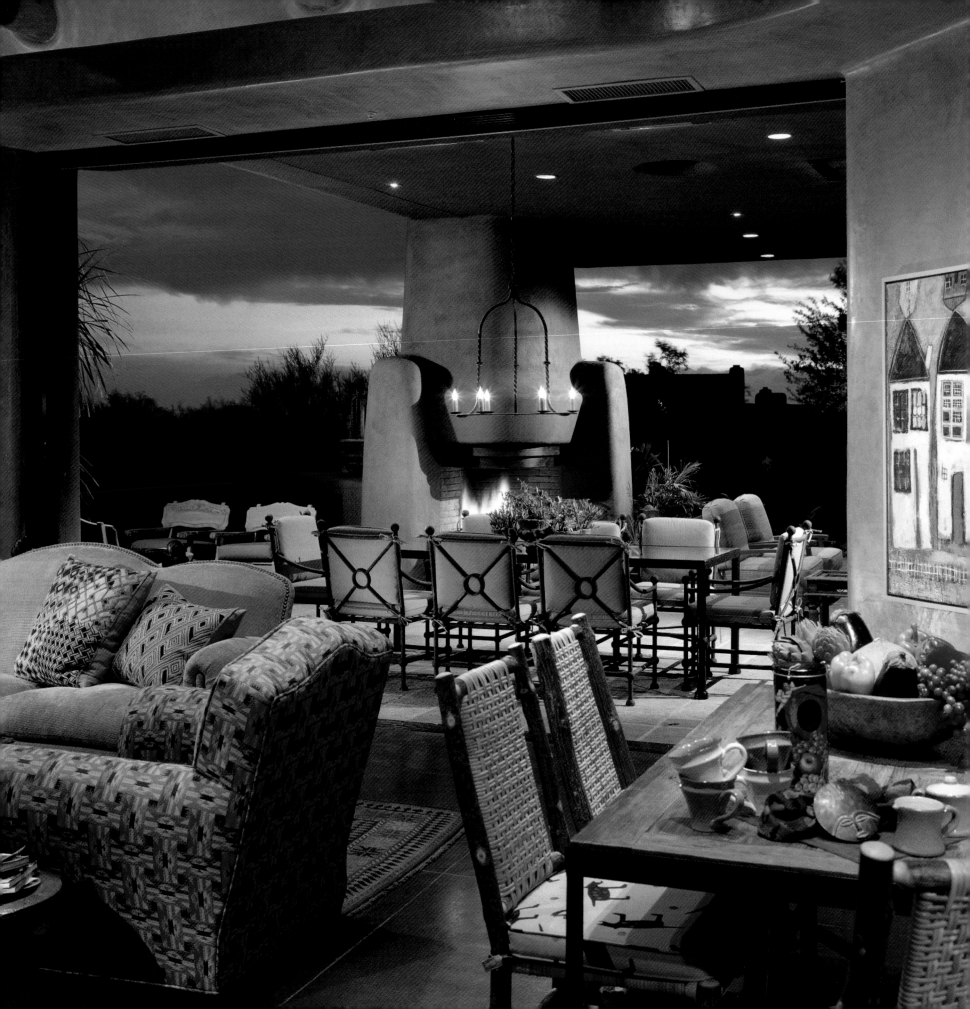

Patty Burdick
Sue Calvin
Jana Parker Lee
Wiseman & Gale

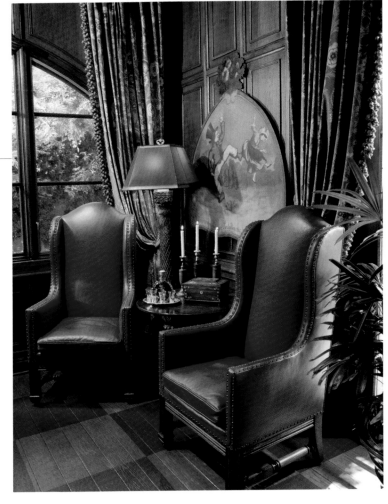

LEFT
Designed by Sue, this casual indoor/outdoor room is quintessentially 'the Arizona lifestyle.' When the telescoping glass doors are fully tucked into the wall, a grand room with multiple seating areas is revealed. Sue focused on color and texture to maintain a cohesive visual flow.

RIGHT
This small conversation area was created by Jana using a cozy mix of textures — including printed velvet draperies, a pair of antique wing chairs, and an 18th-century French tavern sign.

For 40 years, people have come home to the Southwest through the doors of Wiseman & Gale.

Specializing in Southwest-inspired interiors, the highly respected Scottsdale design firm includes 12 professional designers, led by four partners and friends, Patty Burdick, Sue Calvin, Jana Parker Lee, and Scott Burdick. Scott, Patty's son, manages the business while the design triumvirate creates some of the most interesting residential projects both in and out of Arizona.

Patty, who joined the firm 20 years ago, says, "We are very flexible, but because of our history and reputation, we are perceived as a company that works with its clients in a broad Southwestern environment." She notes, however, that the company has expanded from these roots, creating environments in various styles in the Southwest and throughout the country.

The firm's reputation was established by founders George Wiseman and Anne Gale. He migrated to the Valley from California, she in 1959 from Santa Fe, with her husband, architect Tom Gale. They opened their Scottsdale design studio in a location just 100 yards from the current address. "Anne was a 'Master of the Southwest' in 1998 and is considered by many to be the grandame of Southwest luxury design," says Sue Calvin, also a 20-year veteran of the firm and also, like Patty, a former intern who's never left Wiseman & Gale. "Anne early on recognized the eclectic nature of the Southwest style," she adds.

That Southwest eclecticism has firmly branded Wiseman & Gale. "People would bring their treasured family possessions with them when they settled here," explains Jana Parker Lee, who, at 15 years with the studio, is its youngest partner. "Here they would also recreate and reinterpret these items, using the

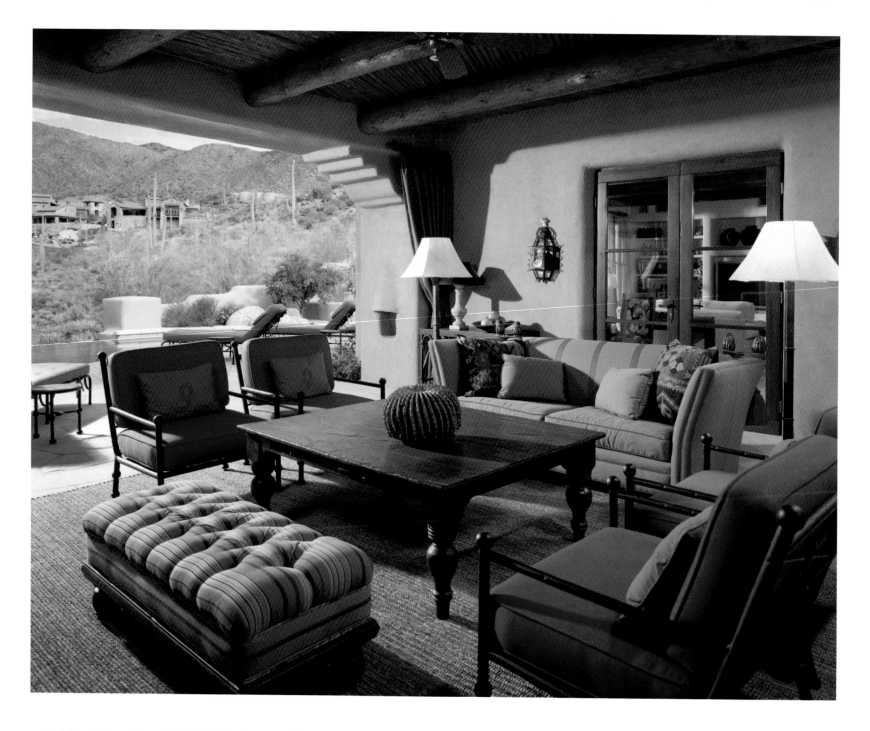

materials and the tools available in the Southwest." The three women and Scott purchased the business from Anne in 2002, upon her retirement.

All of the women learned from Anne the many derivations of the Southwest interior style: Spanish Colonial, Arizona Territorial, Santa Fe and Contemporary Southwestern. "Our designers are proven experts in the scale, light, color and history of the Sonoran Desert—and understand its unique challenges," Jana says.

Sue adds: "Our rugged, masculine designs appeal to people who love the majesty of the Southwestern landscape. We'll use a bold red as a neutral—Anne Gale made that one of our trademarks. Additionally, we'll seek out less delicate Spanish or Japanese antiques, along with 'anything' 17th century to achieve this boldness. Our designers possess an extensive understanding of the unique elements found in the desert Southwest—with manipulation of light and scale being of primary importance to our designs because our spaces so

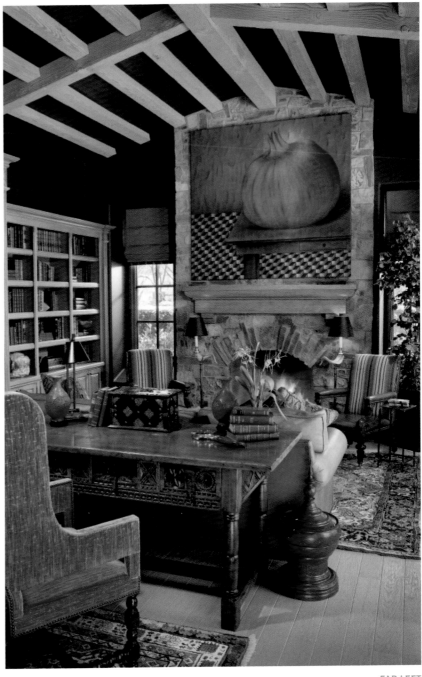

FAR LEFT
Inspired by the spectacular Sonoran desert view from this outdoor 'pool portale,' Patty chose an acid green and deep red palette to complement the natural surroundings.

ABOVE LEFT
A very fine reproduction of a Spanish Colonial table serves as the desk in this multi-purpose library/office. Jana designed a 'reverse' color scheme — painting the walls chocolate brown with light woodwork instead of the typical dark beams and light walls.

ABOVE RIGHT
Glass doors in the dining room open onto a cozy patio and fireplace. Sue used an antique Kilim rug for pattern on the chair backs — but kept the seats in comfortable linen.

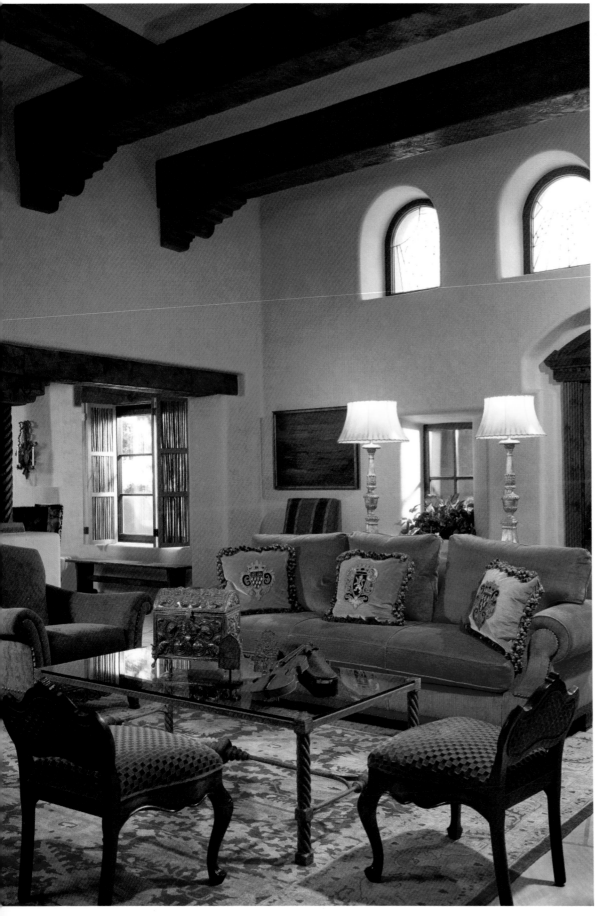

often open from one to another. Because of this, we tend to use materials and colors that flow throughout the home. This applies to paint colors, floor coverings, etc."

While different in finesse and fortes, the women consolidate as one, offering a product that is always distinctly Wiseman & Gale. All of the women learned, too, to be people pleasers, to focus on clients' needs first, their environments, their visions, their joys—never forgetting the sense of whimsy and "wow" that has always set Wiseman & Gale apart.

"We manage the stress and try and make decisions easy for our clients, allowing a creative and interactive relationship to develop that is fun and long lasting," Patty says. "Our whole design process leads to that moment when clients see the finished product and realize that their expectations have been exceeded."

LEFT
In Scottsdale, hand-hewn beams dominate the living room of this rustic adobe home in Saguaro Forest, Desert Mountain. Patty notes that this space was designed to accommodate the client's musical background and entertainment needs — with furnishings chosen that could be easily gathered for impromptu musical performances.

NEAR RIGHT
The master bedroom's tone-on-tone palette and Spanish and Italian antiques mix beautifully to create an elegant, quiet space. Patty retrofitted the antique chest at the foot of the bed to disguise a large pop-up flat screen TV.

FAR RIGHT
Jana covered a comfy chair in Fortuny to make this soothing tub niche elegant.

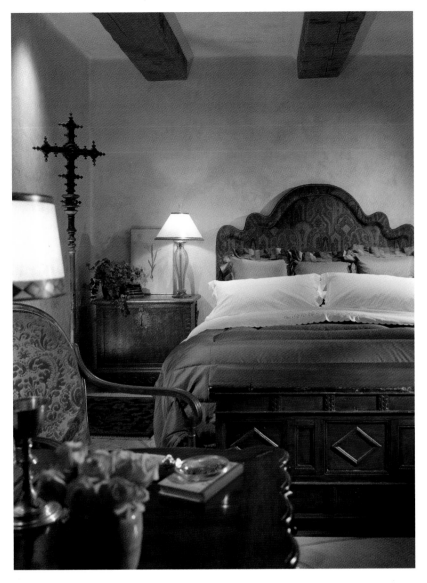
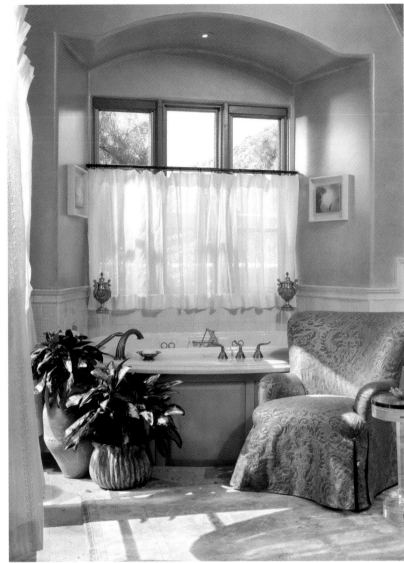

More about Patty, Sue & Jana …

WHAT IS THE BEST PART OF BEING AN INTERIOR DESIGNER?

Patty—The installation: seeing the finished product.

Sue—Two great times: creating the interiors (fabrics and furniture) and then installing and seeing the finished product.

Jana—Having the opportunity to constantly see new product and the latest designs in fabrics, etc.

WHAT IS THE SINGLE THING YOU WOULD DO TO BRING A DULL HOUSE TO LIFE?

Patty—Add color, color, color!!!

Sue—Paint.

Jana—Color, of course, in rugs and upholstery—not necessarily walls, and art.

WHY DO YOU LIKE DOING BUSINESS IN THE SOUTHWEST?

Patty—People are looking for a reinterpretation of their own look.

Sue—Lots of influences here, so … we have freedom and boldness of color and design here that isn't so in other parts of the country.

Jana—Clients are ready to design simply, comfy and relaxed.

Wiseman & Gale
Patty Burdick
Sue Calvin
Jana Parker Lee
4015 North Marshall Way
Scottsdale, AZ 85251
480.945.8447
www.wisemanandgale.com

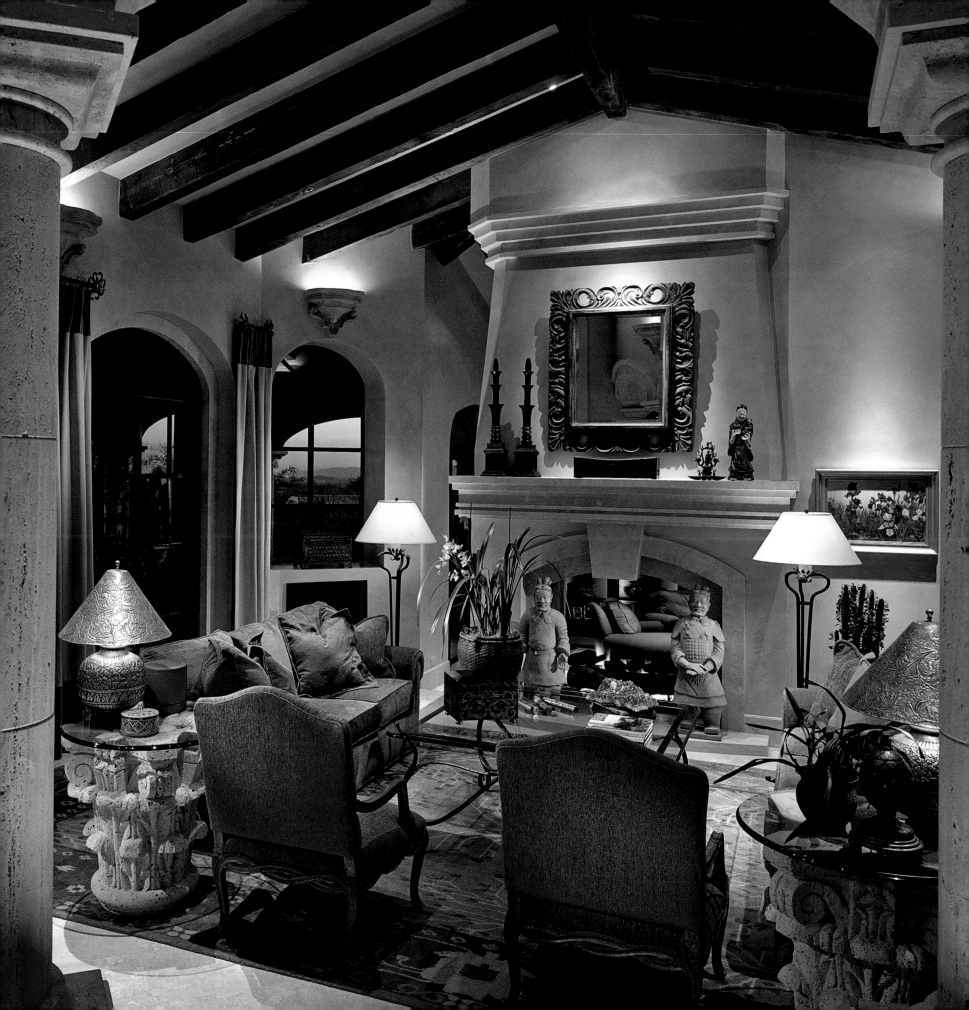

Carol Buto
Carol Buto Designs

LEFT

Carol selected colors of the chenille fabrics to blend with the Tufenkian rug. Existing Cantera stone bases, formerly supports for a dining table, now serve as end tables.

RIGHT

Textures of parqueted grasscloth and seagrass enhance the stone wall in this guest bedroom, designed for a showhouse. A reinterpretation of classical Japanese elements, the room embraces ancient styles with a contemporary vision.

"Skilled, unpretentious, efficient." That's one builder's description of Carol Buto, ASID, who's been in the design business for 38 years—21 in the Southwest. Design driven even as a teenager, Carol toured houses with her beloved parents in native Cleveland, Ohio, and has been opening doors for clients since.

Such longevity comes from listening to clients' needs and according with their budgets, "I never force my ideas or taste on a client," says Carol. "Design is a collaboration. It's the fine art of constructive compromise, which positively serves the project as a whole."

Widely honored and published, including ASID's Medalist and Designer of Distinction Awards, Carol accomplishes projects for the most demanding clients in the finest Southwest communities: in Desert Highlands, Sincuidados, Troon, DC Ranch, Grayhawk, Desert Mountain, in Eagle's Glen, at Forest Highlands and Colorado.

Eclecticism makes her projects work and her clients happy—tasteful choice and a receptivity for new opportunities to create vibrant interiors in ways she hasn't done before. "Diversity is the key to achieving the uniqueness and individuality that each client deserves," Carol says. Diversity: the ability to tap into her experience, her stylistic penchants, while remaining true to clients' directives.

For example, in a Scottsdale "Mediterranean Hacienda" she integrated her client's more casual Western style with the original formal European style of the house—without compromising the integrity of either.

To satisfy clients' needs, she may customize furniture through showrooms or reuse special existing pieces (moving it from home to home, recovering it, recycling it from one function to another) or magically juxtapose the unjuxtaposable. One client asks, sitting in her bedroom and marveling at Carol's ability for accessorizing and blending: "How does she come up with these and make it look so good?"

Carol Buto Designs
Carol Buto
15770 N. Greenway-Hayden Loop
Suite 104J
Scottsdale, AZ 85260
480.348.7496
www.carolbutodesigns.com

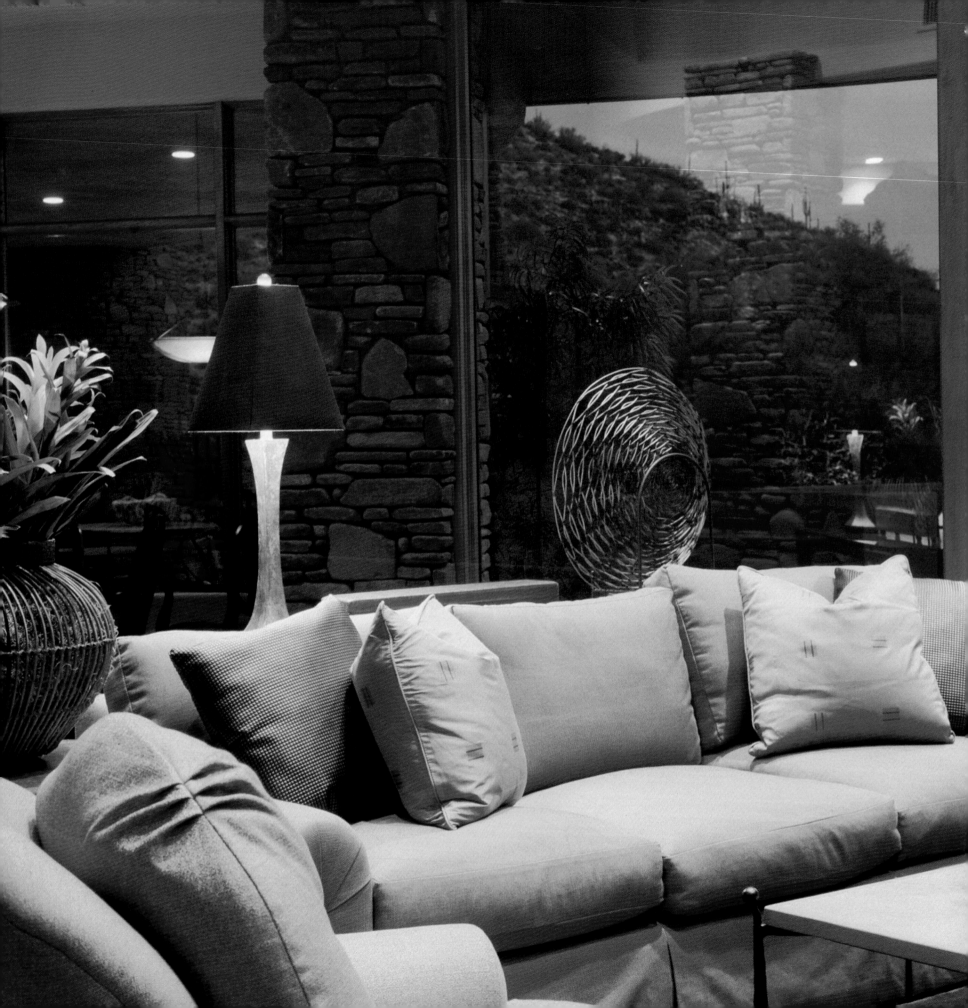

Lori Carroll
Lori Carroll & Associates

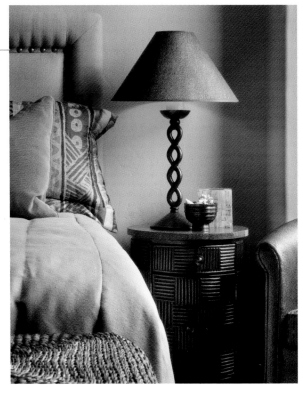

LEFT
By combining a multitude of textures, Lori creates an engaging conversation area.

RIGHT
Welcoming guest rooms include the comforts of home.

With a passion for great design, follows the "less is more" philosophy of famous architect Mies van der Rohe. Reflecting on the delicate balance of creating a perfect environment, Lori knows that adding just one too many items can spoil the success of a project. "I don't like overwhelming a space with excess," she says. "I use a moderate approach to make an impression without a lot of unnecessary embellishments."

Lori has pursued her interior design career living and working in Tucson. During many of the 24 years, she maintained a successful partnership and later established Lori Carroll & Associates in 2000. While her firm has grown quickly, she has chosen her associates wisely and thoughtfully matched them to a range of positions. Elle Taft, Alejandra Hodgers, Andrea Wachs, Mary Roles, Sandy Wiebers, Laurie Colburn, Reneé Robbins and Julie Bishop each contribute significantly to the accomplishments of the business.

The studio offers a broad range of residential and commercial design. From conception through completion, every detail is managed professionally. Architectural reviews are heightened by presenting clients with comprehensive computer automated drawings that assist in visualizing accurate prospective and space planning. By choosing from a wide-ranging collection of resources, impressive finish and product selections can be chosen to suit any lifestyle. When seeking custom product design, Lori's talent stands out as she collaborates with area artisans to create one-of-a-kind creations.

Working closely with some of Tucson's esteemed architects—Eglin/Cohen Architects, Gansline & Associates, Kevin B. Howard Architects, Robinette Architects and Simmons Home Design—Lori takes into consideration architectural details when creating her designs. However, she says, "While I respect the architect's vision, I am not averse to suggesting modifications that I think will produce a more dynamic and livable space for our client."

Lori was born in Denison, Iowa, where her father owned a lumber yard. That early construction influence kindled her creative instinct. "I knew from junior high that interior design was going to be my chosen profession," she says. After graduating from high school in 1981, she moved with her parents to Tucson. She earned her bachelor's degree from The University of Arizona in 1986 while working as a sales associate and design consultant at a local furniture store, Contents.

During that time, she attended a summer exchange program in Denmark through the universities of Arizona and Copenhagen. "It was a great experience," she recalls. "The Scandinavian principles of design confirmed for me the importance of clean lines and moderation." During her stay in Copenhagen, her husband made a surprise visit and proposed marriage. They now have two children, Johnathon and Madison.

Mies and Frank Lloyd Wright have had the greatest influence on her style. Explaining Wright's organic, integrated vision, she says: "He had his hand in everything. He designed the house, the furniture, and the rugs along with selecting fabrics."

Lori, too, likes to start a project in its earliest phases. She systematically concentrates on fundamental matters first, such as stone and millwork, flooring, tiling and cabinetry. Then, after inspiring meetings with her

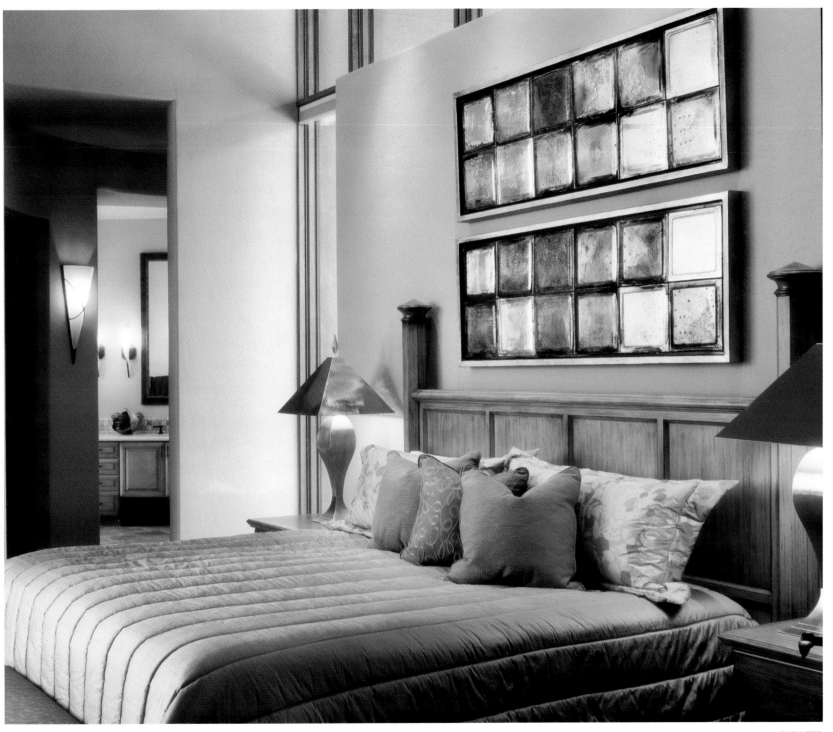

FAR LEFT
Exceptional furnishings and lighting create a captivating entertaining area.

NEAR LEFT
Lori carefully chooses accessories to emphasize the character of a room.

ABOVE
Sophistication is evident in this serene master bedroom.

clients, she begins a search for the finest furnishings and accessories. By integrating details and a combination of materials and textures into the design, Lori finishes a project—with style and without overpowering the essentials.

Lori has no one design style, preferring to blend elements of Transitional, Traditional, Modern and Contemporary. "My desire has always been to accommodate a diverse clientele, with particular attention to detail and providing unprecedented customer service."

Her profession has continually acknowledged her talent. With articles publicized in several local and national magazines, her projects have also been featured in a variety of design books.

Among Lori's many accomplishments, she recently received First Place for Powder Rooms at the 2005 National Kitchen & Bath Association awards. Her peers have also honored her with consecutive Best of Show awards in the 2004 and 2005 American Society of Interior Designers Arizona South Design Excellence competition.

Clients have exuberantly praised her work. "The homes created by Lori Carroll are elegant, innovative and at the same time eminently livable," writes one. Another: "Your willingness to listen and respect our tastes and wishes … your creativity … your professional work ethic … your competency … your amazing team … make for a most wonderful package."

Lori's testimonial powerfully sums it up: "My staff and I love what we do year after year."

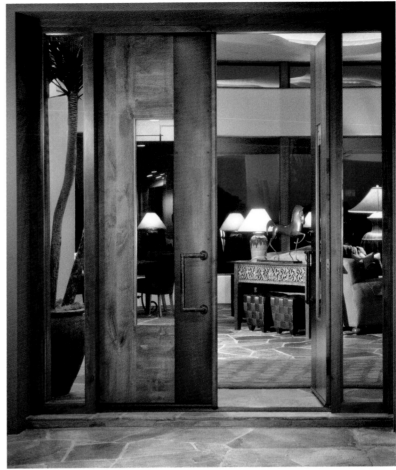

FAR LEFT TOP
By arranging a seating area around a cozy fireplace, Lori creates the perfect setting.

FAR LEFT BOTTOM
Cozy seating areas are designed for engaging conversations.

TOP LEFT
This elegant bath is complete with the latest features.

TOP RIGHT
From the front door, this desert contemporary home welcomes with an inviting ambiance.

More about Lori…

WHAT COLOR BEST DESCRIBES YOU AND WHY?
Lime green because it is lively and energizing and daring.

WHAT IS THE BEST PART OF BEING AN INTERIOR DESIGNER?
Being able to use my imagination to create beautiful environments.

WHY DO YOU LIKE DOING BUSINESS IN THE SOUTHWEST?
Friendly people and the natural beauty of the desert.

IF YOU COULD ELIMINATE ONE DESIGN/ARCHITECTURAL/ BUILDING TECHNIQUE OR STYLE FROM THE WORLD, WHAT WOULD IT BE?
I have respect for all techniques and styles.

Lori Carroll & Associates
Lori Carroll, ASID, IIDA
1200 N. El Dorado Place
Suite B-200
Tucson, AZ 85715
520.886.3443
www.loricarroll.com

Christopher K. Coffin
Christopher K. Coffin Design

LEFT
The dining room features an antique Welsh dresser which houses an expansive collection of Old Paris with English silver on the dessert trolley. Christopher mirrors the back wall to enlarge the space.

RIGHT
The bedroom centers around a vintage Louis Vuitton suitcase, once belonging to John F. Kennedy, which has been made into a coffee table. The walls are painted a rich chocolate brown.

Christopher K. Coffin interiors are worldly.

Christopher, after all, has traveled just about everywhere, so with each residential interior he creates, he brings to it the experiences, connections, and knowledge of styles, textiles and antiques he's gathered.

"For years, I traveled throughout the world as part of the fashion and beauty industry," says Christopher, who was born in Wichita, Kansas. He received a degree in textile marketing from Kansas State University and accepted a position with the British Unilever Corporation, for which he jet-hopped for years as its vice president of worldwide operations. He worked in Rome, Paris, London, Spain, Australia, Canada, Hong Kong and other major cities. "Traveling for corporate

America was expansive and introduced me to creativity in other points of the world," he explains.

As a child, he had spent winters with his parents in Arizona, so, while traveling worldwide, he decided to make Scottsdale his home, where he has lived since 1990. After September 11, 2001, he decided he had spent enough time on planes and traveling to exotic destinations, so he resigned his lucrative position and during the next nine months decided what he wanted to do.

But friends were already telling him what he should be doing is what he was so good at doing: "They were saying to me, 'You have such a good sense of space, color and materials- you missed your calling.'" And, when those friends

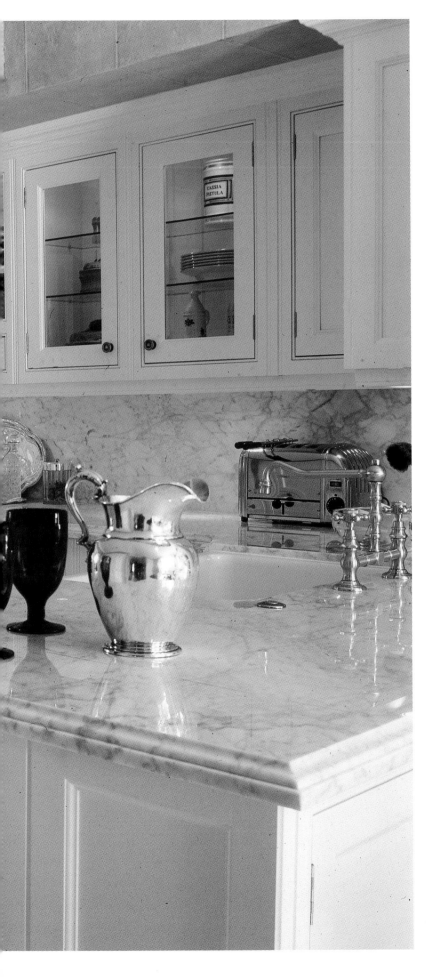

included well-known Scottsdale designers such as Anne Gale, co-founder of Wiseman & Gale, and Donna Vallone, principal of Vallone Design, Christopher listened and opened his studio three years ago—to much success. He has already completed homes throughout the United States, including Florida, Los Angeles and the Hamptons in New York and, in Arizona, Scottsdale and Paradise Valley. His work has also been acknowledged by the industry, having appeared in local and national publications.

This cosmopolitan attitude has kept Christopher aware of trends and taught him to beware of trends. "I focus on classic design and avoid faddish design," he says. "At the same time, I like exciting space that is full of personality and excitement." The world travels have also kept him and his staff of three away from Southwest style and toward a broad traditional look with a contemporary flair, incorporating antiques that he acquires through sources he's developed during the years. "I describe our style as incorporating clean classic lines with a European twist," says Christopher, himself a long-time collector of antiques and accessories from his many travels.

He keeps his staff intentionally small to include an assistant and two design associates. "I'm hands-on and want to keep my eye on everything. After all, it's my name that's going on the design. But, even more importantly, I want to work directly with the client so that I can understand his or her personality. They need to trust me to design an environment that will be as special for them years from now as it is today."

LEFT
A newly renovated kitchen features cabinetry from Clive Christian of England. Old English silver is displayed prominently throughout.

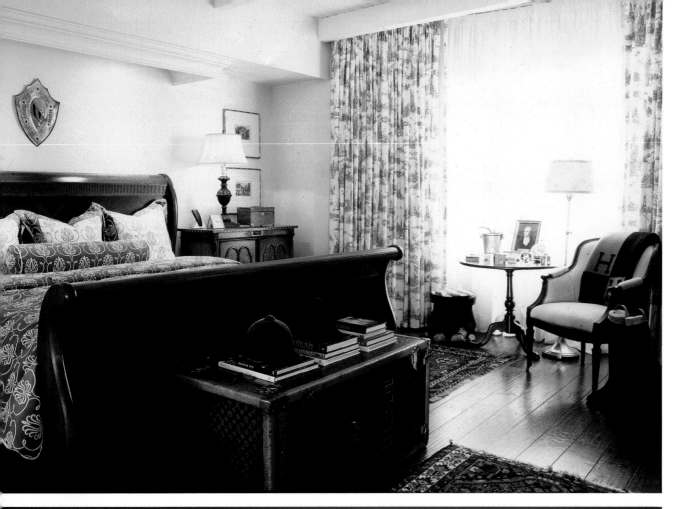

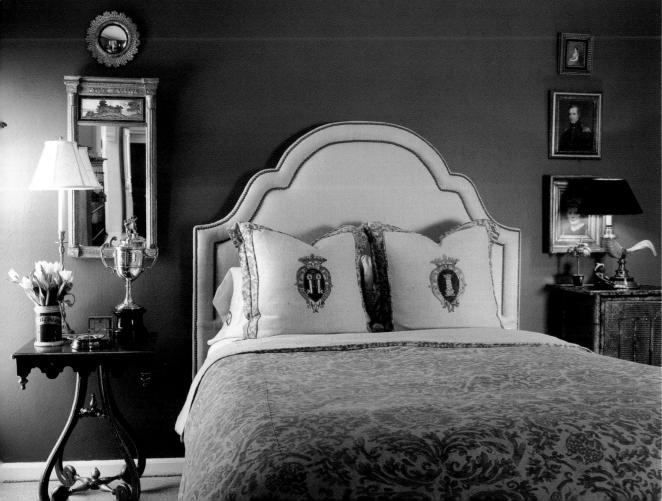

TOP
Champagne colored walls complement brown and off-white toile drapes along with a more contemporary fabric from Scalamandre as the duvet. The European accessories lend a warm masculine charm.

BOTTOM
A linen upholstered bed centers this warm and cozy quiet bedroom featuring vintage Fortuny fabrics and rich antique furniture.

RIGHT
This high-ceilinged living room features rough-hewn painted beams with tea-stained walls. Christopher provides interest with various collectible boxes, vintage Louis Vuitton luggage and slip-covered furniture.

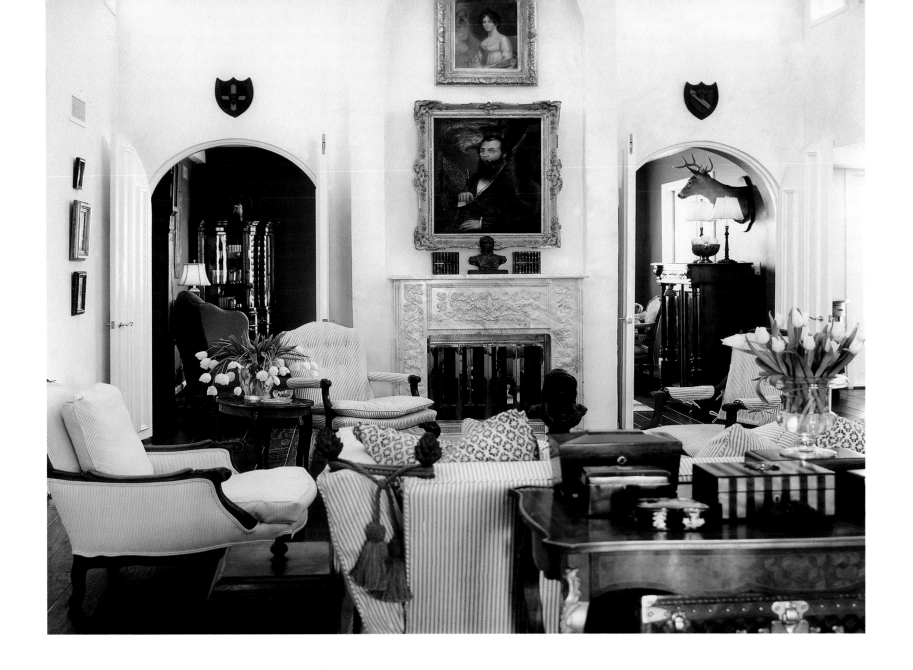

More about Christopher...

WHAT IS THE BEST PART OF BEING AN INTERIOR DESIGNER?

Every day is a new day and never repeats itself twice.

WHAT COLOR BEST DESCRIBES YOU AND WHY?

Neutrals— because I'm very stable. (Although I've recently been taken by Hermes orange and chocolate brown.)

WHAT IS A SINGLE THING YOU WOULD DO TO BRING A DULL HOUSE TO LIFE?

Create an open, airy space.

WHAT IS THE MOST UNUSUAL/EXPENSIVE/ DIFFICULT DESIGN OR TECHNIQUE YOU'VE USED IN ONE OF YOUR PROJECTS?

A client requested a saltwater aquarium in the entry of the home!

Christopher K. Coffin Design
Christopher K. Coffin
7500 E. McCormick Parkway
Scottsdale, AZ 85258
480.945.4080

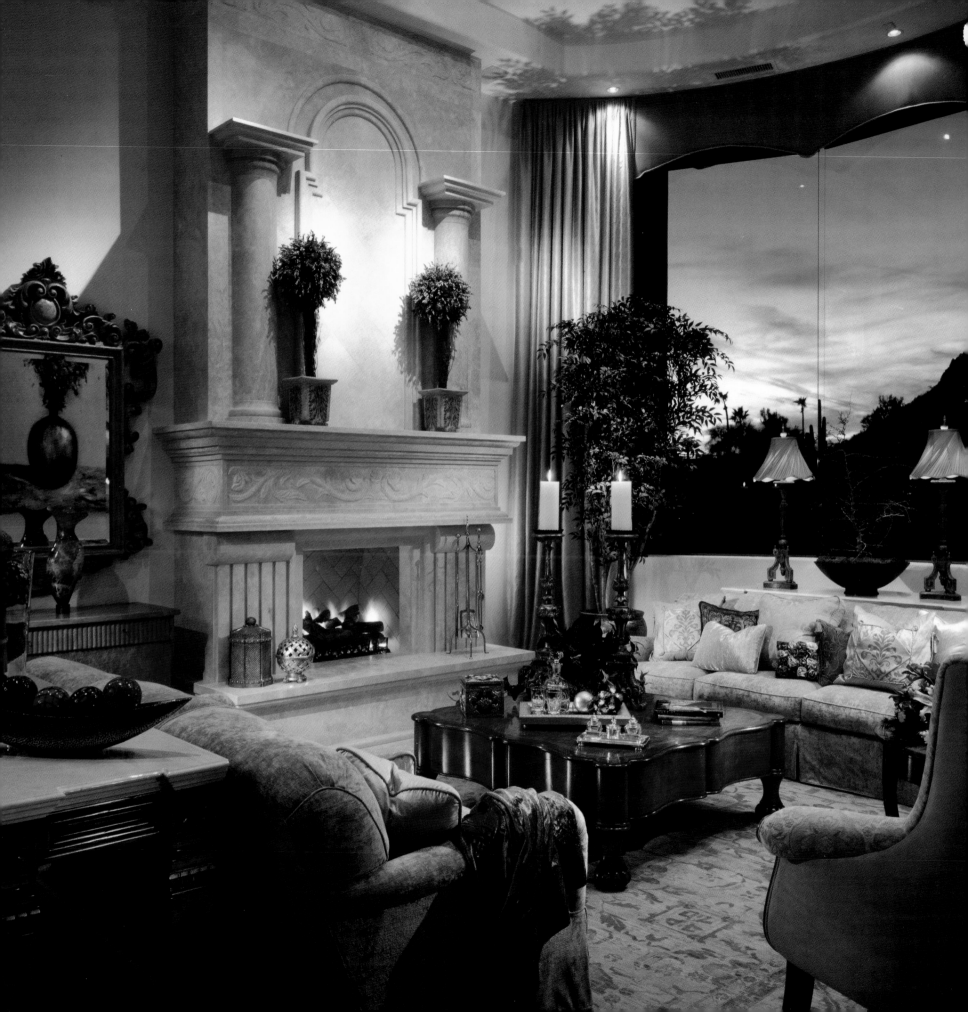

Kimberly Colletti
Tre'ken Interiors

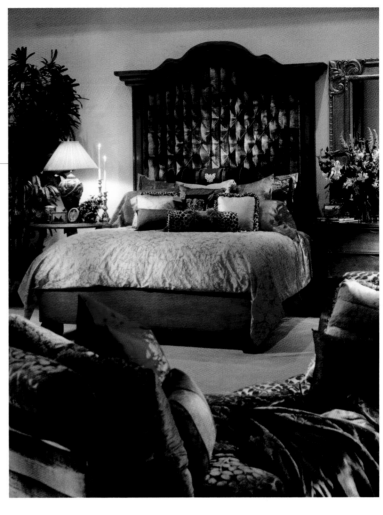

LEFT
One of Kimberly's favorite design houses to purchase from is 'Melrose House' in Los Angeles —for the discriminating buyer with an eye for elegance and sophistication. The pieces here are exquisite.

RIGHT
This beautiful custom-made bed includes an antique velvet tufted headboard and alder frame.

Midwest gals like to keep it simple. But not too simple.

Born and educated in Ohio and Michigan, Kimberly Colletti agrees that "Less is more," but that doesn't eliminate vibrant textures and colors from winning interior designs. In fact, Mies' well-known dictum is just a good starting point. "Timeless, classic designs can occur in a variety of styles," she says. "The key is to know where to start—and when to stop."

As a girl and young woman, Kimberly would visit Arizona with her family, who owned a golf course in Michigan and wintered and vacationed here to enjoy its many courses. "I always knew that I would want to live out here," she says. "I always loved Arizona and the sun."

Twenty-three years after arriving in Arizona, she's still happy to have the Midwest in her soul and the Southwest as her address. "I love our casual, elegant lifestyle," she notes. Seven years ago, she started Tre'ken Interiors, which she named for her two children, son Tre and daughter Kennon, who remain her greatest inspirations. Since then, Kimberly's added son Max, so she says, with a laugh, "Perhaps we need to rename the firm 'Tre'ken to the Max!'" She adds: "I want all of them to be proud and know they can do anything in life."

Her boutique firm has an office manager, an in-house draftsman and a senior designer—"a great staff," she says. Most of her work is custom homes, but she is beginning to see a good deal of high-end remodeling work as well—projects which she also enjoys.

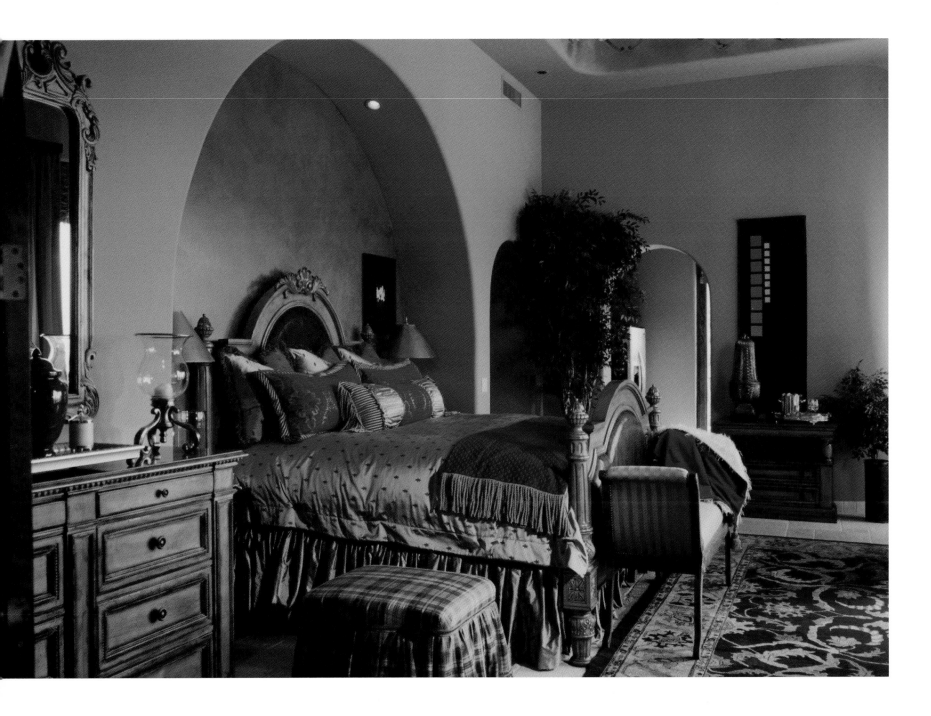

Tre'ken has completed residential designs in the Valley as well as in Washington, California, Idaho and Chicago. In addition, she has been published in national and regional publications such as *Arizona Foothills, Phoenix Home & Garden,* South Coast Style and two of Brad Mees' coffee table books. Her greatest compliment, in fact, came from clients who exclaimed in a magazine article about their home: "We wouldn't change a thing!"

For Kimberly, texture is everything in good design. For her, that's natural linens, cottons, silks, soapstone, honed and polished marble, wood floors and tumbled stones. Her colors are pulled from the desert—strong earthy colors that emphasize a sense of place. With a partner, she is developing Kimberly Edmond, a furniture line of soft and case goods debuting in the spring of 2006— available to the trade or through her office.

Whatever its color or materials palettes, every design begins with the clients. "Their lifestyle is the first step in the process," Kimberly says. "I have to be sure that what we are designing is what they need." To this end, she supervises every project to establish trust among the four central parties—the client, the architect, the builder and the designer. The result, she explains, are timelines and budgets consistently satisfied and "extraordinary homes that are elegant, classic and timeless."

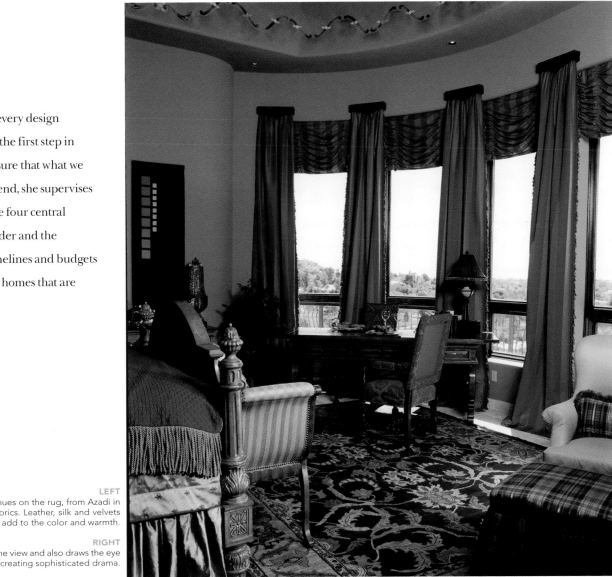

LEFT
The design direction in this room starts from the hues on the rug, from Azadi in Scottsdale, how they play with textures on the fabrics. Leather, silk and velvets add to the color and warmth.

RIGHT
A unique window treatment captures and frames the view and also draws the eye toward a hand-painted stencil in the soffit, creating sophisticated drama.

More about Kimberly...

WHAT COLOR BEST DESCRIBES YOU AND WHY?

Browns, rusts, deep reds: They are warm and comfort colors.

WHAT IS THE BEST PART OF BEING AN INTERIOR DESIGNER?

With each new project there is a new challenge, a different style; my passion for design is constantly being reborn.

WHAT IS THE SINGLE THING YOU WOULD DO TO BRING A DULL HOUSE TO LIFE?

Paint, paint, paint! It can do miracles!

IF YOU COULD ELIMINATE ONE DESIGN/ARCHITECTURAL/ BUILDING TECHNIQUE OR STYLE FROM THE WORLD, WHAT WOULD IT BE?

Wood grain on the exterior of automobiles.

Tre'ken Interiors
Kimberly Colletti
8300 North Hayden Road
Suite A-112
Scottsdale, AZ 85258
480.596.9500

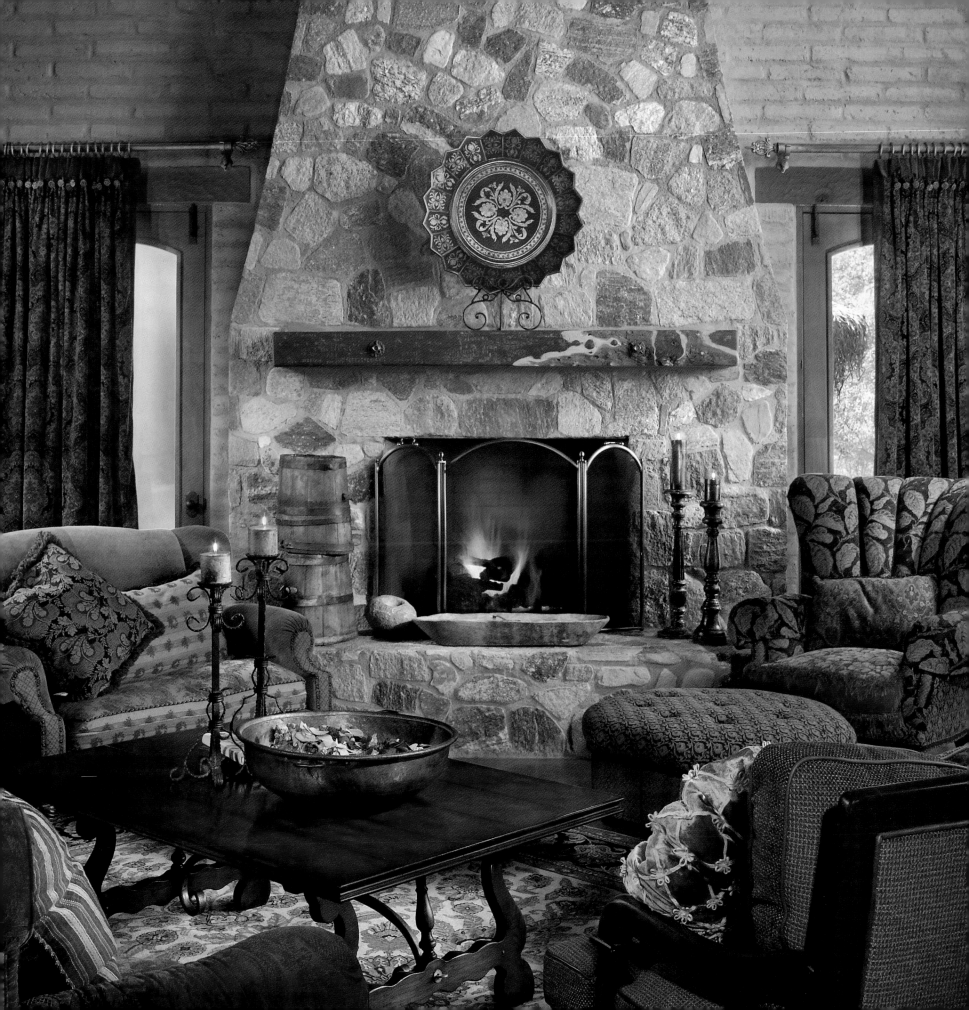

Sarah DeWitt

DeWitt Designs

LEFT
This home features a territorial-style rock fireplace with mixed-fabric vintage furnishings — with a western twist.

RIGHT
An overscaled iron and glass chandelier is reflected in an overscaled hand-carved wood-frame Columbian mirror, itself framed by an antique column rescued from a dismantled convent from the plains of South Dakota. A 'less but oversized' philosophy creates a much larger, more dramatic interior for a small home.

Great spaces inspire great designs. That's one reason why Sarah DeWitt opened her second showroom in Tucson—2,000 miles away from her Midwest home.

A lifelong resident of South Dakota, DeWitt also loves the expansiveness of the Southwest, its sunny palette, its openness. As a girl, she would spend vacations at Ghost Ranch, an area celebrated by Georgia O'Keeffe, just north of Santa Fe, New Mexico. When she wasn't there, she was learning retail in her father's furniture stores, which later inspired Sarah and her husband of 25 years, Jim, to open a high-end furniture and design studio in Sioux Falls.

"I love the large-scale homes, the intense light, the mountains and desert—all wonderful inspiration for great designs!" says Sarah, a 30-year interior design veteran who opened her studio three and a half years ago in the growing downtown arts district. "We love the small town atmosphere here."

The 20,000-square-foot facility is the resurrection of a 1929 Spanish Revival adobe brick building—a former Chevrolet dealership. Her 13-year-old Sioux Falls showroom is also 20,000 square feet, and she is restoring an even larger 1895 brick warehouse there as a "new" showroom. Her combined staff of 22 professionals has access to 4,000-square-foot resource libraries in both locations, allowing them to provide the finest materials for residential and commercial clients. Each has complete room vignettes, which display imports, high-end home furnishings, original art, hand-tied area rugs and other fine accessories.

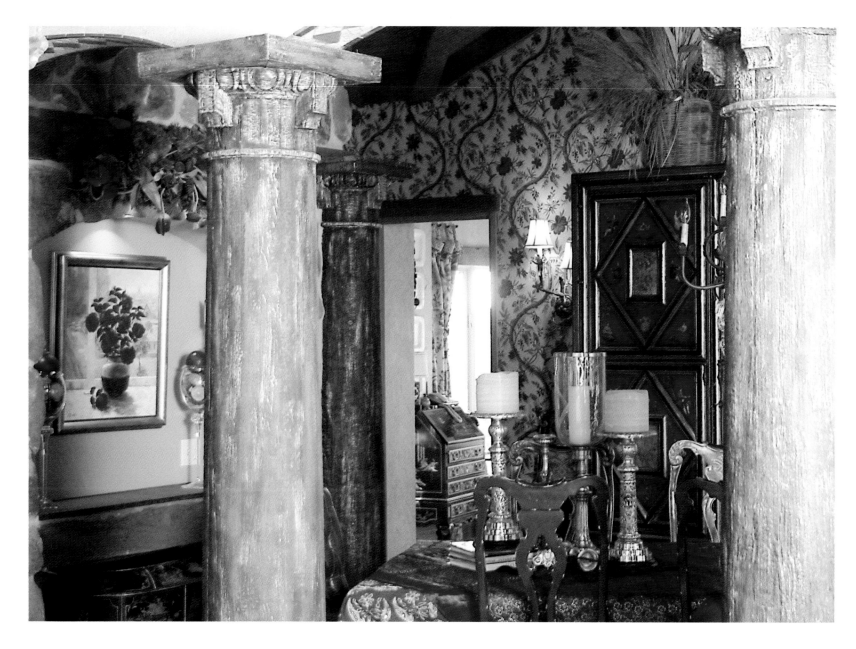

Both areas, in fact, share tastes in design. South Dakotans feel particularly connected to the West, Sarah says. Moreover, both enjoy European styles with elegant layering, rich fabrics and architectural details. Tucsonans, in contrast to South Dakotans, incorporate a more intense color palette and larger-scale furnishings because of their environment. Contemporary is more prevalent, though with a softer edge and more texture.

For Sarah, patina is the common thread between all of her designs, creating casual elegance, whether in a Tuscan or in a layered Contemporary; in Sioux Falls or in Tucson. This can be the patina of worn, layered wood, textured, faded fabrics, aged plaster, muted colors or antique architectural details. "Patina adds warmth and livability to any design," she says.

Antique architectural elements such as columns, fireplace surrounds, Old World ceilings and floors and stone corbels add to warmth and intimacy. "To incorporate these as if they have always been there is both an intriguing problem and a creative solution," she says.

For Sarah, thinking in three dimensions and problem-solving is a constant challenge. "I love finding the 'pattern' that brings a design together," says Sarah, who was honored by being selected to participate in the Tucson Museum of

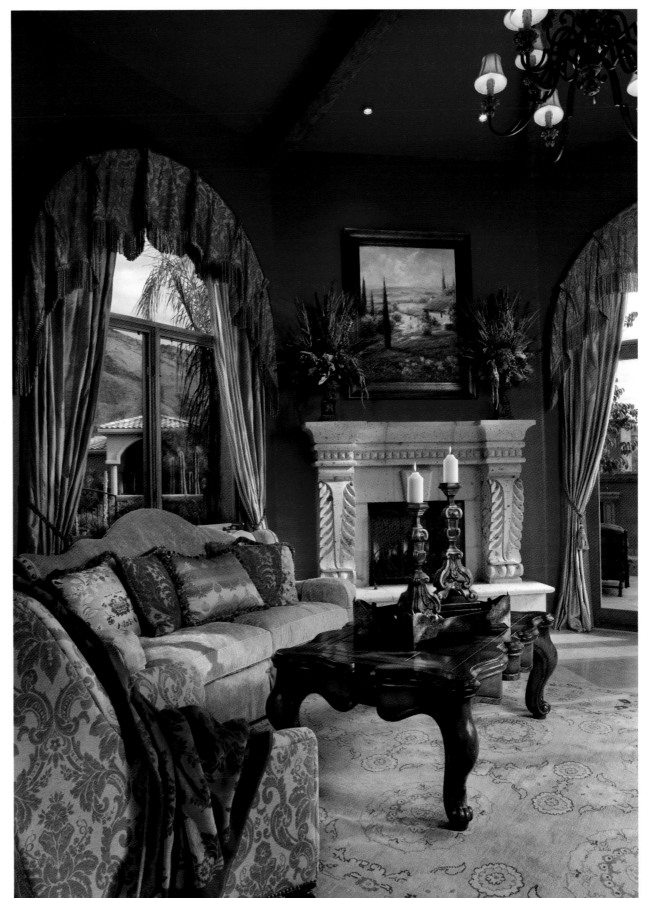

FACING PAGE LEFT
In this room, details include antique columns, inlaid stone on the arch, a wood ceiling, and the repetition of black accents — from slate, to the chinoiserie secretary and urn.

RIGHT
In a Tuscan-inspired home, a unique-shaped sofa mimics the arched window, the distinctive arched window treatment and the arch of cocktail table base. An imported Turkish rug, a Tuscan oil painting, the accessories and dramatic earthy red wall/ceiling color add to the texture.

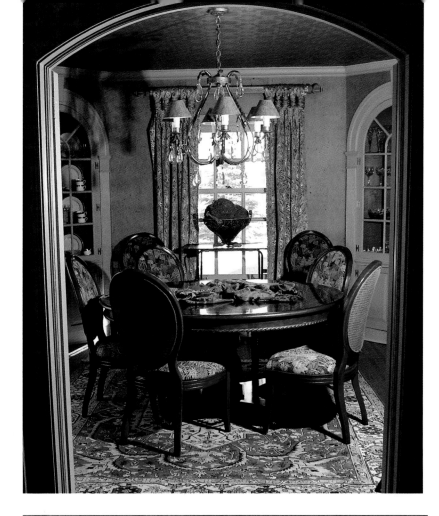

Art Designer Show House in 2003 and 2005. "An intricate grasp of fabric patterns, color, texture and details executed in the right scale for any particular home sets my designs apart."

"Details, details, details," she tells her staff. Finishes, trim, pillows, hardware, ceilings, walls, floors and furnishings: "All must be part of a harmonious whole. All are synchronized to create a cohesiveness that layers story after story about the client."

She builds each home design on clients' styles and personal belongings. She looks at their pictures, their books—even goes through their closets—to find items and memorabilia that provide this authenticity and individuality. "In one closet, I found a collection of my client's mother's perfume bottles. I was able to incorporate these into their design. Utilizing treasured pieces makes the space really theirs."

While each room and every home tells a story about the clients, Sarah believes that they seek her to take them to another level. "You need to give them something back. They come to me for those standards." Leading these is the importance of achieving comfort, intimacy and livability. "You can have a picture-perfect room, but, if no one feels they want to sit down and have a cup of coffee and talk, it's not a successful design. In contrast, I design spaces people want to live in."

As one client told her, "This home is not only beautiful, but I want to actually live here!"

TOP
This photo features a closer look at the unique "imitation" Moroccan leather ceiling, rice paper wall covering (inherited with the original purchase) crown molding, and luxurious velvet embossed drapery embellished with lush trim and beads.

BOTTOM
A luxurious window treatment with a unique-shaped cornice accented with a special gimp and beads. Note the lush tiebacks and the mix of two silk patterns. This bay window showcases unique accessories instead of cushions.

RIGHT
A traditional 1940s home features painted woodwork and a unique ceiling treatment of wall covering layered with a varnish crackle to create an aged patina. The walls are covered with a wonderful red grass cloth. This is a fun combination of mixed-fabric sofas, a mirrored screen, leather-embossed tables and stone accents.

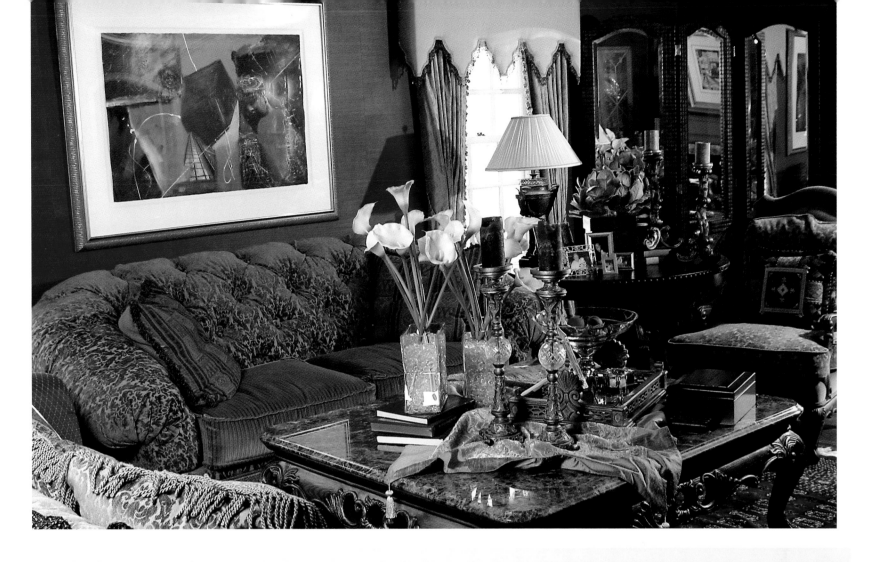

More about Sarah...

WHAT DO YOU LIKE ABOUT BEING A PART OF SPECTACULAR HOMES OF THE SOUTHWEST?

Not only do I have an opportunity to showcase some of the exquisite homes and variety of styles I have designed, but also an opportunity to let others realize that "Southwest" design does not have to be a cliché. Even if one lives in the Southwest, one can express his or her own lifestyle.

IF YOU COULD ELIMINATE ONE DESIGN/ARCHITECTURAL/ BUILDING TECHNIQUE OR STYLE FROM THE WORLD, WHAT WOULD IT BE?

Eliminate HIGH TECH!!!

WHAT IS THE SINGLE THING YOU WOULD DO TO BRING A DULL HOUSE TO LIFE?

Color on both the walls and the ceilings—not necessarily intense—just the right tone. It can totally change a home.

WHO HAS HAD THE BIGGEST INFLUENCE OF YOUR CAREER?

My clients—each and every one—become the catalyst of new adventures, a new problem, a new solution, style, etc. This is how I have grown as a designer.

WHAT COLOR BEST DESCRIBES YOU AND WHY?

Fuchsia—a sassy color that is vibrant and passionate.

DeWitt Designs
Sarah DeWitt
415 N. Sixth Ave.
Tucson, AZ 85705
520.622.1326

400 N. Main Ave.
Sioux Falls, SD 57104
605.335.4354
www.dewittdesignsinc.com

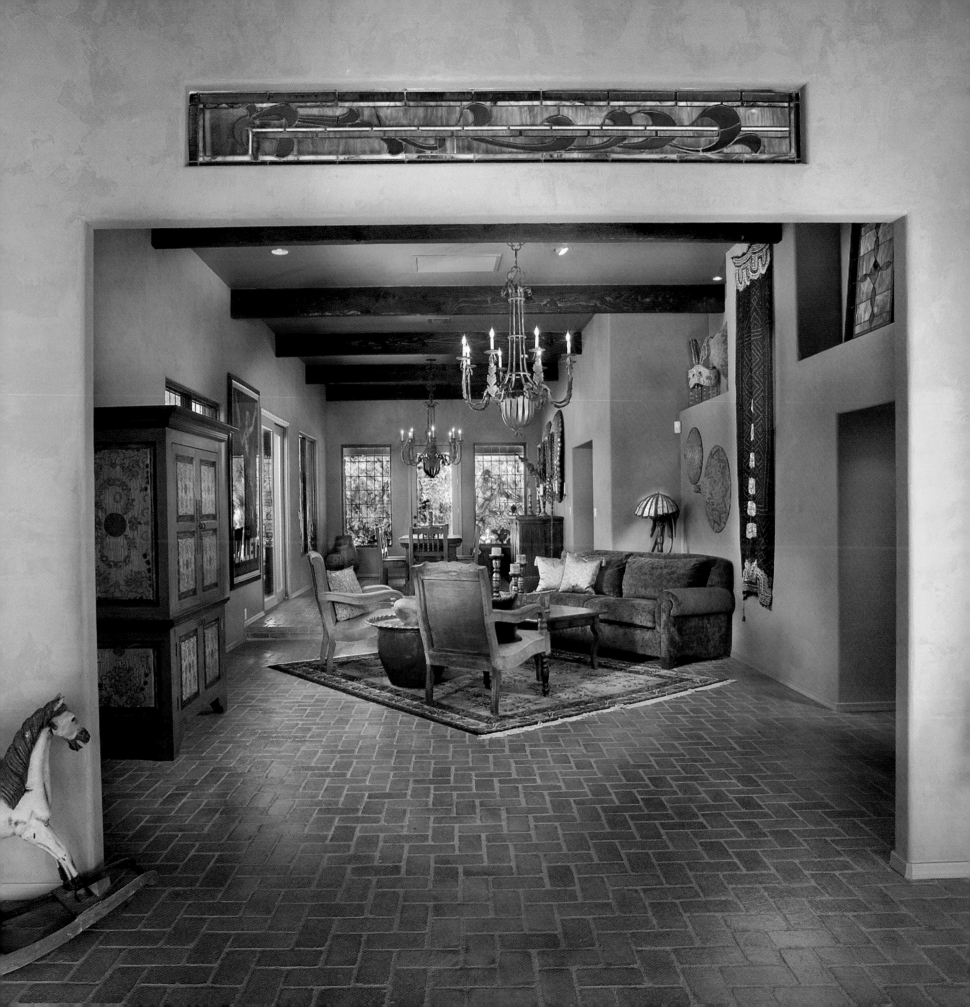

Janice Donald

Eren Design & Remodeling Company

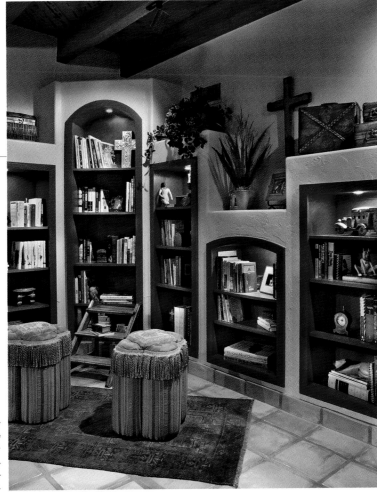

LEFT
This room addition uses natural rustic materials to blend with the existing 1930s ranch house.

RIGHT
Janice provides built-in bookshelves to add style and character to this Southwestern adobe home.

For Janice Donald and her team, old spaces are new frontiers—filled with opportunities for simplifying life and expanding lifestyles.

The 20-year-old Eren Design & Remodeling Company provides full-service design-build remodeling services. At Eren, ceilings are raised and celebrated by relocating heating and cooling ductwork; city and mountain views are enhanced through strategic window changes; narrow dark hallways lead into sunlit corridors; dated kitchens enter the 21st century with entertainment-friendly islands and state-of-the-art appliances; sleepy-eyed bathrooms are brightened into welcoming places; and house remodels rejuvenate homes with great lots.

"We turn dreams into reality," says Janice, who became the firm's CEO/CFO five years ago. She and her husband, co-owner Terry, had moved from native Ohio 30 years earlier for a change in climate.

After serving as Eren's outside accountant, a love for contracting and architecture led her to acquire Eren, obtain a general contractor's license and begin operating the remodeling company as a design/build company with an emphasis on quality of design and quality of process. Eren's team also includes two remodeling consultant/designers; an office manager/bookkeeper; a director of lasting impressions; four project managers (including Terry); and two assistant project managers.

"The remodeling business as a whole has created a lot of skeptics, a lot of consumers afraid that their remodeling experience could resemble one from their past that left them less than fully satisfied—or, worse yet, harmed," says Janice. But, by making the right choices on projects,

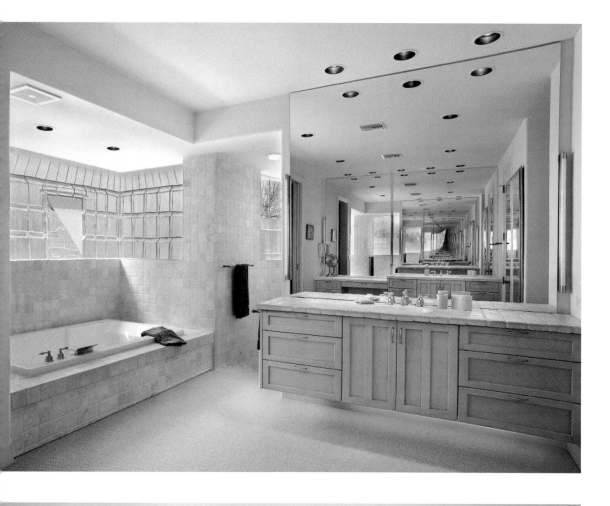

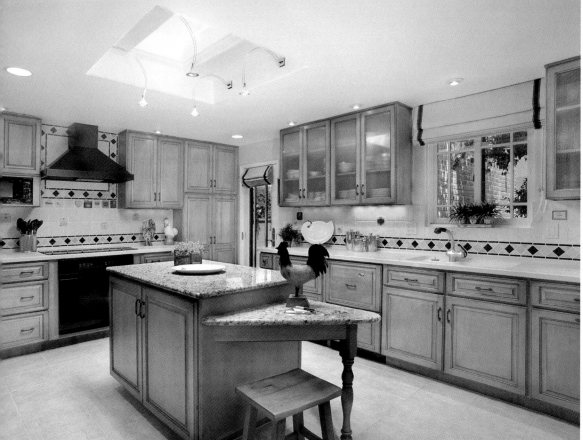

Eren delivers a positive experience. "We listen; we probe; we discover; we advise; and we have the crucial conversations that ensure a remodel with no regrets," she adds.

Clients appreciate this attitude—many of them returning to Eren for projects on other homes "It was reassuring to know that your standards are equal to my own," wrote one satisfied client. The award-winning company has also been professionally acknowledged, including as "Tucson's Remodeler of the Year" in 2003 by the Southern Arizona Homebuilder's Association.

Eren provides this exceptional service through a three-phase process. The first is feasibility: Can the clients do what they want for the amount of money they want to spend? In this phase, Eren associates discuss design concepts such as style (Southwest to Contemporary), functionality and life-cycle costs as well as infrastructure concerns such as heating, cooling and electrical. In the second design phase, the scope of work is fully developed, and the clients select materials and finishes. Finally, closely monitored construction brings the project to a satisfying completion. "In this way," Janice says, "we do it right and do it well—the first time."

TOP LEFT
Under-cabinet lighting enhances the light, airy and spacious feel of this bathroom.

LEFT
Janice celebrates the owner's interest in good wine with unique wine-label deco tiles at cooktop backsplash.

More about Janice...

WHAT IS THE HIGHEST COMPLIMENT YOU'VE RECEIVED PROFESSIONALLY?

Our clients who have referred us to their now adult children to assist with their design and remodeling projects.

WHAT IS A SINGLE THING YOU WOULD DO TO BRING A DULL HOUSE TO LIFE?

Add light and if possible views through windows that work well and enhance the life of the home. (And two?) Inject a surprise feature, an unexpected element that tugs at your senses: like turning the corner and seeing a great work of art that takes you somewhere.

WHAT IS THE MOST UNIQUE/IMPRESSIVE/BEAUTIFUL HOME YOU'VE SEEN IN THE SOUTHWEST? WHY?

The most impressive home I've seen was an old ranch house that has been tastefully restored, probably many times over, but always with the mission of retaining the charm and integrity of the bones of the home. What impressed me most was what you feel from the moment you approach the property. This was a home in keeping with desert living and providing comfort to all who enter: great art, great windows, and inviting outdoor living spaces.

HAVE YOU BEEN PUBLISHED IN ANY NATIONAL OR REGIONAL PUBLICATIONS? WHICH ONES?

We have been featured in Tucson Home recently for two of our whole-house remodels. I have had a number of articles about me in national remodeling magazines.

Eren Design & Remodeling Company
Janice Donald
SAHBA, NAHB, NARI, NKBA
Associate Member AIA
55 N. Avenida de la Vista
Tucson, AZ 85710
520.885.2500
www.erendesign.com

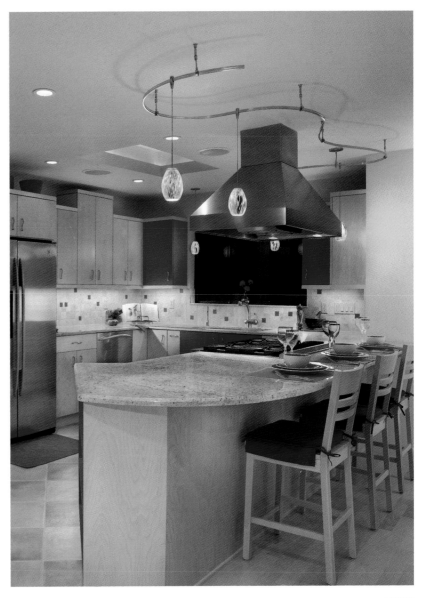

ABOVE
In addition to the curved pendant track, the bright-red accents in the glass-tile and painted cabinetry give this kitchen a fun, bright feeling.

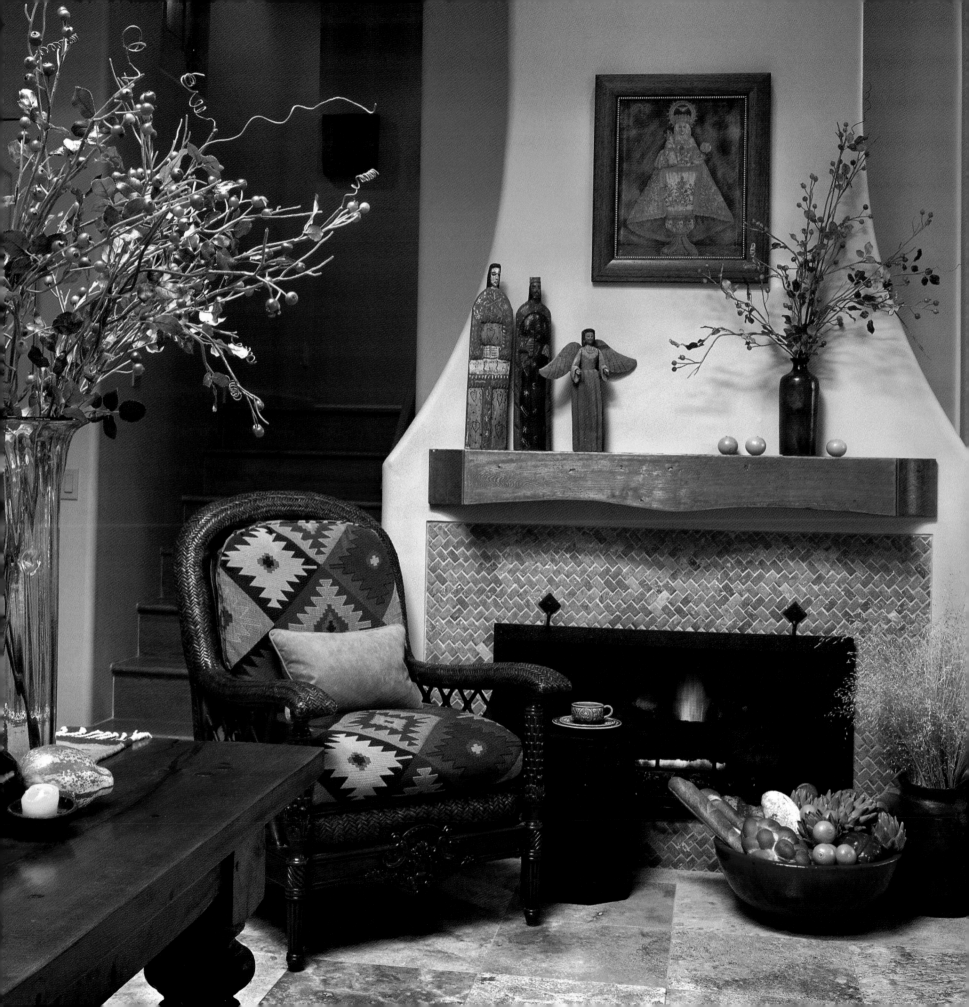

Judy Fox
Judy Fox Interiors

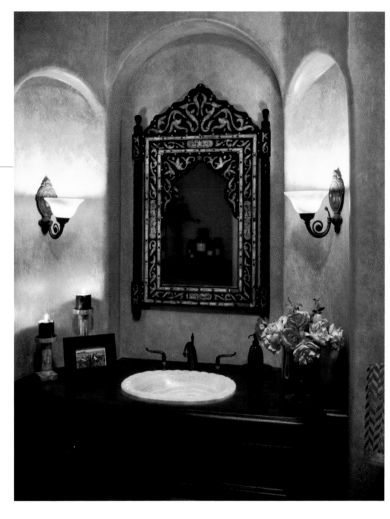

LEFT
This rich kitchen fireplace includes a sandblasted mantel, a tumbled stone and fir surround, and a travertine floor.

RIGHT
In this powder room, the density of the rich mahogany cabinet offsets the underlit onyx sink. The inlaid-stone and wood mirror reflects the wall arrangement opposite.

Good interior design for Judy Fox, Allied Member ASID, begins with clients' own interiors: their dreams, their hopes, their needs and lifestyles.

For 30 years, the Scottsdale interior designer has created residential interiors that manifest no plan and propose no manifesto. "We are client driven and appreciate many styles," Judy says. "The common denominator: Is it well done?"

Clients have judged her work very well done for years, as have critics and colleagues. Her work has been featured in magazines, and she and her design team have been regularly awarded by the local Arizona North Chapter of ASID, including its prestigious "Best of Show."

"My first job is to look at the space through the client's eyes," says Judy, who was born in Boston and attended the New York School of Design and Harvard University. "I live in the space before the client does."

Judy and her design team—collaborators Nancy Petrenka, ASID, and Jennifer Kaman, ASID, and office manager Anitra Ondrush—offer clients diverse looks that dovetail their lifestyles. These intersections can be their hobbies, budgets, possessions, memorabilia such as a sympathy letter from a friend, a curio from a life-changing vacation, or a timeworn stuffed animal from childhood. Each object can intensify the aesthetic power of a space.

"Each job is personal," she says. "Each job has its gestation and must be taken at its own pace." That need to create new structures is what

particularly impassions Judy about the design process: "Making order out of disorder is always a foundation for me," she says.

Her challenge: Lay out options and provide guidance (and often mediation between partners), then follow the clients' informed choices. "I see my role as an advocate for the client," she says. And, interior design advocacy is most eloquent when based in a vocabulary of mutuality, relationship, pace and good taste. "An exquisite home is not driven by price," Judy says. "It is driven by the sensitive and tasteful use of good design, fine products and

professional project management." A good sense of humor helps, too. "Home design is stressful, so we always design a little whimsy, fun and joy into the process," Judy says.

In building a home or its rooms, people are often building or rebuilding their lives as well. "All the complexities of a relationship are brought to bear on the interior design process," Judy says. As a result, interior design is a journey that is educational for both designer and client. For instance, she explains, space and scale are unique in the Southwest, so a client who tries to move her Victorian

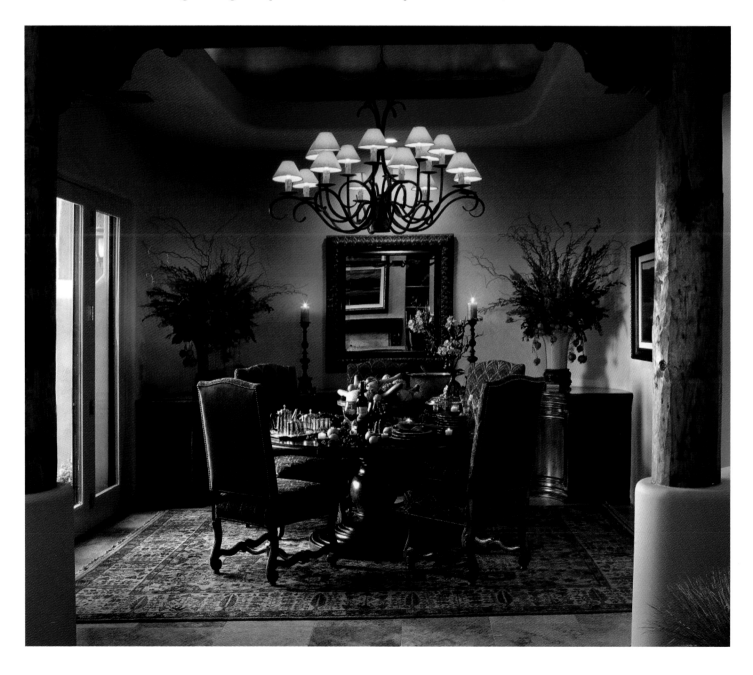

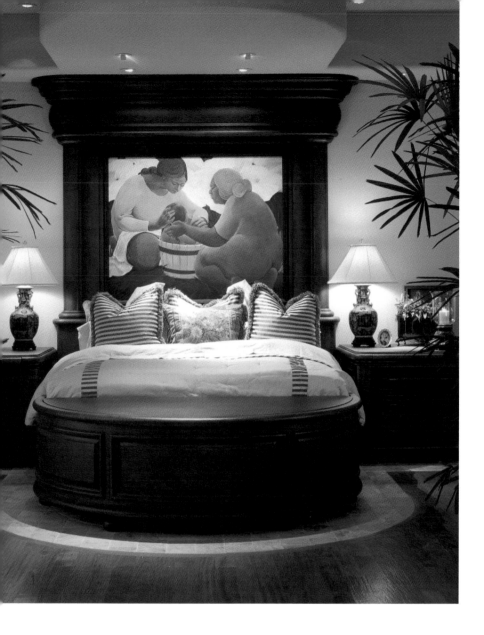

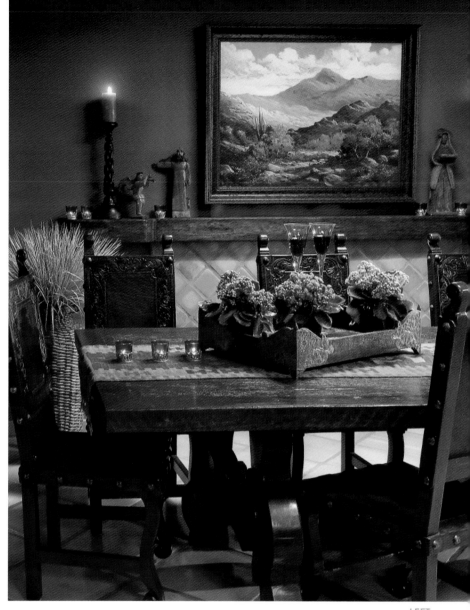

LEFT
A patio light washes the ultra-suede-backed dining room chairs. The curved beams and poles provide a frame for the room.

ABOVE LEFT
When seen from the master suite entry, 40 feet away, this headboard retains its focal-point interest. The illusion of an oval bed is emphasized by the curving floor and soffit detail. Actually, only the footboard is curved and allows for storage of pillows.

ABOVE RIGHT
Rustic materials in this breakfast room, such as the saltillo tile wire-brushed mantel, create a warm Southwestern feeling. The low ceiling called for landscape painting: Its horizon line provides a window effect.

heirloom pieces into the high-ceilinged, expansive and sunlit space of a Scottsdale home may need to reconsider. Judy says, "I often must point out why this or that just isn't going to work—and how this or that will."

With a positive, goal-oriented relationship between the client, designer, architect, builder and the trades, excellence is always possible. "Excellence happens when any event occurs in a way that is better than ever before," Judy explains. "We ask, 'What will it take?' to make this home a win/win? We ask, 'Have we done all that we can do?'"

Judy's business success has allowed her to win as well for a variety of local charities—groups that affirm family values, help children and empower women. These include Childhelp USA; the Susan G. Komen Breast Cancer Foundation; the Ronald McDonald House; the Girls and Boys Clubs; and the Arizona Women's Partnership, which provides healthcare for uninsured single moms. "I want to do whatever I can," she says, "to further women's ability to fulfill their biological roles as mothers, their social roles as family makers, and their growing business and professional roles."

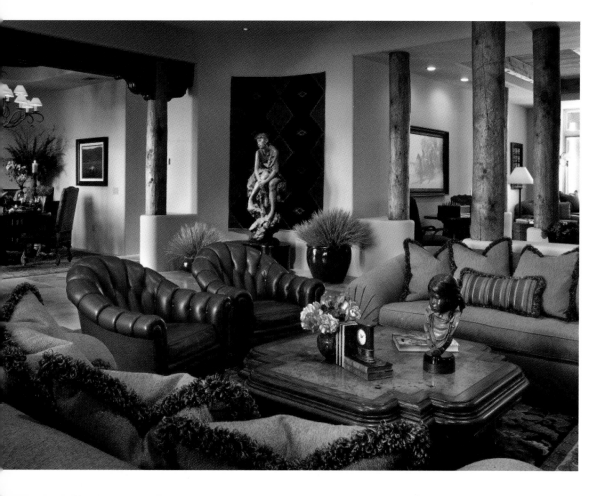

Today, as throughout her career, Judy continues to enjoy elegant, ordered space that incorporates subtle layers of detail: "complexity juxtaposed with simplicity, patterns against solids, textured surfaces bordered by smooth surfaces."

Metals and woods, glass with leather, stone and chenille: There are many combinations, she explains—and one superlative response. "To turn a corner and be delighted, to have the eye surprised: This is good design. This is an environment that nourishes its people—and expands their lives."

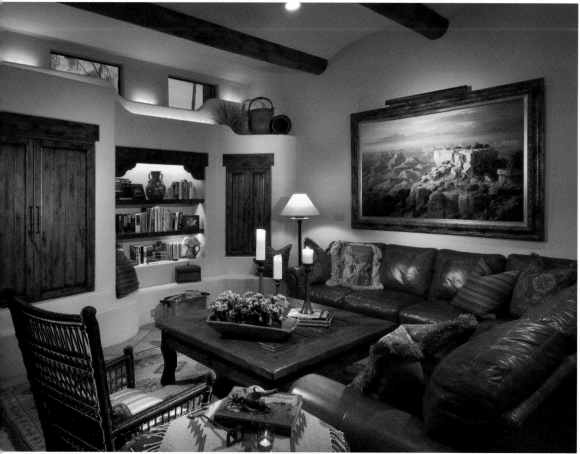

TOP LEFT
The living room is an open floor plan showing other rooms; it offers a rich conversation area with a variety of seating around an inlaid burl coffee table.

BOTTOM LEFT
This family room includes deep, comfortable seating to kick back, put your feet up and watch the Phoenix Suns on TV behind pocket doors.

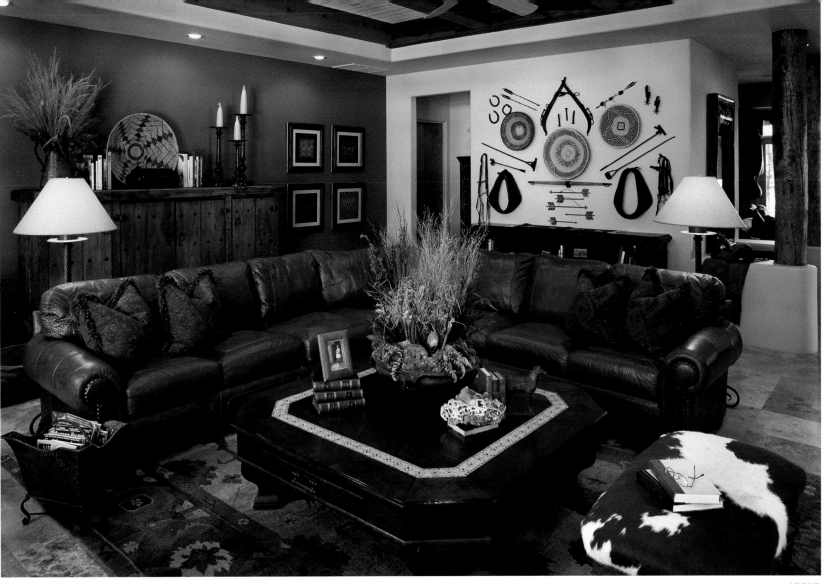

ABOVE
A tumbled stone inlay in the coffee table brings the rug design onto the table surface in this family room. A wall arrangement represents a Southwest ranch collection.

More about Judy...

WHAT COLOR DESCRIBES YOU?

Terracotta: It's warm, of the earth and enduring. All colors look great against it.

WHAT IS THE HIGHEST COMPLIMENT?

The best compliment is when a client says, "We are using our whole house instead of three rooms!"

WHAT WOULD BRING A DULL HOUSE TO LIFE?

Paint: lots of bang for the buck. You are affecting one of the largest surfaces in a home.

WHAT IS THE BEST PART OF BEING A DESIGNER?

To offer a client new beginnings and new possibilities. A client sent me a wonderful quote: "Some people stay in our lives a while and help us become more than we were before." That describes my role, ideally, with all my clients.

WHAT BUILDING TECHNIQUE COULD YOU ELIMINATE?

Tract house mentality in a custom home.

Judy Fox Interiors
Judy Fox
4147 N. Goldwater Blvd.
Suite 101
Scottsdale, AZ 85251
480.860.6475
www.judyfoxinteriors.com

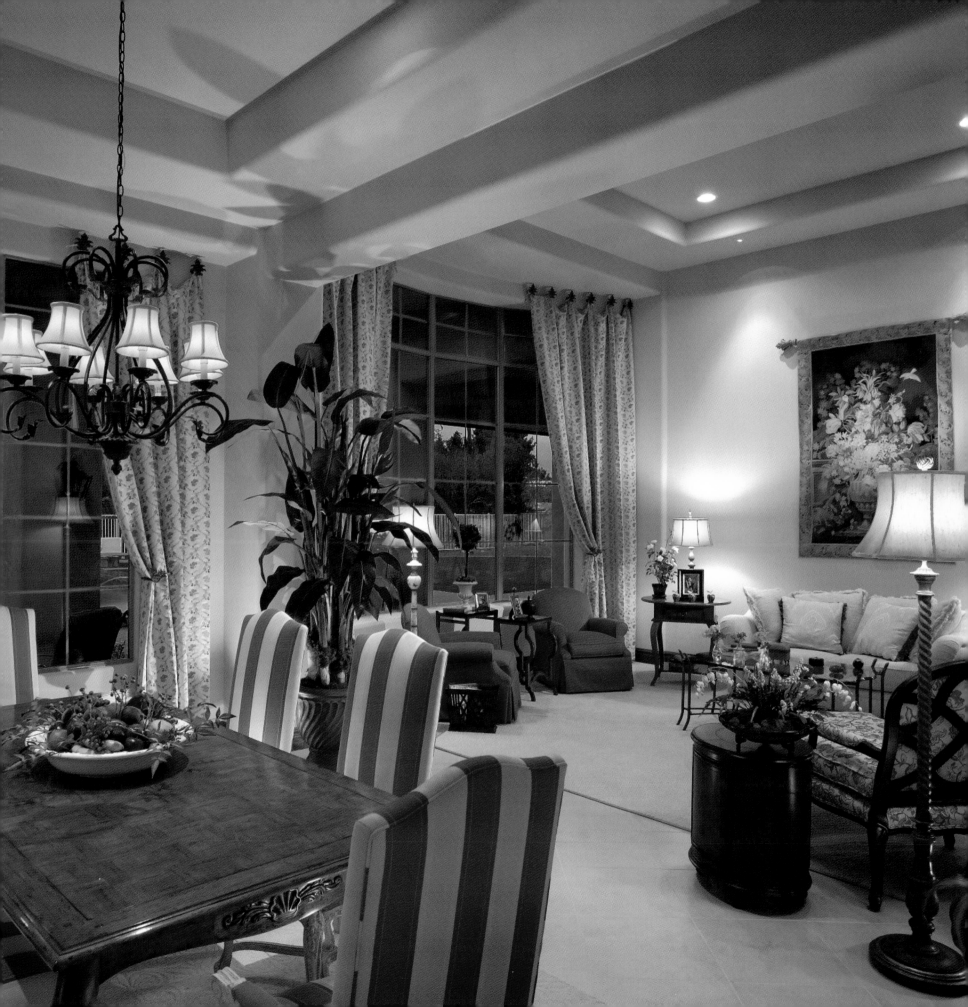

Ernesto Garcia
Ernesto Garcia Interior Design

LEFT

For this project, Ernesto's client's main request was that the home project a feeling of relaxed elegance. Well-traveled, he has a predilection for a variety of Mediterranean styles. Working with him meant working with a collage of images collected from homes ranging from Tuscany, La Dordogne, Andalucia to many other Southern European regions. Ernesto's mission was to blend this multiplicity of styles into harmonious spaces, using images that evoked his client's traveling experiences while creating a coherent dialogue between all furnishings, accessories and collectibles.

RIGHT

Ernesto treats his interiors as three-dimensional canvases on which he paints the abundant stylistic influences of the Southwest: Tuscan, French Country, Spanish Colonial, Portuguese Baroque and others. This foyer is a typical example of that eclecticism at play. Ernesto wants people to experience a sense of 'arrival' and at the same time understand the theme of this home.

Ernesto Garcia is a chameleon of styles. The interior designer by profession, and architect by education, has been bringing a diversity of inspirations to his practice for 23 years. For the last two he has worked for Robb & Stucky Design Studio in Scottsdale.

"My upbringing makes me almost unavoidably prone to eclecticism," Ernesto says, adding, however, that, although versatile, he is also adept at designing within a specific style.

Ernesto was born in Argentina, the grandson of Spanish and Lebanese immigrants. His father's parents were from Spain and worked the land on a ranch in the northern part of the country, near the capital of the province. His mother's parents came from Lebanon and, more urban,

lived in the capital. His grandfather arrived when he was 13 and made his fortune in the garment industry, then went back to Beirut to meet and marry his grandmother.

"These were incredibly different backgrounds and, aesthetically, they have had a profound effect on me," he explains. On Sundays, he would experience both worlds, and they live with him today in his world and his designs. "The home of my Lebanese grandparents was light and brilliance: rich in colors and exuberant in patterns and textures, beautiful rugs, nacre inlaid tables, cedarwood, silks and gold embroidered fabrics. On the other hand, the home of my Spanish grandparents was restrained elegance and almost monastic—classic white stucco walls, austere, unmannered and sparsely furnished."

This love of materials has stayed with him. "I am caught up in their shapes, colors, textures and history; and yet there is a part of me... that sees all these objects as metaphors, as verses of a poem. All good designers are poets."

Embracing the poetry of materiality and polarities of his background, he attended the well-respected National University of Tucuman, where he achieved a master's of architecture. Here, from an architectural faculty led to modern prominence by architect Cesar Pelli, he picked up a modernist architectural vision.

"All of this has provided me with abundant inspirational sources," he explains. Add his widespread traveling and our shared exposure to multiple images by books and the Internet and the result is his aesthetic that attempts to synergize this diversity into the art of space. "Anymore, I rarely see an interior that I can consider stylistically 'orthodox,' says Ernesto, who has been nationally published in magazines and a book.

After spending time in Europe, he lived on the East Coast and the Pacific Northwest, then was lured to the Valley by its Spanish Colonial history as well as its Contemporary and other styles. "I love the energy of this place," he says, calling the Southwest the "New Frontier." "There is an incredible convergence of social, cultural and economic energies to this area," he says. "When a region exerts this sort of attraction, it inevitably tends to become a 'cultural factory,' a trend-setting ground, and I, like so many others, want to be a part of it."

More about Ernesto...

WHAT COLOR BEST DESCRIBES YOU AND WHY?

Red, red, red. Any red. Chinese, saffron, garnet. It is sensual and invigorating. To me it symbolizes life more than any other color.

WHAT IS THE HIGHEST COMPLIMENT YOU'VE RECEIVED PROFESSIONALLY?

A client once told me that the new home I had designed for her helped her "reconnect with life and become more aware of how much beauty surrounds us in this world."

WHAT ONE ELEMENT OF STYLE OR PHILOSOPHY HAVE YOU STUCK WITH FOR YEARS THAT STILL WORKS FOR YOU TODAY?

I make myself look at every project as the new and unique venture that it is. Experience stays—but preconceptions go out the window. Every client is a new person with a different history and particular needs. For the creative process, I try to go into this inner place of childlike innocence where new images and ideas can be conceived. Most importantly, I set out to learn new things with every project.

WHAT IS A SINGLE THING YOU WOULD DO TO BRING A DULL HOUSE TO LIFE?

First, I would rethink the floor plan, find out what layouts would make the most of its architecture and its views. Then I would study how the light affects each room and analyze the scale and stylistic relation between the furnishings. Next, I would review the palette of the room, which doesn't necessarily mean I would add a lot of color; it just means I would examine the chromatic relationship between the whole and the parts.

Ernesto Garcia Interior Design
Ernesto Garcia, ASID, NCIDQ
3150 E. Beardsley Road
Suite 1048
Phoenix, AZ 85050-3562
602.317.3205

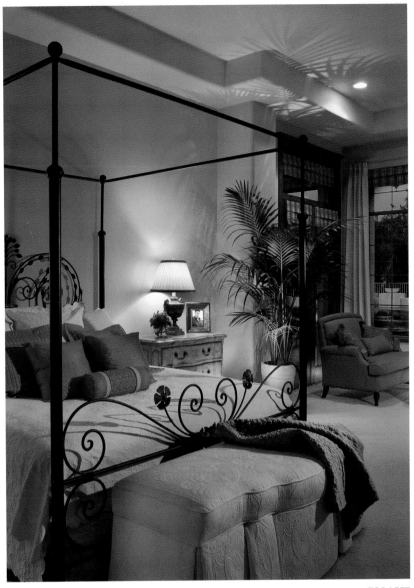

TOP LEFT
This is one of the most hopeful and refined spaces Ernesto has designed. Strongly anchored in the past and yet futuristic, it is fastidiously detailed, and yet there is a lack of preoccupation with convention in it. The columns that frame it come from a demolished estate in England. Ernesto designed the rug while in Barcelona on a visit to Gaudi's Casa Mila.

BOTTOM LEFT
Ernesto wanted this corner to be an unashamed metaphor for the desert: ample, imposing, bright, rich and austere at the same time. The strong and heavy Spanish Colonial table is delicately flanked by chairs with embossed leather backs and silk-upholstered seats. A reference to the hacienda of the 21st century: rustic, luxurious and restrained.

ABOVE
For Ernesto, master bedrooms mean peace and serenity, but they are also about sensuality, from beautiful beddings to embracing seating; finding the balance is always a challenge. In this one, he wanted the Andalusian wrought-iron bed to subtly dominate the space; although delicate in its structure, you cannot escape its magic. Hundreds have told Ernesto they'd love to wake up in this room.

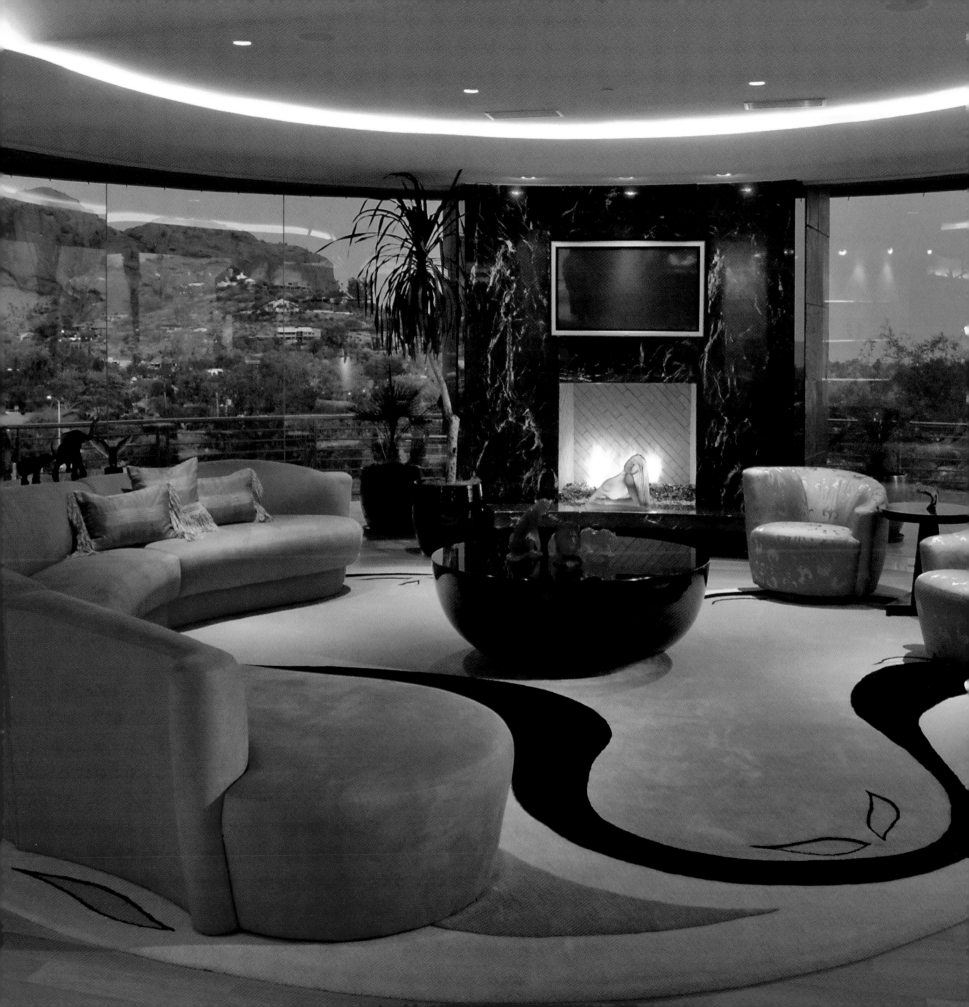

Robin Grant
Grant Designs LLC

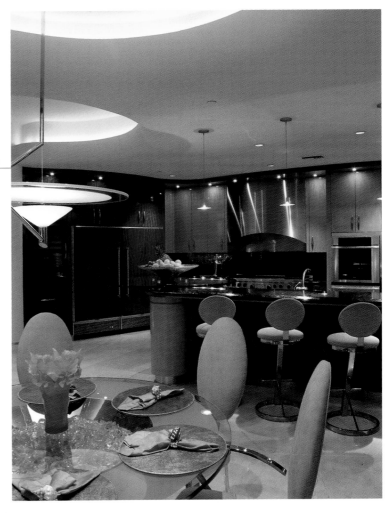

LEFT
A sitting area for spectacular views of Phoenix' Echo Canyon and Camelback Mountain, this soft, muted living room is centered by a custom black-marble table designed by Grant. The focal-point circular table sits on a specially-dyed rug, designed by Grant to follow the curves of the ultra-suede and silk furniture.

RIGHT
This kitchen features a remarkable island, light bridges and meticulously mated appliances and millwork. The elegant circular table features a nickel base shaped like a bolt of lightning rods and a thick glass covering a bowl of cut chipped glass. Surrounding this are custom sage-green ultrasuede chairs. Grant selected the circular light overhang to complement the movement in the base.

The Southwest is her home, and the Southwest home is her workplace.

"Who wouldn't want to make their home the most beautiful place on Earth?" asks Robin, a 20-year Valley resident and for the last 10 a one-designer studio. "We're a small, intimate company," she says of her group, which includes an executive director and assistant designer.

"I love the natural and mystical energies here. I love that the true Southwest style is a distillation of styles, that so many people have brought so many different influences to the area. I love the climate and the sunshine and the desert colors."

Born into a farming family in upstate New York, Robin is a direct descendant of the 18th president, bringing the family tenacity

and personality to every project. "I have an ability to transform my clients' vision of their lifestyles into unique and pleasurable design experiences."

Commitment and accountability anchor her business. She incorporates her clients' passions in the designs of their homes and the furniture and accessories she creates for them. "To every project, to every design piece I create, I strive to bring integrity and talent and as little egotism as possible," says Robin, whose work has been published in *Design & Architecture* and *Arizona Foothills*, which selected one of her projects for its 2004 Showcase Home tour.

In a recently completed home in Paradise Valley, for instance, she created the interior design as well as the designs for a variety of focal-point pieces. In the living room, for example, she designed a circular

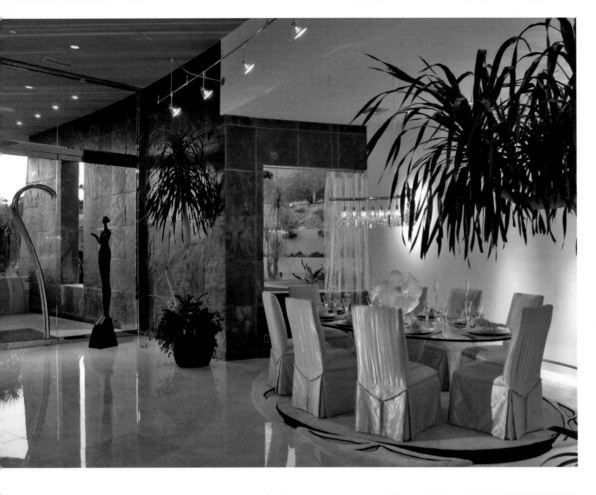

black granite coffee table that sits between pieces of a multi-colored circular sectional. The table, circularly tapering down to the base from a super-polished surface, centers the room: by mirroring the shape of the sofas, the radiused fireplace and the view windows that look down to the city. "Circles are key to so many of my designs," she says. "They offer a sense of completion and provide wonderful balance for the angles of the built structure."

Her client's chosen style guides what she designs; her joy for her work guides how she designs. "My style, Contemporary or European, Mediterranean or Wright-inspired, can be seen throughout each project, expressing my passion for interior design. I don't limit myself to one style—I keep an open mind for new ideas and new looks."

Creating vibrant interiors from the blank space of every new project, and ensuring that her work answers to her clients' goals and passions, challenge and excite Robin. "I want to be the person in the background. I want them to say, 'We pulled this all together. We did this.'"

So, what, for Robin Grant, is the most beautiful home in the Southwest? "The home that exudes the love and passion in one's life."

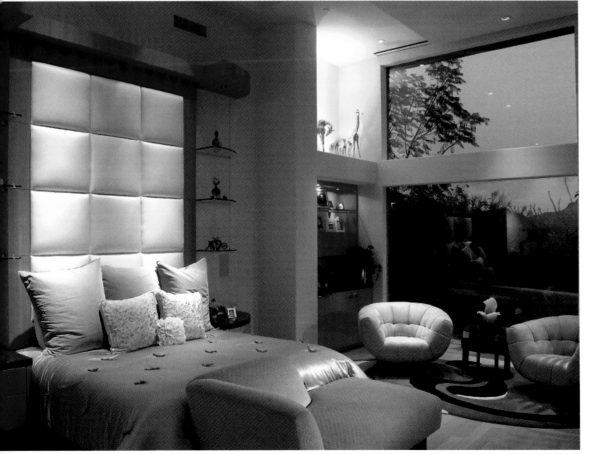

TOP
This dining room welcomes guests just off the foyer of a large Paradise Valley Contemporary. All elements are custom: the beaded silk chairs; the crystal and chrome chandelier; and the crema marfil marble table, designed by Robin Grant to complement the room's sexy, curving lines.

BOTTOM
The elegant Paradise Valley bedroom centers around a custom bed with a pear wood headboard frame and suspended glass shelves. The headboard is silk in soft ivory, while the rich coverlet is aqua taffeta and silk. At the foot is a stamped ultra-suede chaise, matched in the sitting area with round barrel chairs which swivel for desert views on a wool rug designed by Grant to incorporate colors of the room.

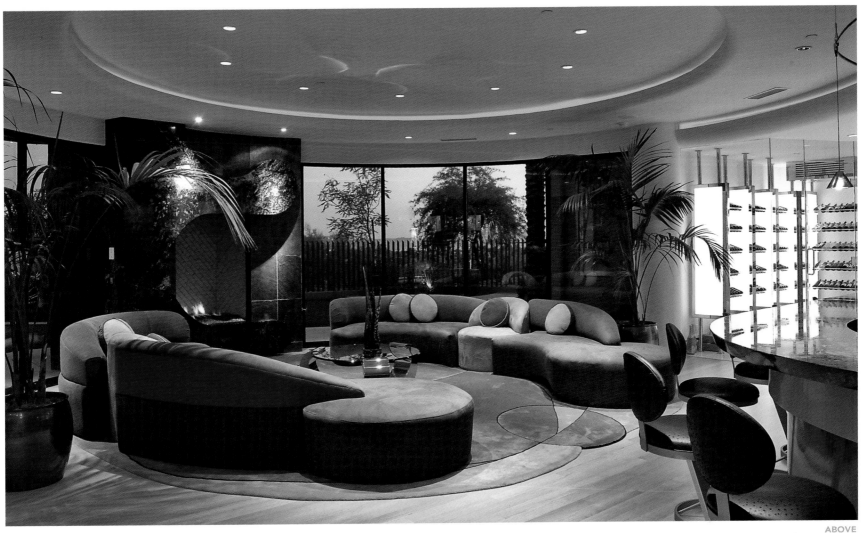

ABOVE
The lower level of this home is all play, full of color and movement—blues, purples, greens—with blue and purple ultra-suede curved sofas caressing two plush chairs in lime-green textured ultra suede. 'Complementary colors are always interesting when used together—especially in this sofa and rug combination,' Robin explains.

More about Robin ...

WHAT COLOR BEST DESCRIBES YOU AND WHY?

Yellow golds. It exemplifies my enriched life and my bright outlook toward the future.

WHAT IS THE SINGLE THING YOU WOULD DO TO BRING A DULL HOUSE TO LIFE?

Add color and energy, from either design pieces or the oxygen of bright and colorful plants and flowers.

NAME ONE THING MOST PEOPLE DON'T KNOW ABOUT YOU.

Flowers, flowers, flowers—anything and everything that has to do with my garden rejuvenates me. My garden is my weakness and my strength. It reaffirms my relationship with the earth and my creativity.

WHAT IS THE HIGHEST COMPLIMENT YOU'VE RECEIVED PROFESSIONALLY?

Regular referrals tell me that not only are my clients satisfied with my work but that they trust me enough on both professional and personal levels to forward my name to their closest relationships.

Grant Designs LLC
Robin Grant
3370 North Hayden Road
Suite 123
Scottsdale, AZ 85251
602.620.8088

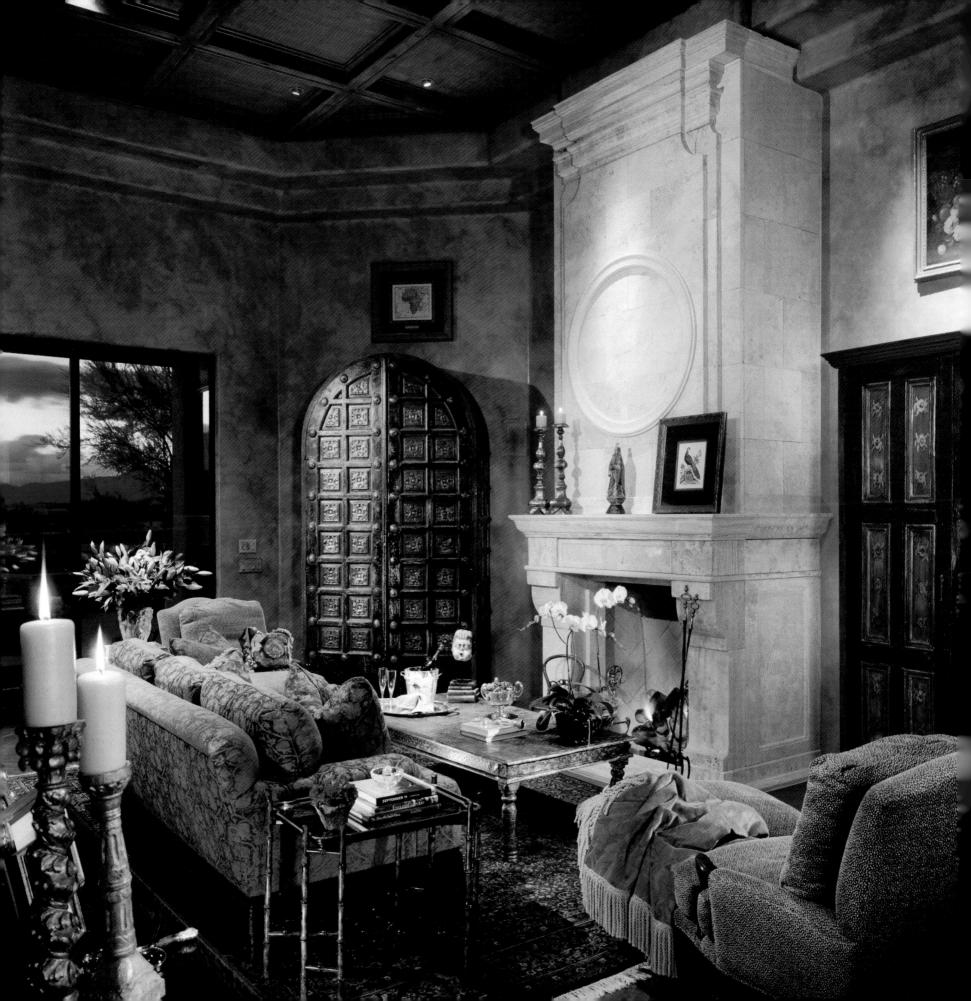

Marieann Green

Marieann Green Interior Design, Inc.

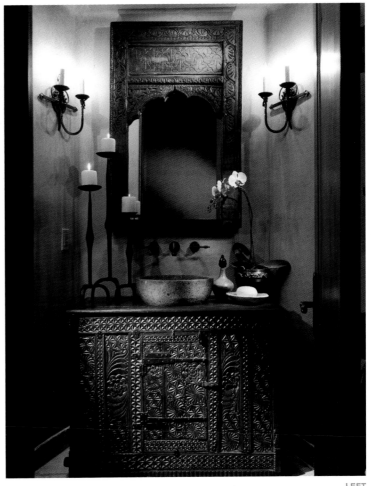

LEFT
The focal point of the great room is a hand-carved limestone fireplace from Italy. The Guatemalan armoires house a wet bar and plasma television.

RIGHT
A hand-carved framed mirror from East India and wall sconces adorn the integrated plastered walls of this powder room.

Marieann Green Interior Design, Inc. is an Arizona-based interior design firm, specializing in high-end residential projects. Founded in 1977 and formerly located in Beverly Hills, California, the highly innovative company has received numerous awards and accolades for its excellence in design.

The firm's projects have been published in many prestigious magazines, books and newspapers. Marieann's design projects are regularly featured on Fox 10's "This Cool House" segment, and *Phoenix Home & Garden* magazine has named her a "Master of the Southwest." Additionally, Marieann is profiled in national and international editions of *Who's Who is Interior Design*.

Marieann is committed to designs rooted in a collaborative dialogue between client and designer, creating an environment that corresponds to clients' needs and reflects their individual styles.

"I always find a way to incorporate clients' existing treasures and trinkets into their new home. Mementos from travels and gifts form loved ones reflect a person's life and should not be discounted. A house is not a home unless it reflects who you are."

Marieann is often asked about her style. Her response never changes: "A good designer can work in any style." And she does.

Marieann Green Interior Design, Inc.
Marieann Green, ASID, IIDA
8912 East Pinnacle Peak Road
Suite 641
Scottsdale, AZ 85255
480.473.1122
www.marieanngreeninteriordesign.com

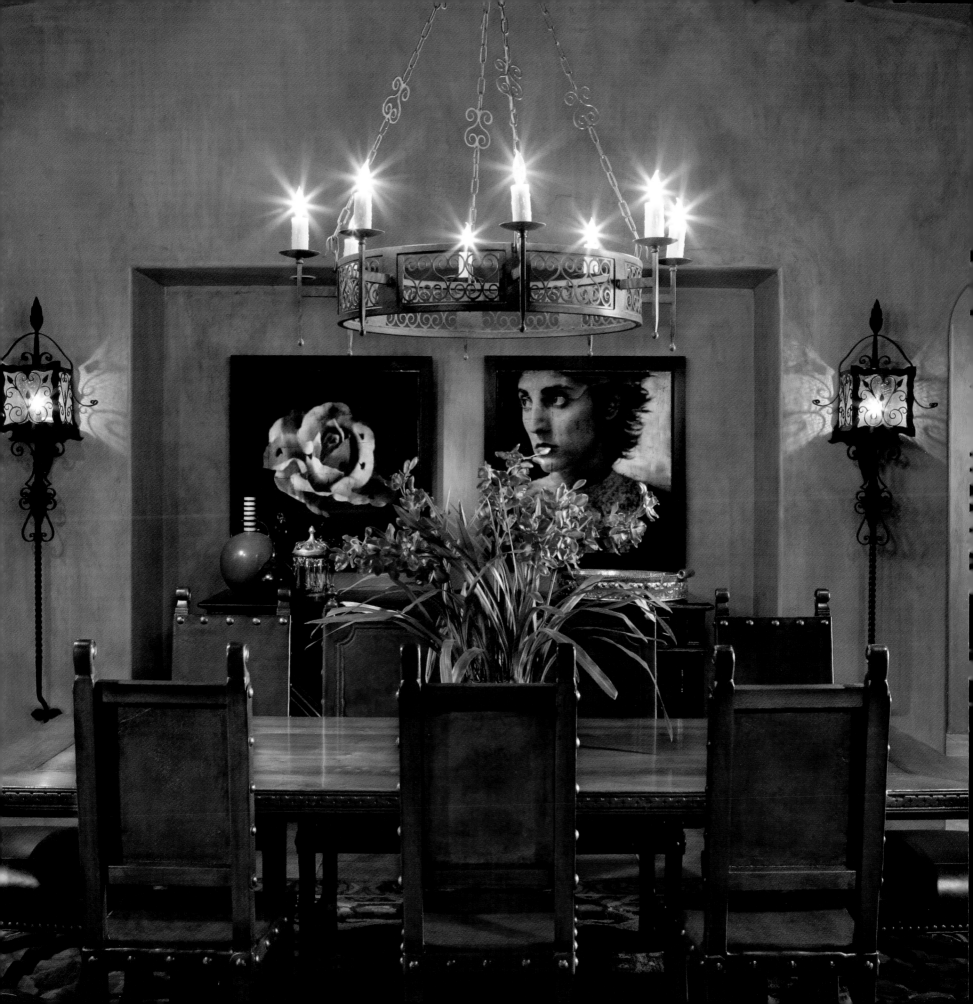

Rhonda Greenberg & Sharon Faircloth

Paradise Interiors Inc.

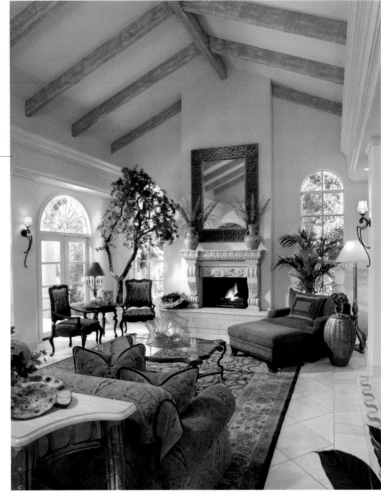

LEFT
The charming Spanish hacienda-style dining room invites
you to gather round for feast and cheer.

RIGHT
Shades of the earth combine to create the casual
elegance of this living room.

For Rhonda Greenberg and Sharon Faircloth, interior design is about far more than the right style, colors, furniture, and accessories. Rather, it is all about relationships—with clients, vendors, their staff, and each other.

"Designing someone's home is an intimate process," says Rhonda. "When we work with a client, we become more than client and designer. We become friends. That guides us in the direction we need to take for their home." Clients often comment that it's almost as if the two women are reading their hearts and minds when they create a design.

Rhonda and Sharon include some of the most reliable vendors in the industry in their circle of relationships. That connection is the basis of their ability to complete design projects very quickly, a skill their clients depend on.

But most importantly, since establishing Paradise Interiors nine years ago, their personal relationship has blossomed. "We are two sisters who love the opportunity of working together every day," Sharon mused. That bond is one of Paradise Interiors' greatest strengths and when it is combined with powerful connections to clients, vendors, and a highly valued staff, it produces a design firm with heart, one that feels like family.

Rhonda and Sharon have had the design gift since youth when their mother would often ask, "What color do you want to paint your room today?" As a result, both bring an innate design sense to the firm—an ability to size up a room, understand its challenges and its possibilities. Rhonda is known for her ability to squint her eyes and "see" the completed room. And Sharon has a great merchandising knack, with years of retail experience, especially in store planning and layout.

Together, they team with their staff of six to provide turnkey services. "We love having the opportunity to work with clients to bring their dreams into reality,"

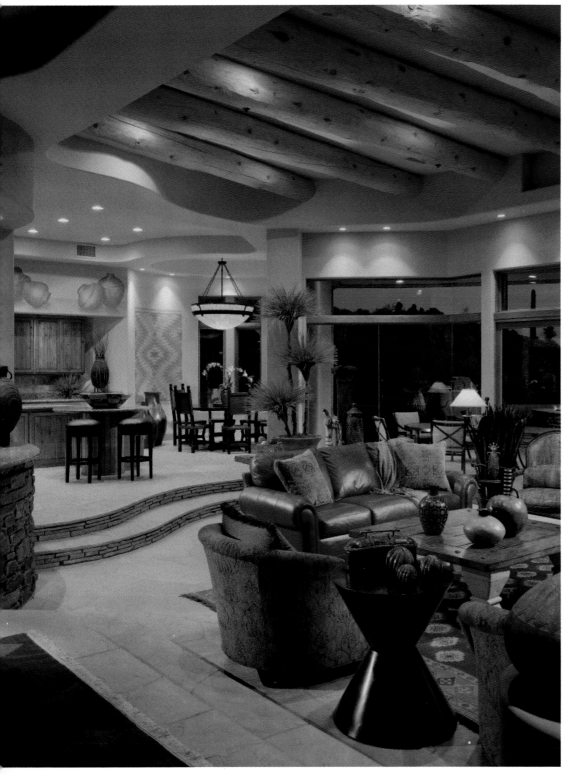

ABOVE
Here is a place to live, laugh, kick back and enjoy life.

RIGHT
Under the striped umbrella, a cozy chaise for two.

Sharon commented. Most importantly, the firm strives to make each home unique so that it mirrors the personalities and lifestyles of the owners. Clients frequently have friends tell them, "Your home looks just like you. It's wonderful!" In turn, those clients return to Paradise Interiors to design other homes in cities across the country—and their friends call for their homes as well.

A majority of the firm's clients have their second and third homes in the Valley and they often need that home completely furnished while they are away. They like it that Paradise can deliver everything they need for their dream home very quickly. "We furnish everything but you! That's our logo," Sharon and Rhonda claim in unison.

Because they often work from a "blank canvas," Rhonda and Sharon are able to create a theme throughout a home—regardless of whether the style is Southwestern, Spanish Colonial, Contemporary, Tuscan, Old World, or some other style. Both are particularly sensitive to the desert landscape, incorporating nature's colors and textures into interiors then creating a comfortable, harmonious flow from room to room in order to establish a living environment with charisma and warmth.

They'll always add a bit of fun and the unexpected, too: a glass paperweight used as a doorknob or an extruded steel backsplash. "We call them our 'gems and jewels,'" Rhonda says.

Most valuable, though, is client satisfaction. "We never forget that we're in a service industry," she adds, "and our goal is to listen between the lines, find out what excites our client—and give them the home of their dreams!"

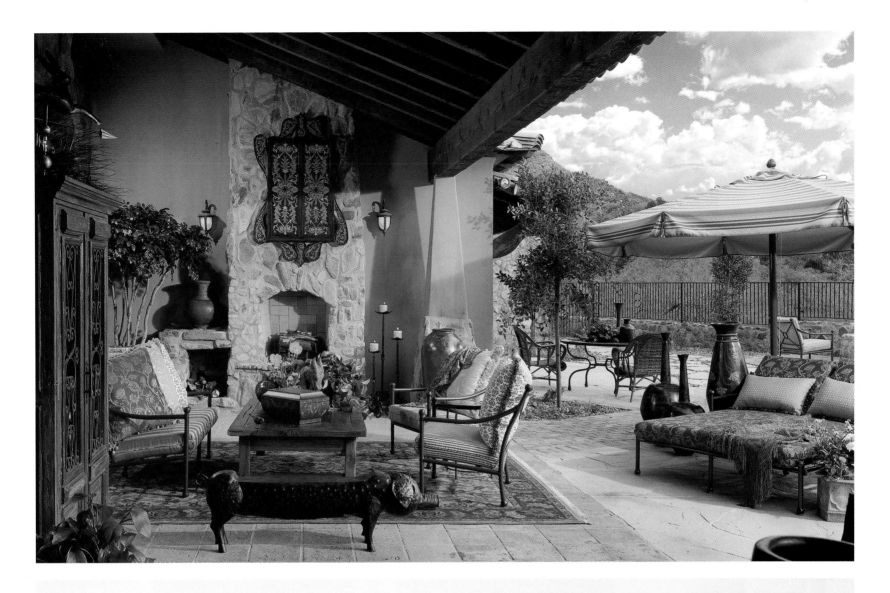

More about Rhonda & Sharon ...

WHAT COLOR BEST DESCRIBES YOU AND WHY?

Rhonda—Turquoise! Vibrant, rare, natural, connected to the earth and found here in the Southwest, and the color of my kitchen table!

WHAT IS THE MOST UNUSUAL/EXPENSIVE/DIFFICULT DESIGN OR TECHNIQUE YOU'VE USED IN ONE OF YOUR PROJECTS?

Sharon—One spectacular kitchen we designed combined rainforest marble countertops, a forged steel backsplash and knotty alder cabinetry. The challenge then became the oversized island in the heart of the kitchen, which required a work station with a prep sink and a large dining counter. We employed all the elements above, once again by using the marble in the task area and the rounded knotty alder dining counter with a jagged slash of steel connecting the two.

WHAT IS THE HIGHEST COMPLIMENT YOU'VE RECEIVED PROFESSIONALLY?

Rhonda—HGTV came to the Southwest looking for color and featured my home on five segments of "Interiors by Design" with Chris Cassen Madden We regularly have our clients' homes on "Cool House," a local design program on Fox 10 news.

Paradise Interiors Inc.
Rhonda Greenberg, Allied Member ASID
Sharon Faircloth
15344 N. 83rd Way, Suite102
Scottsdale, AZ 85260
480.948.9899
www.paradiseinterior.com

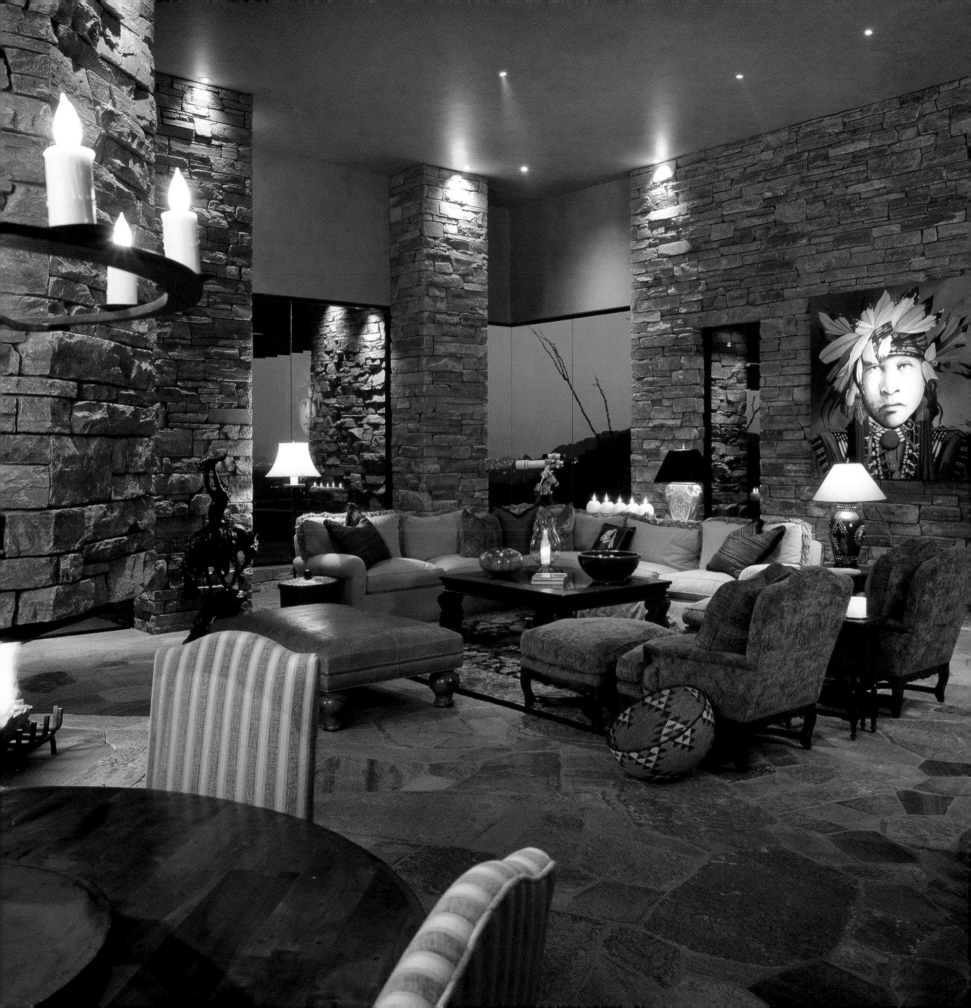

Ellen Beth Harper
Harper Studio of Interior Design

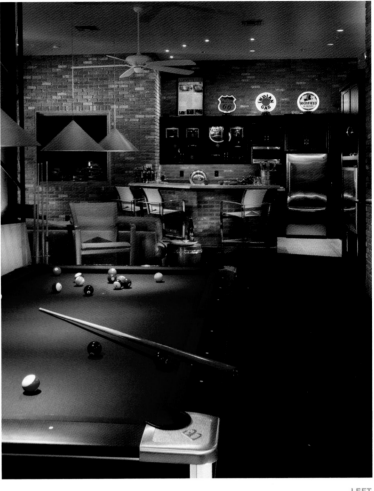

LEFT
On 20 acres in the high desert north of Scottsdale, this home epitomizes Contemporary Southwest design. Spectacular views and the indigenous architecture generate a warm but dramatic interior that reflects the Southwest in a classic way.

ABOVE
This is one of the most unusual spaces Ellen has been involved with. The underground garage is all about the client's vintage Corvettes. She wanted to enhance the color and drama by creating an intimate wet bar/entertainment space within a very large 6,000-square-foot showroom.

When Ellen Beth Harper isn't designing upscale interiors, she's hiking up mountains in the preserve abutting her Phoenix home or in the Colorado Rockies.

The 25-year veteran designer has other passions. With husband Tom, she enjoys riding horses and fly-fishing. She also loves spending time with her two sons: Danny, a professional and aerobatic pilot, and Chad, a college student and avid rock climber.

Wherever she is, Ellen likes the atmosphere with others. "People make me go—the relationships I have from my private life and the relationships I've created and built through business," says Ellen, a Fine Arts graduate of the School of Interior Design at Arizona State University.

Appreciative clients, project associates, and her great staff, Lael Beier and Kris Salveson, make her commissions stimulating and educating. "I've been very lucky in having such challenging projects that are not mundane and never boring," she says.

Her classic, timeless interiors—from mountain retreats in Crested Butte, Colorado, to an ultra-Contemporary Desert Mountain residence in Scottsdale, to a 6,000-square-foot Paradise Valley basement/garage for vintage Corvettes—inspire clients to return for new inspirations.

Return work is one great compliment. "The other is unspoken—when a space looks like a client, not me. The best result is something that they, not I, create," says Ellen.

Harper Studio of Interior Design
Ellen Beth Harper, ASID
Stable Galleria
7610 E. McDonald Drive, Suite B
Scottsdale, AZ 85250
480.443.8882

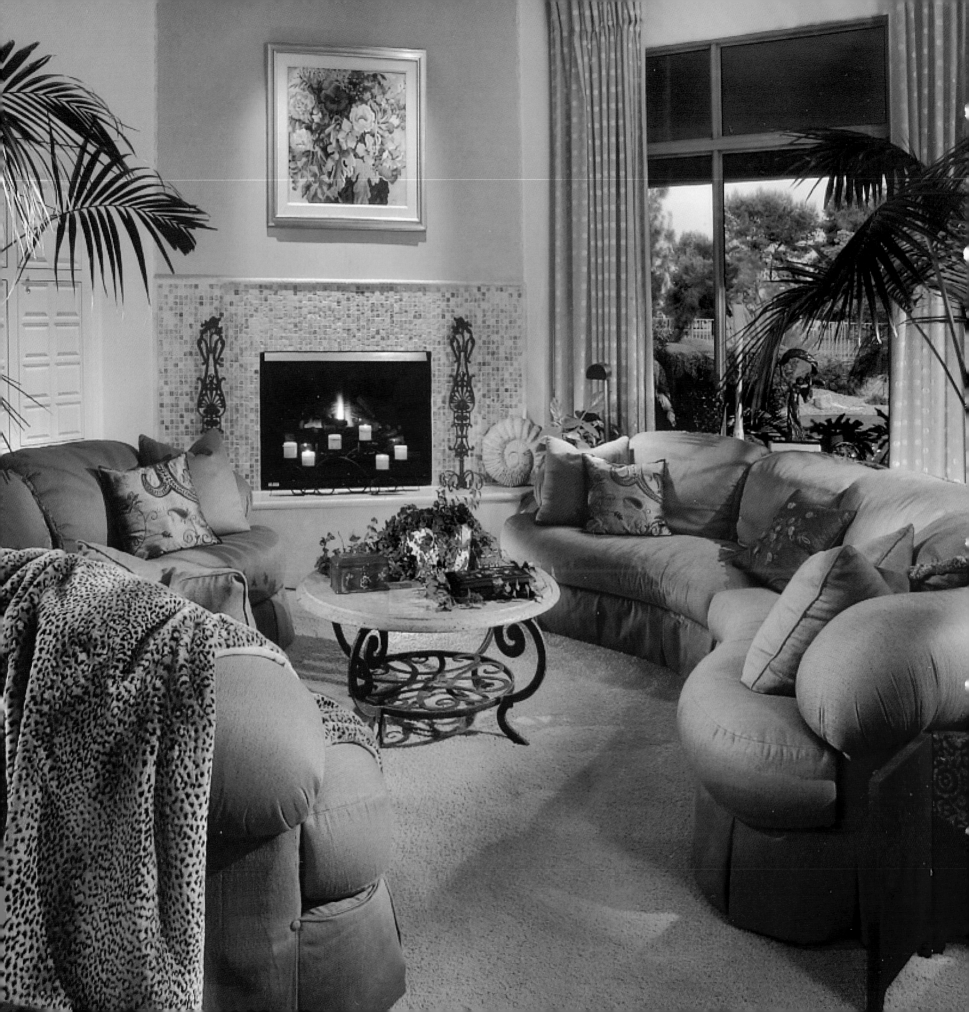

Sherry Hauser
Sherry Hauser Designs

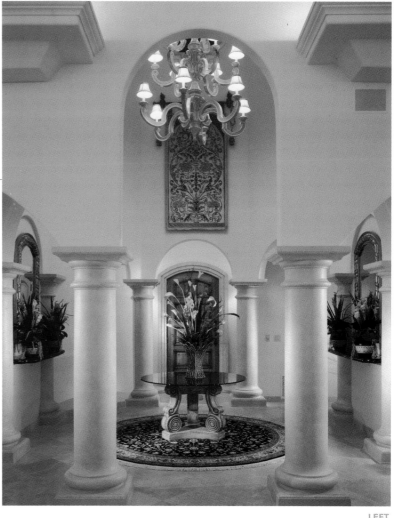

LEFT
The designer's living room showcases a vivid floral combined with casual sofas and easy access for entertaining or television viewing (in the nearby cabinetry).

ABOVE
The entry detailing of David & Nancy Schuff's elegant horse property sets the feeling of overall interior design.

"Great endings evolve through careful planning in the beginning," says Sherry Hauser, ASID, and past president of its Arizona North chapter.

And, starting right on an interior design, whatever the style, is at the blueprint stage—working with the architect, contractor and client before the walls go up, before the end tables are trundled in and the sconces installed. "I'm very much into getting the bones right and enjoy working with architects to make this happen," she says.

This can be a long process. "I'm often working with a client for a number of years—from initial layout until they acquire their last piece of artwork," says Sherry, who's been an award-winning designer in the Phoenix area for 25 years.

An Indiana native, Sherry taught interior design at the college level before taking on clients and started professionally by covering up the errors of others—so she knows the importance of getting it done correctly to begin with. She is also a first place award winner in the recent ASID Design Competition.

"I'm at my best when listening to clients and taking a project in the direction they are comfortable with, while raising the project to the highest level that I can," says Sherry, who takes on just a few projects at a time to ensure superlative service. Her style: eclecticism - always with attention to scale and proportion.

After all, the interior must follow the client's wishes, not the designer's. "I work from the furnishings out," she says. "I want to know how many people are sitting in the living room, how many are expected for meals—then I determine if the space is suitable."

Another example of the importance of an early start: Windows require careful consideration for view, privacy and sun control. Early in the process, she attends to window treatments to ensure ease of operation. "I make sure to address these issues prior to construction," Sherry says, adding, with a chuckle, "I like surprises—but not on my design projects."

Sherry Hauser Designs
Sherry Hauser
14225 W. Greentree Drive
Litchfield Park, AZ 85340
623.935.5061

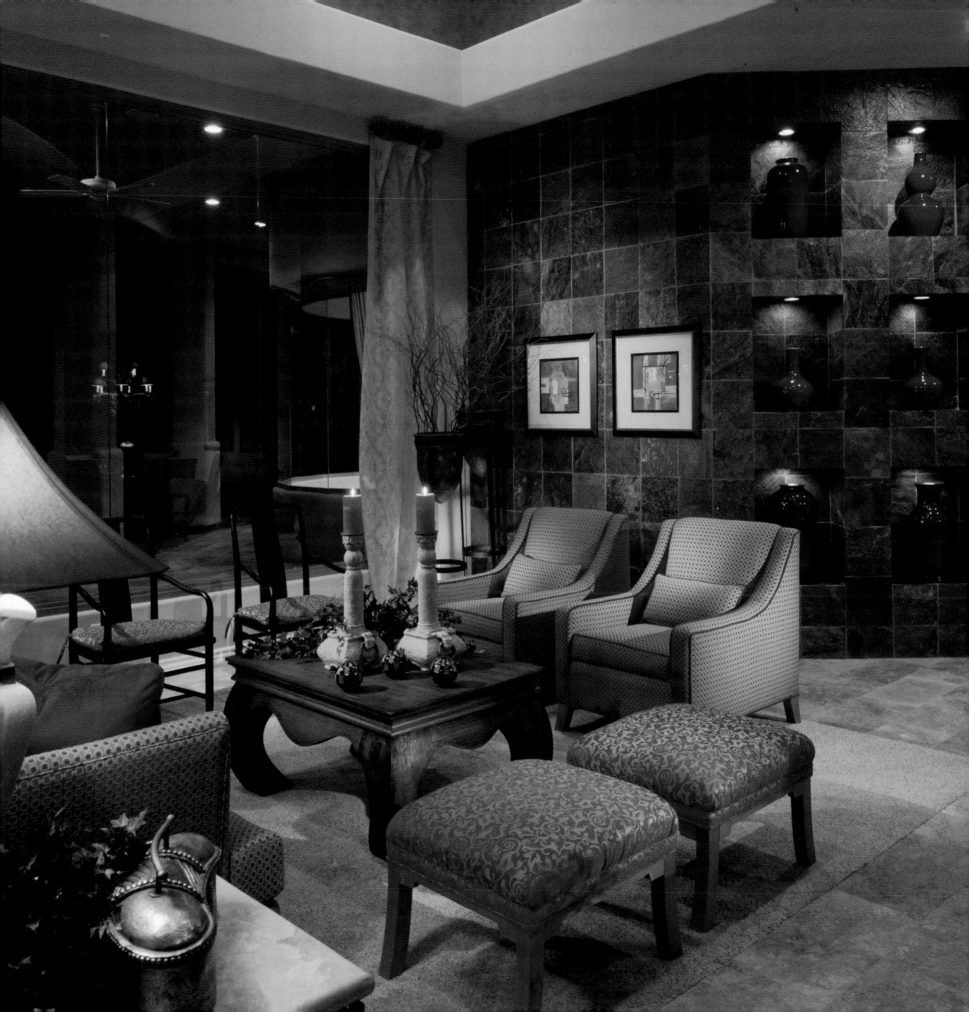

Debra May Himes

Debra May Himes Interior Design & Associates

LEFT
In this living room, a wall of nine niches covered in slate, with red vases in various sizes and shapes, provides a dramatic focal point for this room.

RIGHT
Designed by Debra, this dining table provides a design that is graceful and elegant. Materials include maple, ebony, black granite and chipped-edge glass.

You can't go wrong in life when you follow "Grandmom" and Wright.

Debra May Himes, ASID, IIDA, says that her mother's mother inspired her and the granddad of American architecture helped her build solid, client-focused business procedures.

Debra got moxie and motivation from her grandmother, who owned a junkyard in Texas and, in Arizona, worked in real estate, owned a restaurant and navigated the success of a North American Van Lines truck-driving school. "She was a hard worker who always encouraged me to network and get involved with local business groups and chambers of commerce," she says.

"Frank Lloyd Wright took a project and wanted to design every detail for the client, from the furniture to their clothing," adds Debra. She is an Arizona native who studied in Flagstaff at Northern Arizona University, which recently honored her with a Cliff Harkins "Distinguished Citizen Award." "I strive to provide what clients need for their project; to give them something special that they can call their own. I listen to my clients preferences and translate them to a 'look' and design style that works for them—only better than they can imagine," says Debra, who is NCIDQ certified and a former ASID chapter president.

After working in Phoenix for a luxury furniture retailer, she opened her studio 23 years ago. Based in Chandler, just south of Phoenix, she maintains a relatively small company with an executive assistant and

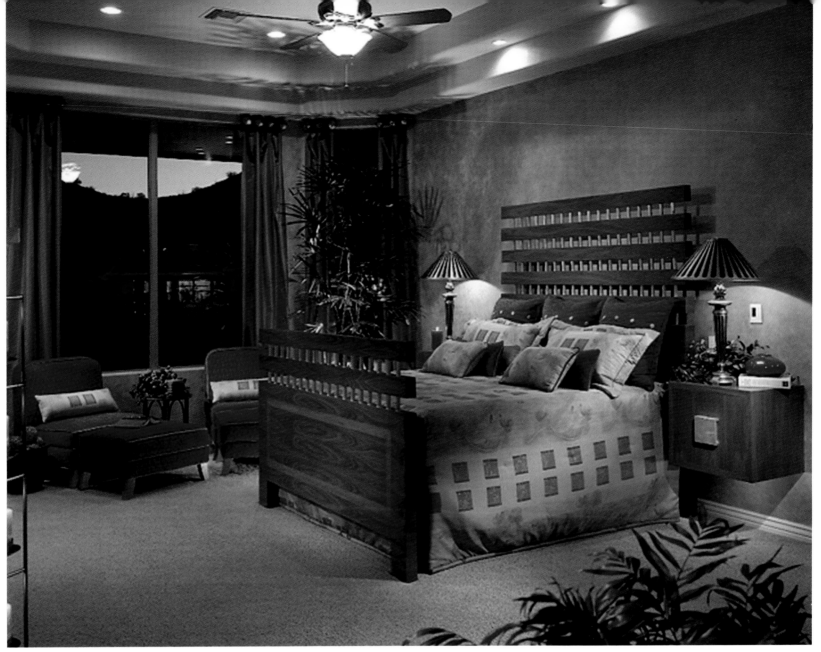

ABOVE
This bedroom showcases Debra's custom-furniture designs. The furniture is fabricated from black walnut with cherry inlays and brushed-aluminum detailing.

an interior design assistant. "That just means my clients have access to me," she says, "and that I supervise all of the design work."

The company specializes in residential interior design, but has a diverse clientele ranging from hospitals to corporations to law firms and banks. "While we specialize in unique styles, we offer design for nearly any taste from contemporary to rustic."

Her interior design style is elegant but livable, tactile, and emotionally compelling, with elements such as hand-hewn beams, textured fabrics and Venetian plaster. She particularly enjoys creating architectural details such as dramatic entrances and niches. Her designs can be organic in nature or very architectural. She interweaves materials and furnishings in a fashion that is contrasting yet complementary. Much of this comes from Wright, of course, but Debra also designs custom furniture and elements such as armoires, desks, powder room tables, wall-hung night stands, credenzas and even gates and staircases. She works with local fabricators as well as artisans, who hand-carve pieces such as her armoires and dining room tables.

In 1997, when she was designing space for a contemporary interior, a need for a storage chest arose. She searched her memory, showrooms and catalogs for the perfect piece. "I couldn't find it," she recalls. Instead, she came up with her own design, and the clients were thrilled. So was that year's ASID awards committee, which awarded it first place for custom furniture.

Her furniture pieces incorporate a host of materials such as black walnut accents against cherry, brushed aluminum, black granite and glass for added texture and contrast. The pieces have been so well received that she has created a for-the-trade furniture line, Jonathan David, honoring her sons. She also has plans for a bath pedestal line of numbered pieces that will be available to the public at high-end kitchen and bath showrooms.

What's most satisfying about custom work is that it allows her flexibility in designing specifically for the client. In a Chandler home, for example, she began with a custom front door. "I love to create dramatic entrances, to set the theme from the entryway," she says. The locally fabricated door displays an ivy scrollwork pattern. This detail is immediately mirrored in the travertine, granite and marble medallion on the foyer

TOP RIGHT
For this project, Debra created a soft contemporary bath pedestal with an Asian flair constructed of iron and onyx — designed to be lit.

BOTTOM RIGHT
For this project Debra created a soft contemporary bath pedestal with an Asian flair constructed of iron and onyx, and designed to be lit.

floor. This well-thought-out design is particularly compelling, as the shadows from the door often overlap the pattern on the floor. She continues this theme on staircase scrollwork as well as throughout the home, using iron brackets for the kitchen countertops, wet bar and the fireplace mantel.

Such interiors provide warmth and elicit enthusiastic accolades. "The highest compliment I receive is when clients tell me that I understood them well enough to design the project to their lifestyle and tastes—that I, as we say in the business, 'nailed it.'"

LEFT
Designed by Debra, this armoire is constructed of cherry, black walnut and brushed aluminum with hand-crafted brushed-aluminum handles.

RIGHT
This contemporary master bath design is truly in the details with the wall of slate and black granite and travertine detailing. Pewter accents provide further interest and texture.

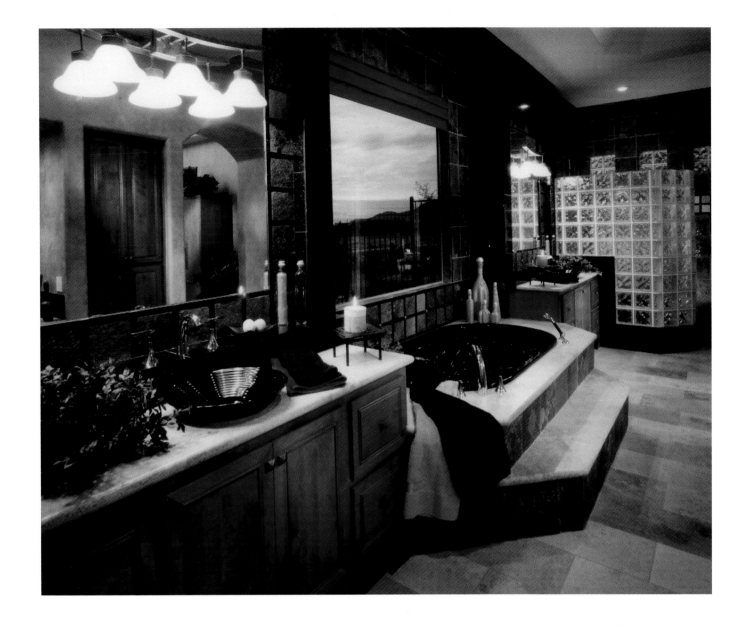

More about Debra...

WHAT COLOR BEST DESCRIBES YOU AND WHY?

Purple: It is bold yet demure.

WHAT IS THE MOST UNUSUAL/EXPENSIVE/DIFFICULT DESIGN OR TECHNIQUE YOU'VE USED IN ONE OF YOUR PROJECTS?

A lit onyx entry wall for a commercial firm.

YOU CAN TELL I LIVE IN THE SOUTHWEST BECAUSE . . .

I understand Southwest culture and design. I also love the beauty and severity of the desert.

DESCRIBE YOUR STYLE OR DESIGN PREFERENCES.

My design style is almost always eclectic. This provides interest and diversity to the project. My architectural detailing is often accented with travertine, granite, marble and slate. My furniture and project designs frequently incorporate materials that are unrelated, yet provide interesting contrast and texture to the design.

**Debra May Himes Interior
Design & Associates**
Debra May Himes, ASID, IIDA
4120 W Kitty Hawk Way
Suite 2
Chandler, AZ 85226
480.497.2699
www.dmhdesign.com

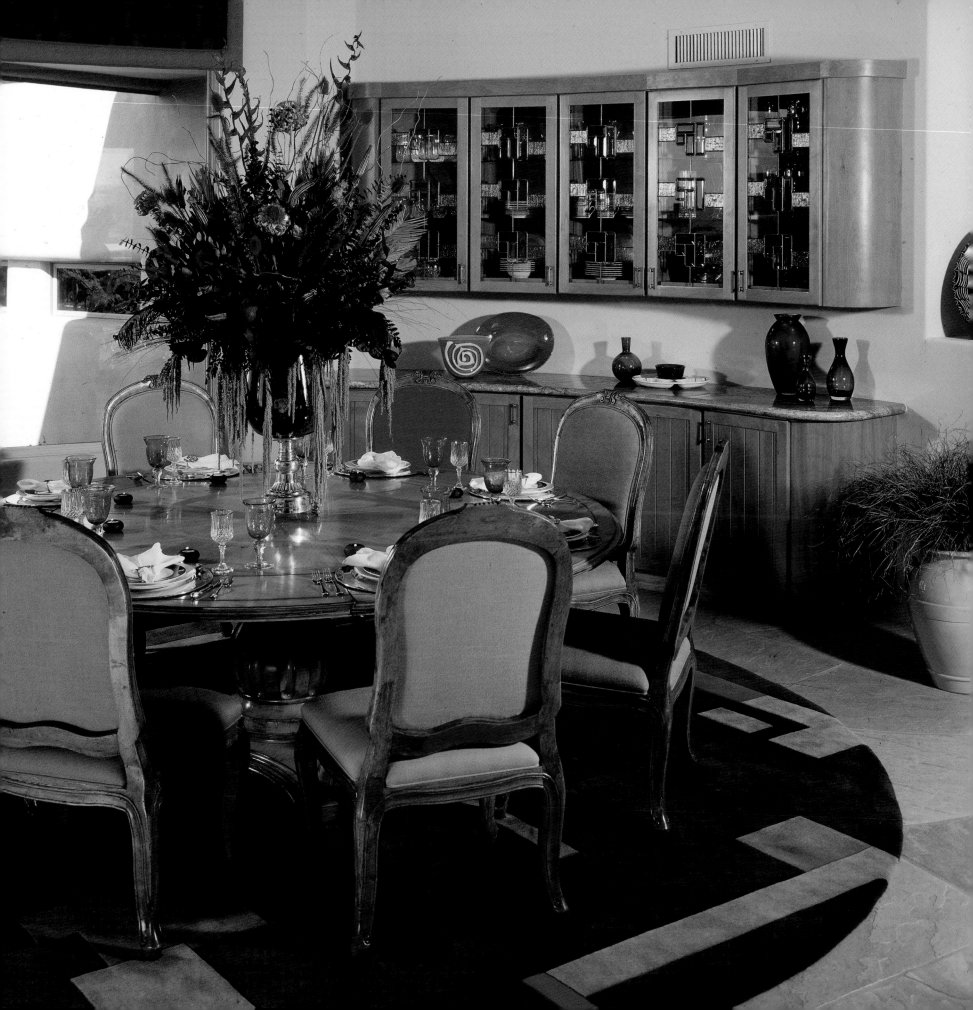

Beverly S. Hogshire
Interiors By Design

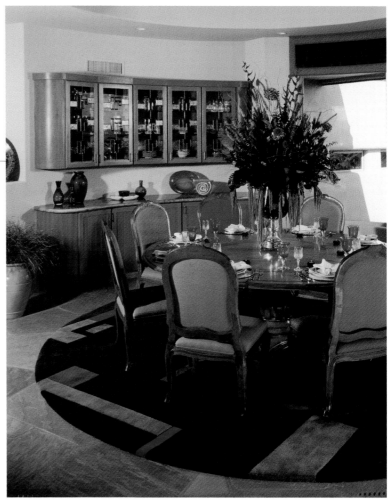

LEFT
Beverly incorporates ceiling beams, clavos, art, pots and rugs
to reflect a transitional Southwest style.

RIGHT
With chairs upholstered in four colors gleaned from the
custom area rug, the room underscores the value of color in
enhancing decor.

Beverly Hogshire works by design, not by necessity. In 1990, she moved to Scottsdale with husband Jim, who had owned a chain of gas stations in Indiana—and who now does her bookkeeping and accounting. St. Louis, Missouri born, Bev was raised and educated in Indianapolis, where she earned a business degree at Butler University. There she first put her design aptitude to work at a large furniture store and soon began a design business in 1986.

"We came out here to retire," says Bev, an Allied Member of ASID. "But I missed work, I missed the business and I missed working with clients."

In Scottsdale, Bev worked for a local builder while learning the design resources available locally and soon reopened her firm. "I work now when it's comfortable for my clients and for me," she says, adding that no more than two or three homes occupy her simultaneously. "This way I can offer service in abundance without worrying about the time it takes. It works very well for them—and for me.

"I think that the small companies can offer more individual service to their clients," Bev explains. "I do consider every one of them my personal responsibility and take whatever time is necessary to see that my client is completely satisfied. In fact, there is one client in Desert Mountain I've been working with for eight years."

She adds, "The first step in working with clients is to talk a long time. Most of the time, they will tell me that they want to bring at least some

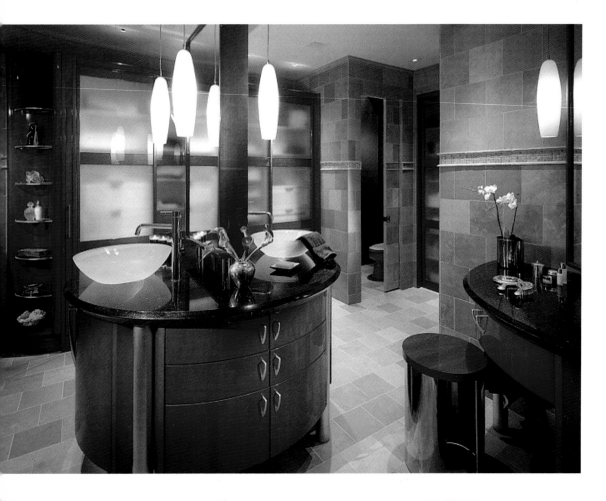

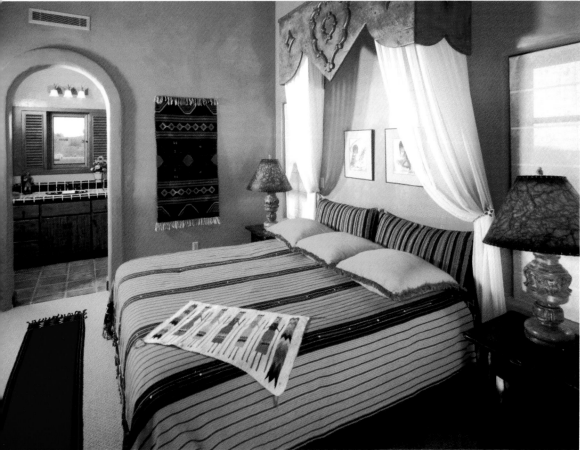

of their former lives to the Southwest. They might want to bring pieces of furniture and then accessorize when they get here." For her, that's very much in line with traditional Southwest style—a result of people from the East and from Europe moving west and bringing with them heirlooms and other treasures from their former homes.

To unify such apparently disparate elements, Bev uses color, reupholstering and accent pieces to achieve a successful Southwest environment. "In this way, everything doesn't have to be thrown away—including their money."

Her style is best described as eclectic, with particular interest in the clean lines of Contemporary. "Nowadays the Southwest style incorporates a little bit of everything. We don't have to stick to howling coyotes or log beds to look like we belong here. Beautiful rugs, pottery, carved furniture and desert colors make creating wonderful rooms fun!"

Bev's work is also well regarded professionally. The Arizona North Chapter of ASID has given her several design excellence awards for residential work and product design, her interior designs have appeared in a variety of local and national magazines, and her home was featured on a local television show.

Clients are her greatest influence—and best advertisers. "I think one of the reasons they're happy, and refer me, is that they know that I want to produce what they'll be comfortable with." Bev gets results—and compliments. "One client told me, 'It's just exactly what I wanted it to be—although I didn't really know it until it was finished!'"

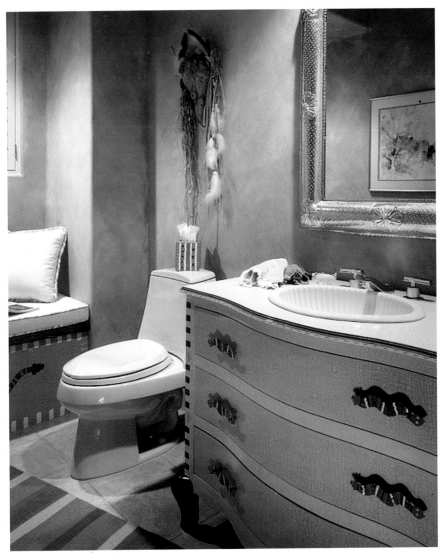

TOP LEFT
Studio Becker vanities and storage units reflect the high contemporary look in a master bathroom.

BOTTOM LEFT
The Mexican guest room encompasses brilliant color, a custom corona by Scottie Reid and hand-painted tiles.

RIGHT
This funky Southwestern powder bath uses Native American art and symbolism as well as a tin mirror to enhance the vanity, which has been created from an old dresser.

More about Beverly ...

WHAT COLOR BEST DESCRIBES YOU AND WHY?

Yellow. My husband calls me Sunshine and I do seem to have a rosy, optimistic attitude most of the time. Life is fun!

IF YOU COULD ELIMINATE ONE DESIGN/ARCHITECTURAL/ BUILDING TECHNIQUE OR STYLE FROM THE WORLD, WHAT WOULD IT BE?

Too much of any one thing—all "cutesy" Southwest, for example.

WHAT IS A SINGLE THING YOU WOULD DO TO BRING A DULL HOUSE TO LIFE?

Paint it in bright colors!

WHAT IS THE MOST UNUSUAL/EXPENSIVE/DIFFICULT DESIGN OR TECHNIQUE YOU'VE USED IN ONE OF YOUR PROJECTS?

In a Mexican home, we designed a powder room toilet that is in an elaborately carved "chest" and has a sensor flush. When the top is down, the room looks like a small and cozy place to powder your nose and has no toilet in sight.

Interiors By Design
Beverly S. Hogshire
9301 E. Bajada Road
Scottsdale, AZ 85262
480.488.2160
FAX 480.488.2160
www.mchaz.com

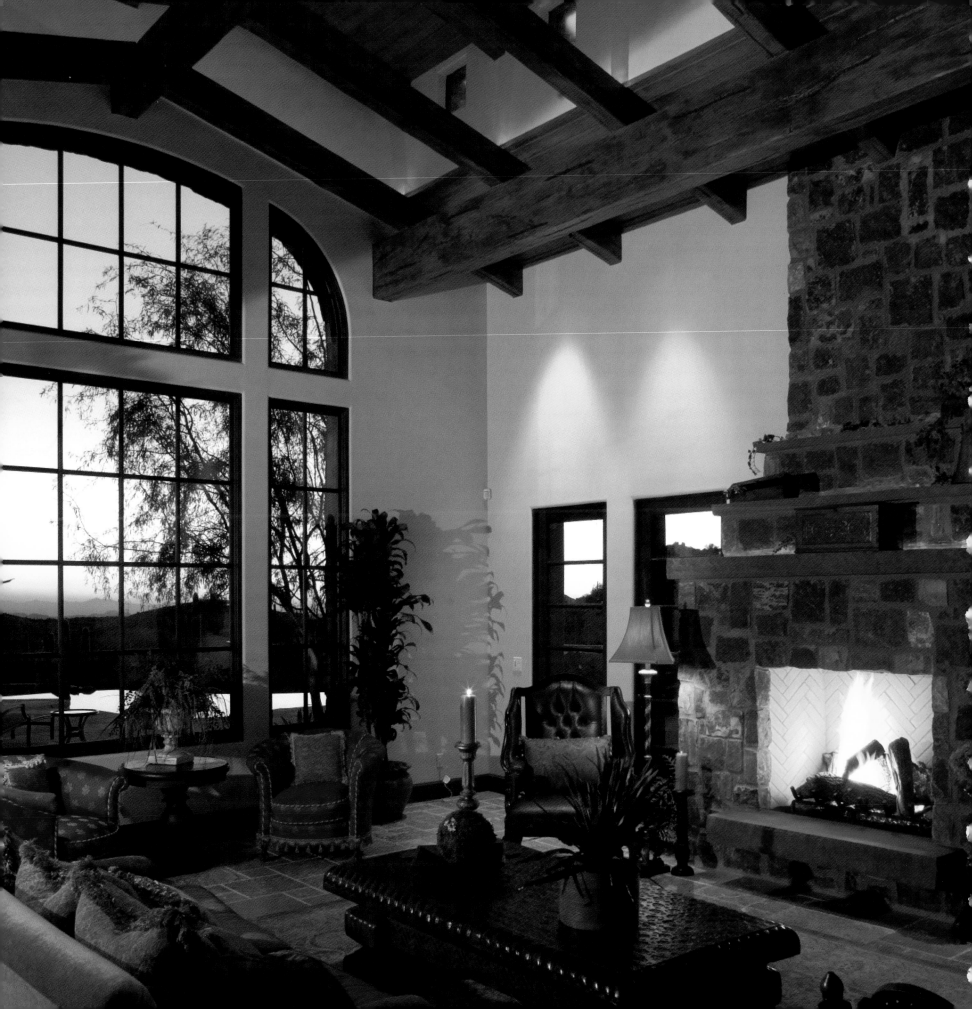

Mary Ann Hopkins

Room Service LLC

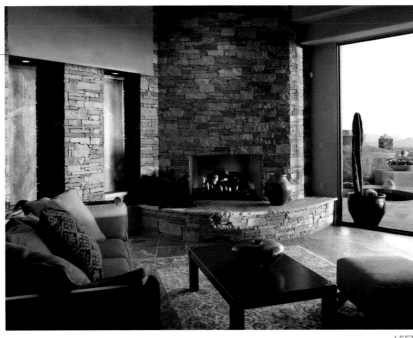

LEFT
Mary Ann designed the Tuscan interior for this home at Desert Mountain in Scottsdale.

ABOVE
The stacked-stone recessed water features create functional art for this Sunset Canyon home.

Friends and clients affectionately say Mary Ann Hopkins directs the "ministry of the interior."

A 25-year veteran of the profession, Hopkins brings to her firm, Room Service, deep religious beliefs, and with that a dedication to helping others, both professionally and outside her everyday work.

"My true passion, outside interior design, is my desire to help hurting people," says Mary Ann, who moved to the Valley 18 years ago with her husband, Rich. Here, she loves the peacefulness, especially the sensory richness of dawn on the desert.

This faith, and faith in her clients and people in general, derives as well from the breadbasket values of her Kansas birth as well as her wide traveling and broad education. After finishing college and graduate work at Kansas City Art Institute, she studied design in France and traveled widely in Italy, where she studied furnishings and art history, in particular, frescoes.

"When I meet with new clients, I really interview them rather than the other way around," says Mary Ann, who is assisted by three employees. "I listen to them and pull out the love and passion they have."

From this, she creates a design that is balanced and proportioned, true to her fine arts training—but she usually accomplishes this from the outside in.

"I start with the art, where so many other designers end up," says Mary Ann, adding, "Every house is like a canvas in which the art, against a soft color palette, speaks so eloquently about what is in its owners' hearts."

Room Service LLC
Mary Ann Hopkins
4815 E. Robin Lane
Phoenix, AZ 85054
480.419.0994
www.roomserviceaz.com

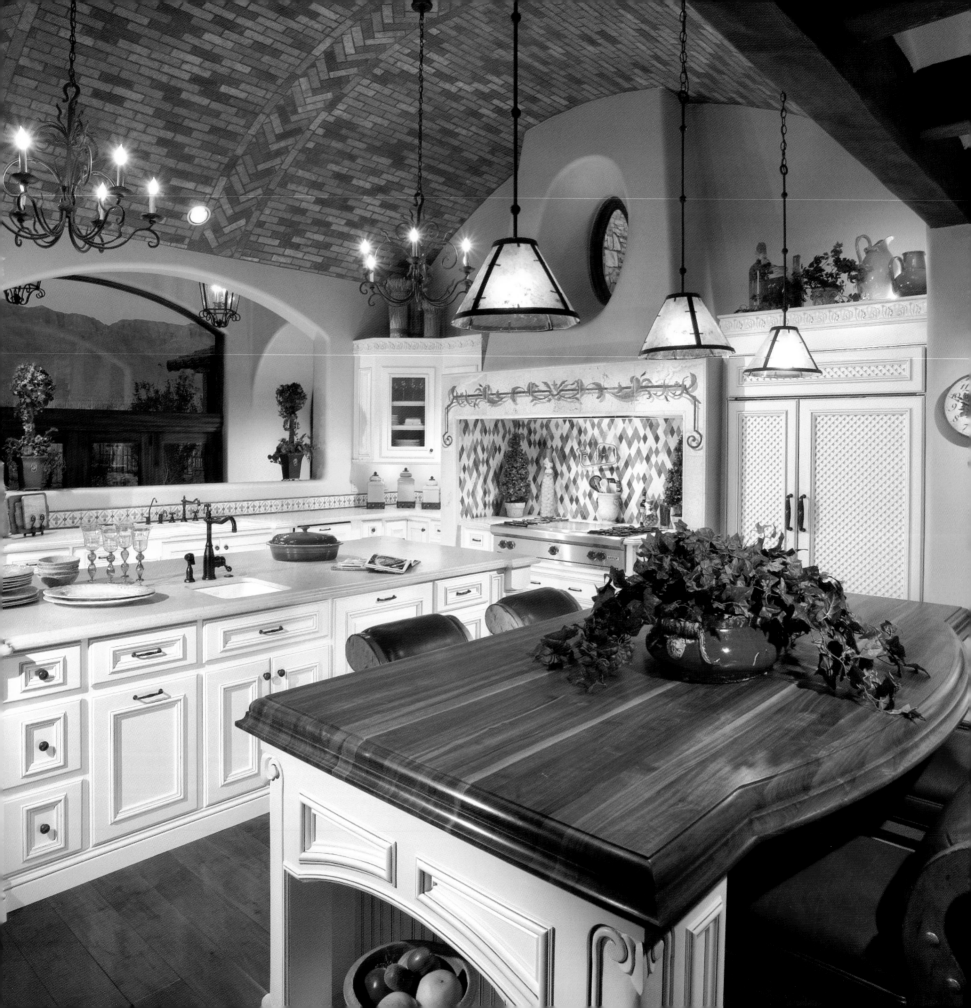

Sandra Kush
Devon Design Ltd.

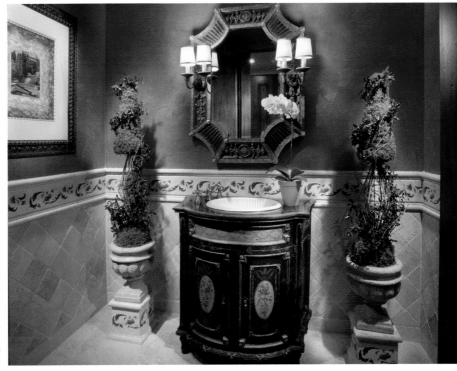

LEFT
Sandra provides a Mediterranean feel to this hard-working but beautiful kitchen. She accents with hand-painted travertine surrounding the Wolf range.

RIGHT
This truly Venetian ceiling is the highlight of this dining room. The groin vault arch is carefully detailed with hand-painted scrolls as well as the arched entry.

"Thoughtfully designed space is the ultimate luxury" has been the creative philosophy of Devon Design Ltd. since its founding by Sandra Kush in 1991. A native of Omaha, Nebraka, Sandra has been active in the Phoenix/Scottsdale interior design and new-home construction industry for more than 20 years.

Partnering with some of Arizona's finest architects and custom homebuilders, Sandra has created a variety of remarkable interior and exterior environments for her clients.

Recognizing that the requirements of her profession call for much more than the artful matching of fabrics and paint samples, Sandra brings to her projects an extensive background and thorough knowledge of her craft. Having partnered for more than 10 years with her husband in an award- winning homebuilding company, Sandra has acquired an extensive background of construction techniques, requirements and challenges. As a result, she has combined these construction skills with her extensive knowledge of materials, color theory and historical styling to provide her clients with a full complement of design services.

Working with new homes or remodels, Sandra has been able to assemble a cadre of highly skilled trades people, from trim carpenters to custom furniture makers, faux finish specialists, stone masons and numerous other trade disciplines, to ensure the proper execution of her design ideas.

"Integration of style and livability are key factors to a successful design project," she says. That belief is the reason Sandra completely analyses the project floor plans to ensure that such aspects as traffic flow, sight lines, functionality and

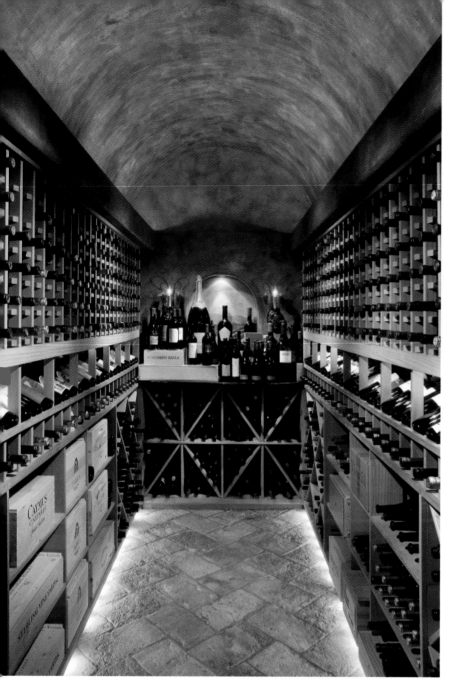

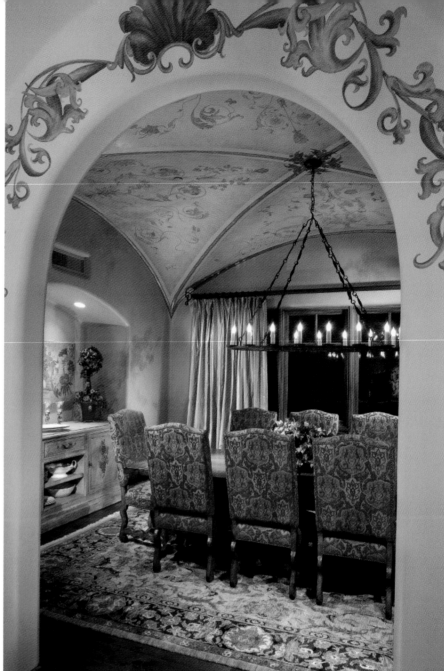

lighting are taken into account. In no room is this analysis more important than in the kitchen. It is not uncommon for Sandra to completely redesign a kitchen as it is this space where these important factors are most often not given proper consideration.

Another dimension to Sandra's talent is her expertise in the selection of exterior home elements to include roof material and color, exterior wall surface finish and materials, exterior lighting and hard-surface material selections. "The proper relationship of the exterior and interior materials and colors is critical to a

successful design solution," she says.

It is this level of detail and creative expertise that has elevated Sandra to the top of her profession. Sandra's design work, in fact, has been featured in numerous publications as well as television and special event tours.

As an Allied Member of the American Society of Interior Designers (ASID), Sandra serves on the board of directors of the Arizona North Chapter of ASID and has chaired several important committees and events for that organization.

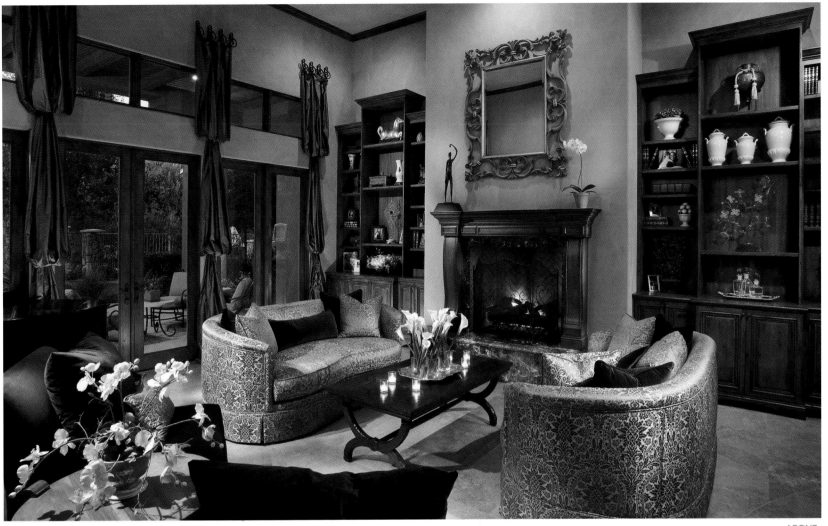

ABOVE
Sandra expresses Old World elegance with luxurious damask curved sofas, Venetian plaster walls, silk drapery and a magnificent fireplace.

FACING PAGE LEFT
A cellar any vintner would be proud to call his own includes Venetian plaster on the barrel vault ceiling and Ann Sacks reclaimed pavers on the floor.

FACING PAGE RIGHT
This truly Venetian ceiling is the highlight of this dining room. The groin vault arch is carefully detailed with hand-painted scrolls as well as the arched entry..

More about Sandra ...

WHAT COLOR BEST DESCRIBES YOU AND WHY?

Red: I am a foreground person not a background person.

WHAT IS A SINGLE THING YOU WOULD DO TO BRING A DULL HOUSE TO LIFE?

Paint can do wonders; color is the giver of life to a dull home.

IF YOU COULD ELIMINATE ONE DESIGN/ARCHITECTURAL/ BUILDING TECHNIQUE OR STYLE FROM THE WORLD, WHAT WOULD IT BE?

I would keep them all—they are all wonderful in their own ways. I would like to see more of a resurgence in Art Deco.

WHO HAS HAD THE BIGGEST INFLUENCE ON YOUR CAREER?

That is such an impossible question to answer; there have been so many people both living and dead that have shaped my career. Knowledge and exposure have had the biggest influence.

Devon Design Ltd.
Sandra Kush, Allied Member ASID
8150 N. 86th Place
Scottsdale, AZ 85258
480.596.6782
www.devondesign.com

101

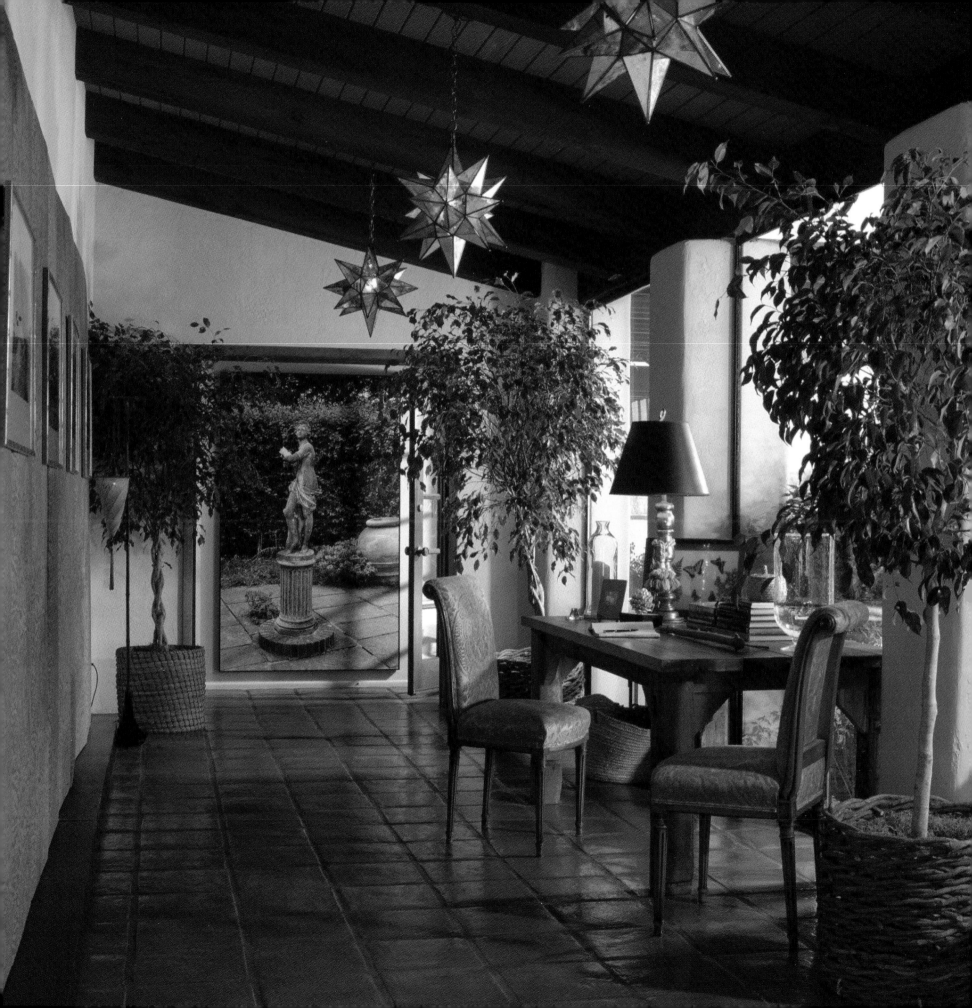

Christy Martin
Studio Encanto

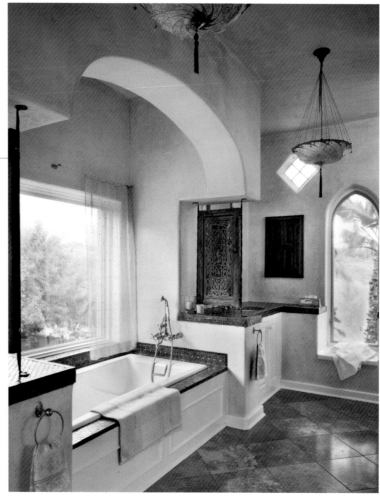

LEFT
A simple, classic design focuses on a spectacular garden view, making for the perfect writer's retreat.

RIGHT
To create a visage of an exquisite spa, this Venetian-inspired bathroom combines rustic marble, smooth, uncolored plaster, antique architectural pieces and hand-painted silk Fortuny lamps.

Christy Martin of Studio Encanto describes herself as a "Modern Romantic," creating interiors combining sleek, clean, contemporary elements with those that are old—and sometimes even eccentric.

Growing up in the Chicago North Shore, Christy was surrounded by beautiful interiors. "I have always loved beauty," she recalls. "As a child, I wanted to be an artist. I understood that I was happiest when I was creative."

She recalls, too, that her parents subscribed to *Architectural Digest* and that she "stopped everything" when it arrived. A dream fulfilled, a story about her design work for singer Linda Ronstadt's Tucson home appeared in the October 2004 issue, followed by a story on her own recently opened 6,100-square-foot warehouse/furniture showroom, which appeared in the March 2005 issue.

"I am grateful," she says of her successful 20-year career—all in Tucson, where she was educated. "Tucson has been good to me. And now that my boys are grown, I am thrilled to work more outside of Arizona." Current projects in California, for instance, include a 1928 Spanish Colonial redux in Beverly Hills and a sleek, contemporary glass box adjoining the ocean. In Tucson, she is working for one of the city's prestigious real estate developments, Saguaro Ranch, where lots start at a million-plus. "This project is incredible: The owner's very romantic vision is set in a remote, rugged desert landscape," she says.

Although high-end residential work has always been her forte, a variety of commercial projects are also challenging her and her staff of six designers and assistants. She recently finished Bluefin, producing a chic seafood bistro by integrating Old French with Contemporary details. Also in Tucson, she has just transformed an old brewery into an Asian-inspired Pilates studio called Bodyworks.

Christy adds, "I really love the idea of creating more public space at this point in my career. It's incredible to think about your vision shaping the background of people's memories. It definitely connects you to the world in a completely different way than the one-on-one experience of residential work."

Whether she is completing a residential or commercial project, she is always motivated to create beautiful, timeless interiors—regardless of the style chosen by the client. "I'm a purist who tries to understand the essence of a style and capture it," she explains.

"Whatever I do, I avoid trendy and confusing—an interior that is disjunct and doesn't know what it is," she continues. "We try to put together a design that is tasteful and does know what it is. All of the elements have to go together nicely."

Going together well doesn't preclude creativity, of course—a little bit of surprise and the unexpected, and tasteful hybridization. She may, for example, place a Renaissance chair next to a stainless steel parson's table—and then watch the heads turn.

Keep it crisp, keep it consistent, keep it beautiful: "I like clean lines, with attention to period details," Christy says. "The wonderful tensions between the two—the contemporary and the historical—make for individualized and long-lasting design."

ABOVE
The owner's collection of books and rare objects, housed in aubergine-painted cabinetry, is a library by day and an exotic dining room by night.

FACING PAGE LEFT
This poignant still life features a bucolic landscape, vintage Native American baskets and a Chinese trade jar transformed into a lamp.

FACING PAGE RIGHT
This dreamy master bedroom sitting area showcases a rare Peruvian cabinet from the 19th century.

More about Christy...

WHAT IS THE MOST UNUSUAL/EXPENSIVE/DIFFICULT DESIGN OR TECHNIQUE YOU'VE USED IN ONE OF YOUR PROJECTS?

In 1997, I designed a home for some clients using only the very best of everything: fabulous period furniture and light fixtures in custom wood-paneled rooms ... and Manuel Canovas fabric for the wallcoverings and upholstery. It's like a jewel box.

ANY AWARDS OR SPECIAL RECOGNITION YOU WOULD LIKE MENTIONED?

Numerous ASID awards for both residential and commercial work. Most recent award: Top 20 Designers in the United States by *This Old House*, October 2005 issue. Recent publications: Brunschwig & Fils up close: from grand rooms to your rooms (in 2005 book) and "Masters of the Southwest 2006" by Phoenix Home & Garden, Architectural Digest, March 2004, Linda Ronstadt residence.

WHAT IS THE BEST PART OF BEING AN INTERIOR DESIGNER?

Having your vision materialize into something tangible.

Studio Encanto
Christy Martin, Allied Member ASID
300 S. Park Avenue
Tucson, AZ 85719
520.624.1133
www.studioencanto.com

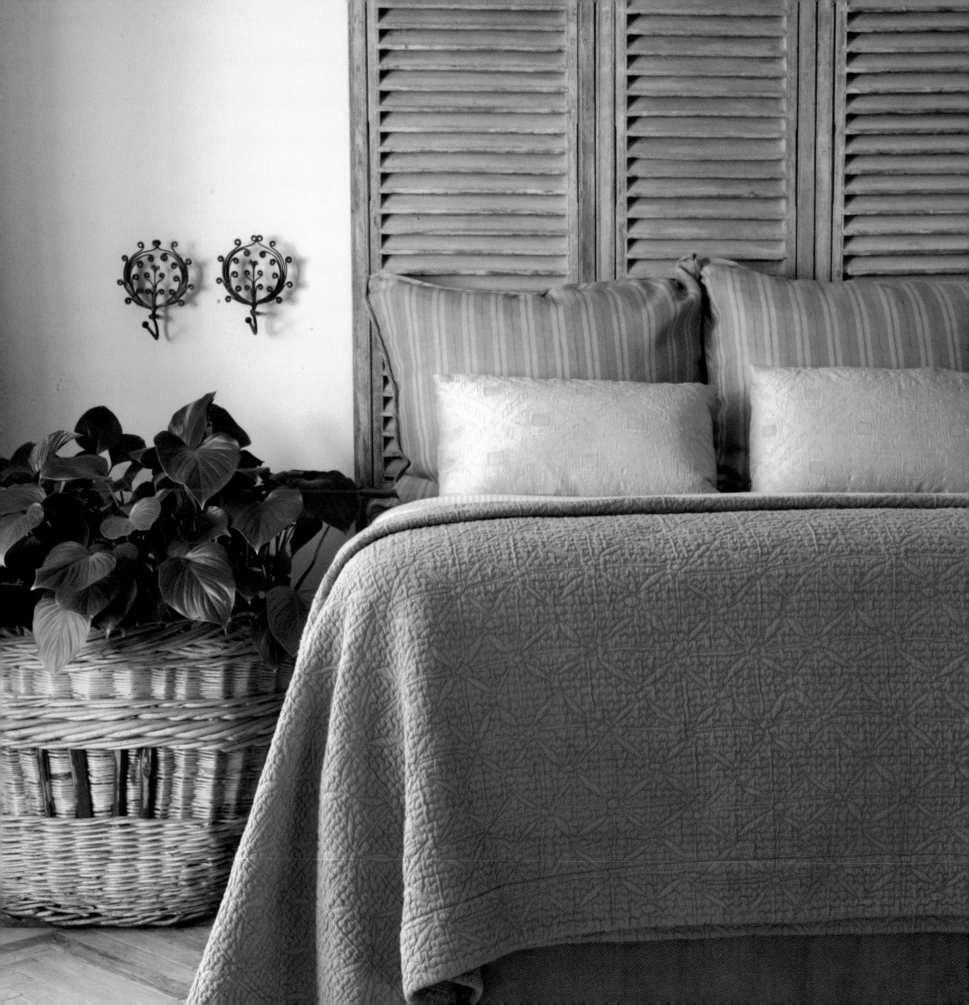

David Michael Miller
David Michael Miller Associates

LEFT
The designer's master bedroom features custom back and lumbar pillows in Rogers & Goffigon fabrics. Antique shutters, suggesting a window, provide a unique headboard.

RIGHT
For a unique, personalized space, the den incorporates artwork from Galleria Russia and an antique ladder.

David Michael Miller makes people feel at home by bringing them home—to themselves.

For David, one of the Southwest's most sought after and lauded interior designers, great interiors are those that have been edited of all superfluous detail and include only those elements that contribute to balanced and inspired spaces.

"I oftentimes think of myself different from many interior designers, in that I spend as much time thinking about what not to put in an interior as I do thinking about what to put in it," says David, now celebrating 23 years in the profession, 16 as the lead for the five-member David Michael Miller Associates. "For me, simplicity in interior design makes for clean, clarified and balanced space." These guidelines cover the wide stylistic variety of David's work—from traditionally inspired to more contemporary interiors.

Those lucky enough to commission David for their homes will likely visit the firm's striking two-story modular masonry studio structure in downtown Scottsdale. The deceptively simple building, designed by Arizona architect Wendell Burnette in collaboration with David, is beautifully articulated—an inspired and neutral space in which to work and design.

In written language, David explains, metaphorically, great writing is comprised of well-selected words, eloquently crafted and joined together to communicate a desired emotion. "Similarly, in design, I try to combine

color, scale, composition and texture to successfully create balanced and sensitive interiors."

David's commitment to "the basics" likely derives from a keep-it-simple Midwestern upbringing. Growing up in Illinois, he early succumbed to the principles and philosophies of Frank Lloyd Wright. David was especially inspired Wright's early residential designs, which so eloquently by domesticated the landscape of Middle America. "Wright's romantic writings of the prairie and of nature resonated strongly with me," David continues. "I was also taken by Wright's concept of using natural materials for their own intrinsic properties and beauties. Mr. Wright wrote at length of this dictum of 'truth in materials,' and that is a principle which has been central to my own work in interior design."

David Michael Miller Associates has distinguished itself by being named a National ASID Design Excellence winner for seven different projects— an unprecedented achievement. David's work has been published locally, nationally and internationally in numerous books and periodicals.

David Michael Miller residential interiors are honest and transparent: In addition to showing sensitivity to materiality, they also appear clarified, with only the active essentials showing. "The best interior space is that which is so finely tuned, so edited down," David says, "that those who experience it are unaware of its presence or its power and yet are nonetheless affected by its simplicity."

LEFT
Custom cabinetry, with Ashley Norton hardware, and concrete countertops create a functional, uncluttered kitchen.

RIGHT
The living room, on white oak parquet, includes an antique dresser with doors, two oil paintings, and a clean, unadorned staircase.

More about David ...

WHAT COLOR BEST DESCRIBES YOU AND WHY?

Warm neutrals for their soothing appeal and subtle effects. Also, indigenous color is inspiring to me, be it the palo verde green of the desert or the brilliant red/orange of an ocotillo bloom.

IF YOU COULD ELIMINATE ONE DESIGN/ARCHITECTURAL/ BUILDING TECHNIQUE OR STYLE FROM THE WORLD, WHAT WOULD IT BE?

I probably most deplore artificiality and contrived effects in both interiors and architecture.

WHY DO YOU LIKE DOING BUSINESS IN THE SOUTHWEST?

This is still a frontier in the disciplines of architecture and design and, as such, anything is possible, no matter who you are. A regional design and architectural identity is still evolving and being forged here. That is a unique and exciting place to be.

WHAT IS THE HIGHEST COMPLIMENT THAT YOU'VE RECEIVED PROFESSIONALLY?

I worked with a banker from New York on a new house in Scottsdale. When the project was completed, after a 30 month planning and building process, he said to me: "David—you are certainly expensive, but for what I got, you were cheap." I could not ask for a better comment from a banker.

David Michael Miller Associates
David Michael Miller, Allied Member, ASID
7034 East First Avenue
Scottsdale, AZ 85251
480.425.7545
www.davidmichaelmiller.com

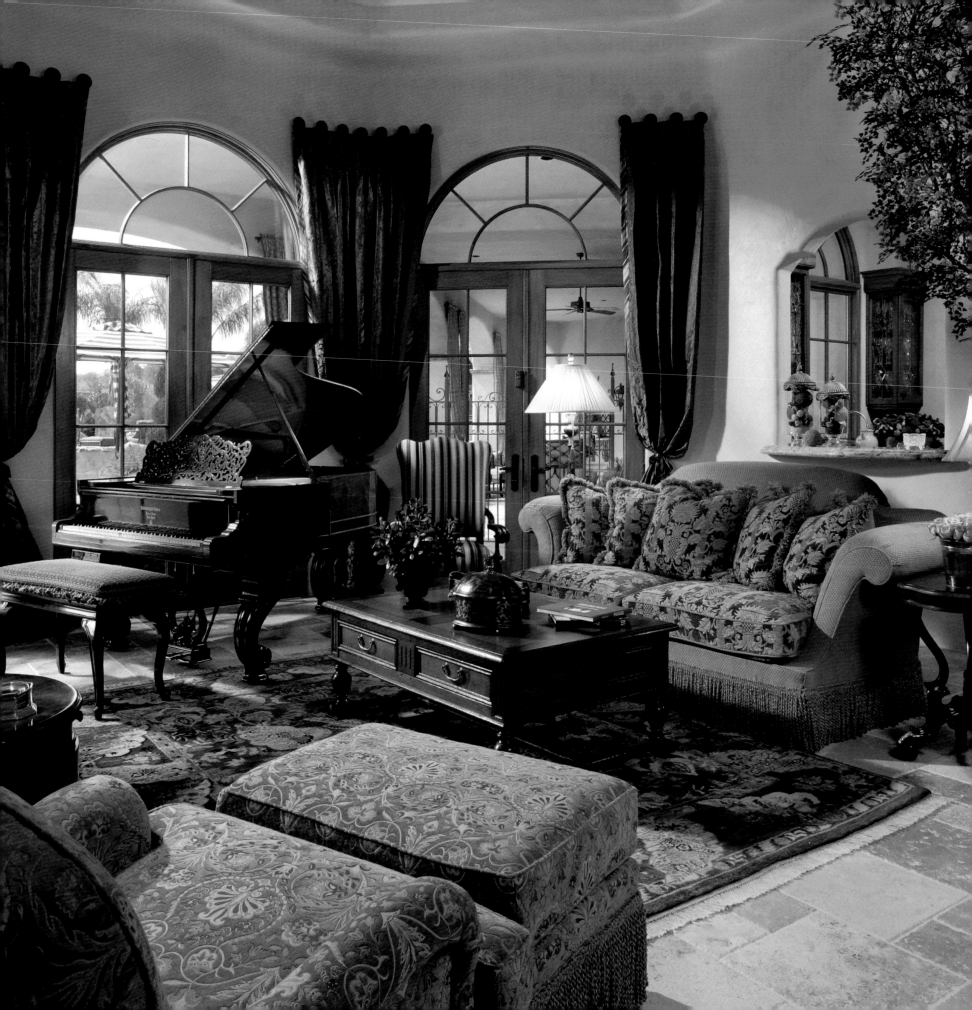

Charley Morrow
European Traditions

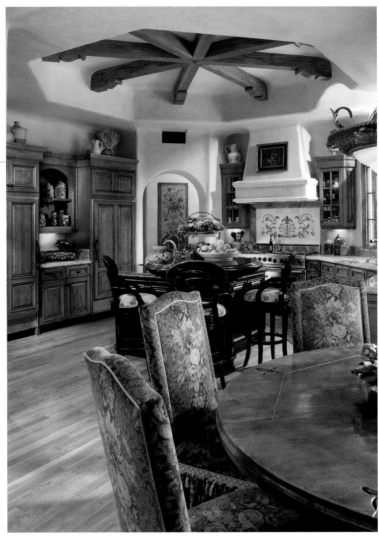

LEFT
Elegant European charm engulfs this luxurious living room setting created around and 18th century antique Steinway piano.

RIGHT
Kitchen and breakfast room Old World ambiance is enhanced by this reproduction fleur de lis dining table imported directly from England.

Charley Morrow has made European Traditions an Arizona tradition.

Born in Lancaster County, Pennsylvania, Pennsylvania Dutch country, Charley moved with her family to Virginia, where she attended school in Richmond, earning a bachelor's of fine arts degree from Virginia Commonwealth University.

Before spending six years in Europe, Morrow was already a veteran of the New York City design market where she worked as a model and production assistant for an agency that created commercials and worked with television shows.

She was drawn to Europe because of her modeling. There she lived in a variety of the fashion capitals, including Barcelona, Paris, and London. While in England, she returned to school to study decorative painting and also began working for photographers and painting murals—experiences that continue to serve her and her clients.

Moving back to the states in 1991, to Sarasota, Florida, Charley continued to paint murals and began combining her talents and experience into an interior design career. About this time, she visited Arizona and loved the climate and its climate of opportunity. "I knew immediately that this is the place I wanted to be," she recalls.

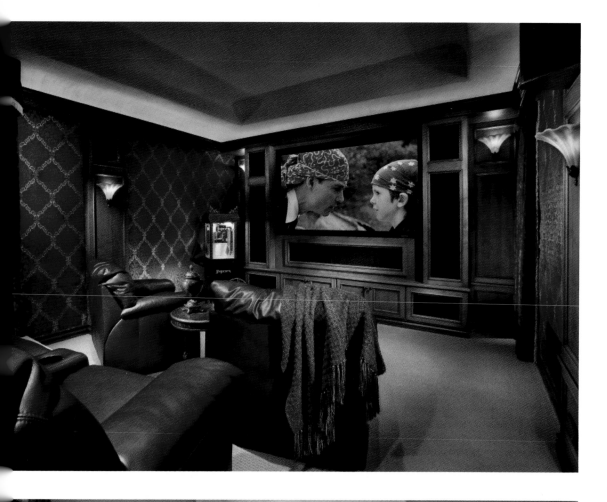

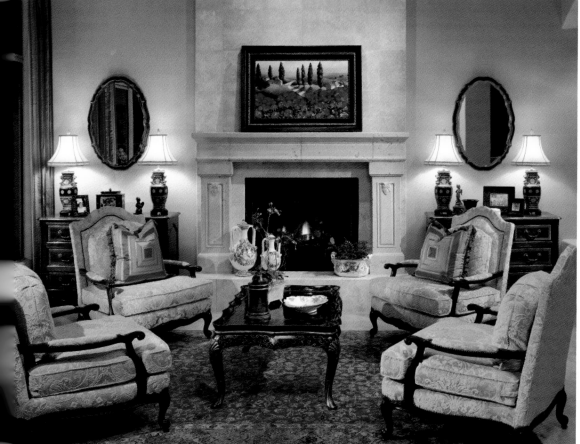

For the last eight years, she and her European Traditions team have brought Europe to the Southwest, with an emphasis on interiors that incorporate traditional with urban influences, custom-designed furniture (often by Charley herself), and integrated colors, textures and forms. "Each room is like painting a picture," the former muralist says. "Each room is a blank canvas waiting to be created."

To create the most sophisticated interiors for her clients, she imports her furniture directly from Europe, where she has established a strong relationship with a manufacturer as well as with other suppliers. Here in Arizona, her European Traditions team includes five interior designers, a floral designer, three carpenters and finishers and two office administrators. While much of her work is in the Valley, she has extended her reputation to other states, including Florida, Wisconsin and Montana, where she is working on other homes for previous clients.

"Most of my clients have many homes and come back to me for other projects," she says. "And that's why it is so important for me to keep them happy and do whatever I have to do to make that happen. I want clients for life."

Accordingly, from the first consultation, she builds long-term trust through candor, advice and good humor. While flexible with their needs, she encourages them toward classical, long-lasting interiors. "I tell all my clients," she says, "that if they stay away from trends, they'll be much happier in the long run."

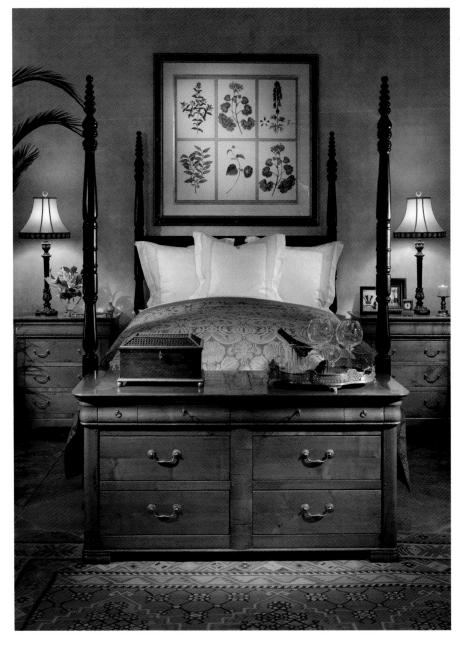

FACING PAGE TOP
The lavish walls of this regal theater are beautifully upholstered to create a warm seductive experience.

FACING PAGE BOTTOM
Chinoiserie cocktail table is surrounded by elegant bergere chairs creating an intimate conversational setting.

RIGHT
The transitional furnishings in this room help establish a sense of comforting richness.

More about Charley …

WHAT IS A SINGLE THING YOU WOULD DO TO BRING A DULL HOUSE TO LIFE?

A beautifully executed finish on the walls and trim; whether it is a paint, plaster or a faux finish, it must be done well.

WHAT IS THE HIGHEST COMPLIMENT YOU'VE RECEIVED PROFESSIONALLY?

When my clients give me carte blanche because they have complete trust in me.

WHO HAS HAD THE BIGGEST INFLUENCE ON YOUR CAREER?

I admire many people in the design industry, but my family has had the greatest impact on my career. Their love and support of what I do pushes me to better myself constantly.

European Traditions
Charley Morrow
15507 N. Scottsdale Road
Suite 135
Scottsdale, AZ 85254
480.348.1837
www.europeantrad.com

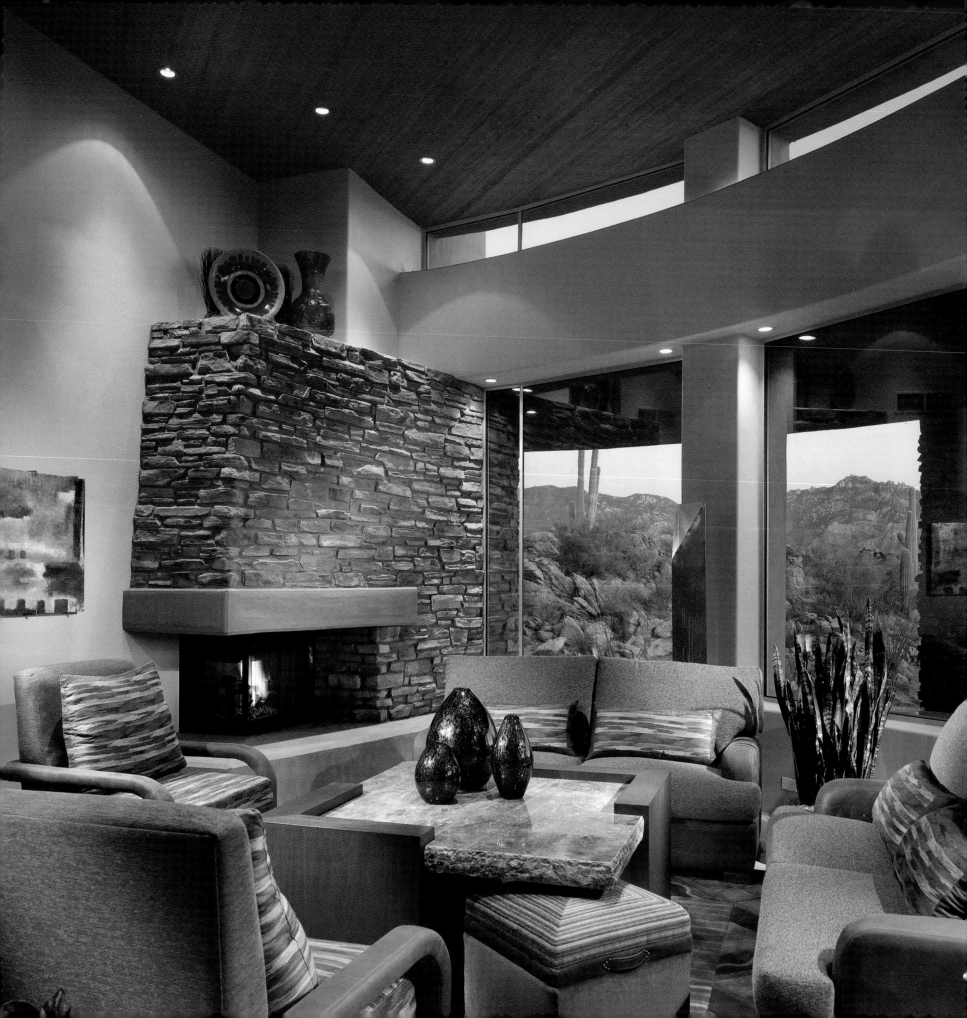

Anita Lang Mueller
Interior Motives

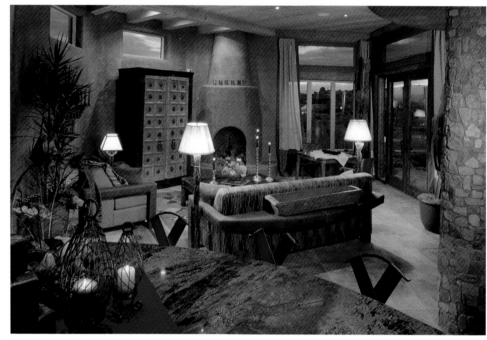

LEFT
The use of natural textures, such as wood, stone and metals, are implemented with simple, strong lines that take their cue from the home's architecture. The earthy color palette glows warmly.

RIGHT
Materials represent desert regions from around the world: Turkish stone floors, Australian granite and mesquite cabinetry. Commissioned upholstered pieces provide simple but strong lines which create juxtaposition with the antique and ethnic furniture and accessories.

Anita Lang Mueller found her gift in childhood. She remembers designing spaces as early as 8, and, respecting her innate talent, she has tenaciously honed and developed it into a widely acknowledged craft.

For 12 years in the Valley, her passion for great design has pushed her to create not just beautifully decorated space but spaces that are functional, comfortable and architecturally true. This is evident at the Interior Motives' elegantly wood-paneled studio and showroom in Fountain Hills, near North Scottsdale, where clients are regularly impressed to see what—literally—what may be in store for their next projects.

"I have always thought spatially, so when I am designing a room I am creating a mental image that includes all aspects of that room," she adds. This ability is particularly keen as she reads blueprints for pre-construction planning. "It is easy to adjust interior elements at this stage with eraser and pencil than it is later on during construction. A fireplace may need to be detailed for a stronger statement, or a wall can be moved for traffic flow, or an archway here can add to the charming spirit of the room."

Commenting on her design philosophy, she adds, "Good design has discipline. I have to edit through the million ideas that pop into my head until I chisel down to the very essence of the project." A perfectionist that Anita frequently reminds herself and staff: "life is too short for mediocrity."

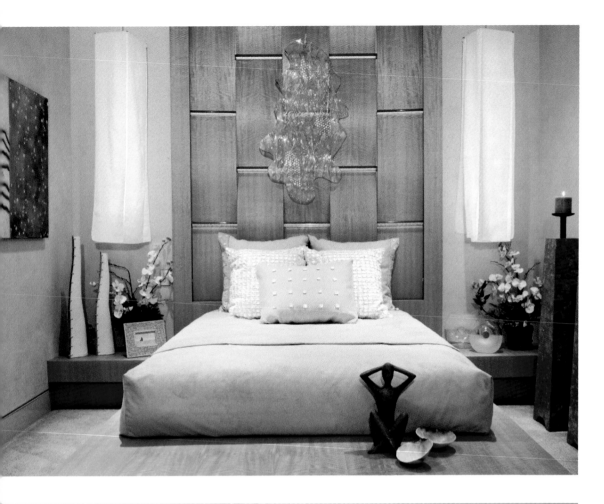

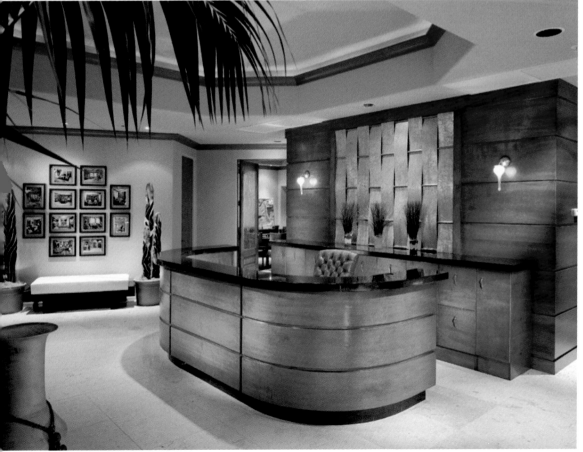

This comprehensive planning and attention to detail set her firm apart. "Our clients often comment after presentations how much detail and thought we have put into the design plan. We help our clients from conceptualizing their new home or remodel, through building—right down to accessorizing the coffee table with the perfect candlesticks." A current client's project binder emphasizes this: Just volume one (of two) is a 4-inch-thick binder with details from fireplace sketches and plumbing choices to door hardware selections. Many of the firm's clients, in fact, are referrals from architects and builders: These professionals appreciate the positive impact this service brings to their projects.

And their work has been appreciated. Anita and her staff have been widely awarded, with magazine features, appearances on television and ASID Design Excellence awards, including a first-place for Retail Design and numerous honors for custom furniture and fixtures in residential settings. Universally, the award committees have taken to her flexibility— her ability to produce superb showhouses, fixtures, furnishings and kitchens. "I would get bored doing the same design over and over again," Anita says. "I believe good designers should be

TOP
Clean simple lines are given drama in this custom bed clad with anigre wood veneer. Calming, sky-blue Venetian plaster walls are combined with natural elements.

BOTTOM
The office reception area has a strong visual element created by walls with horizontal paneling, granite counter tops, and an unusual weave of foil-clad wood and copper tubing.

RIGHT
The rich gem colors for the ceiling treatment were inspired by the frescoed ceiling of the Duomo's Piccolomini Library Room in Siena, Italy, dating to the early 16th century. The settee perfectly mimics the round cupola and general shape of the bath.

able to apply their skills and talents across different styles, while using their clients' dreams as their muse and the architectural vernacular as their guide."

Her adopted Southwest has been her muse, too—its materials and color palettes of granite, mesquite, ochres and earthtones, and the land itself, ruggedly beautiful. But, more, the West still provides an environment conducive to creativity and innovation. "Even without the covered wagons, it still has a pioneer attitude," she explains. "Although inspired by ancient cultures, it is a place still discovering itself and redefining its architecture. Just the landscape itself is inspirational."

Her work reveals this inspiration: One woman who toured a showhouse she designed complimented her, saying, "It makes my spirit soar."

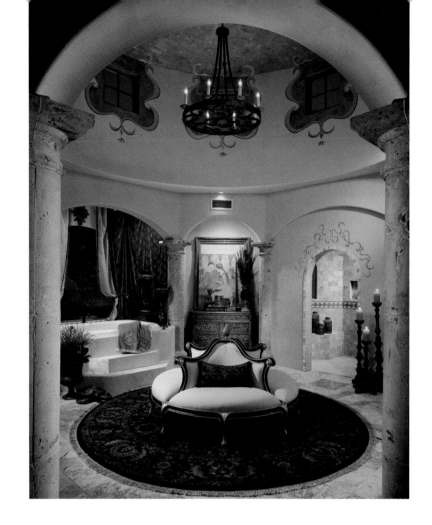

More about Anita…

WHAT COLOR BEST DESCRIBES YOU AND WHY?

Vermilion: Because it reflects the passion I feel for my design work, the love I have for my two girls and husband and my intensity for life.

WHAT IS THE MOST IMPRESSIVE HOME YOU'VE SEEN IN THE SOUTHWEST?

The Hopi House at the Grand Canyon. The way the late Mary Colter researched with sensitivity the Native American culture and implemented in a way to create an experience to any occupant. It's still effective.

IF YOU COULD ELIMINATE ONE DESIGN/ARCHITECTURAL TECHNIQUE OR STYLE FROM THE WORLD, WHAT WOULD IT BE?

The sprawling suburban tract homes. Doesn't everyone deserve good design—not just profitable square footage?

WHAT IS THE MOST UNUSUAL DESIGN OR TECHNIQUE YOU'VE USED IN ONE OF YOUR PROJECTS?

One unusual design is when I wanted to replicate the feel of our Southwest Canyon walls in a home that tributed the desert and its people. I had the walls, which were scoria (concrete and volcanic ash) pigmented in shades of earthy reds and golds and poured in layers. It wasn't until the forms were removed 30 days later that we could see if it worked. I loved it!

Interior Motives
Anita Lang Mueller, Allied Member ASID
16851 E. Parkview Ave.
Fountain Hills, AZ 85268
480.837.8979
FAX 480.837.5455
www.interiormotivesaz.com

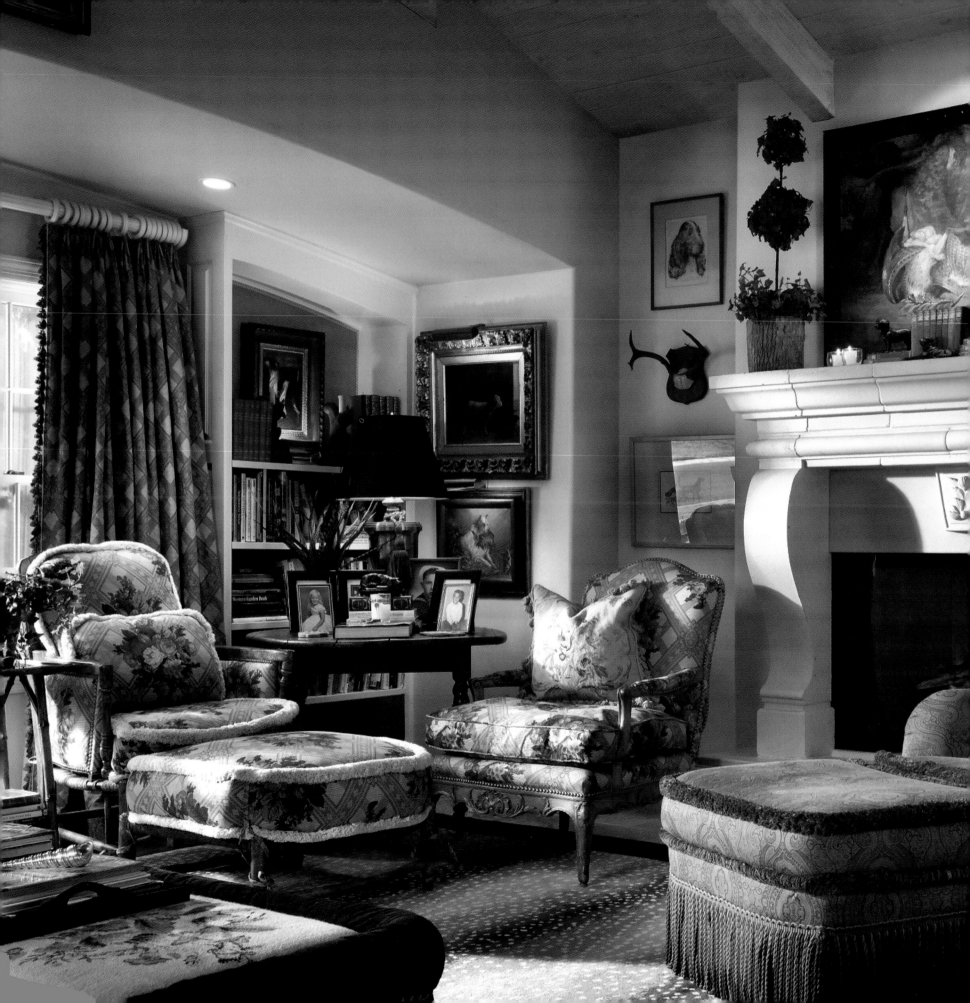

Teresa Nelson &
Kim Barnum
Nelson Barnum Interiors

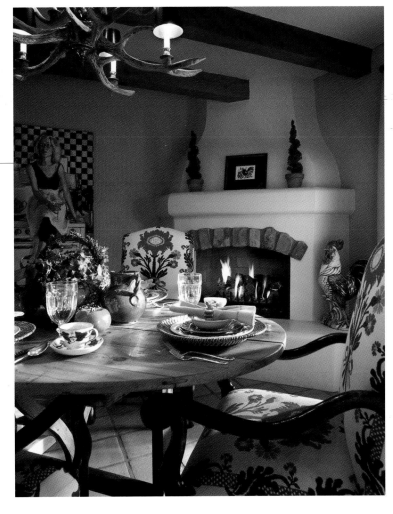

LEFT
Inspired by the homeowner's personal collections, this room
is a classic example of the balance of masculine/feminine and
elegant/relaxed.

RIGHT
An intimate dining space is enhanced with a classic Brunschwig
& Fils linen, contemporary paintings and antiques.

These two Arizona natives import Europe to the Southwest. For the past decade, Teresa Nelson, from Prescott, and Kim Barnum, from Phoenix, have united their skills and combined 41 years of experience to create Old World interiors with an emphasis on French Country. "We are unique in the Southwest with our French/English style, incorporating lots of fabrics, patterns and attention to detail," says Kim, who studied design at Point Loma College in San Diego and Mesa Community College as well as business at the University of Phoenix.

"We go to Europe each year to bring back antiques and collectibles to create homes with a well-traveled feeling," adds Teresa, who earned her degree in interior design and photography at Northern Arizona University and later served a design internship at the well-known Wiseman & Gale studio in Scottsdale.

Their Scottsdale studio is a showroom for their finds. "The thread of our look, our branding, is definitely classic European," Kim says. From some very special collectibles and furniture, the women have made and are making models that will become a line of signature pieces available through their web site. Current pieces in production include an English-style footstool; a handsome 19th-century-inspired settee; and, from a South African train station, a vintage bench that Kim and Teresa purchased on one of their buying trips.

Teresa and Kim met while working for designer Pat Hasbrook nearly 20 years ago. They respected each other's classic palettes and inspiration, and, in 1995, opened Nelson Barnum Interiors. Today, the firm has 12 employees, including designers Chris Benac and Norma Schulz—all dedicated to making people comfortable in their homes.

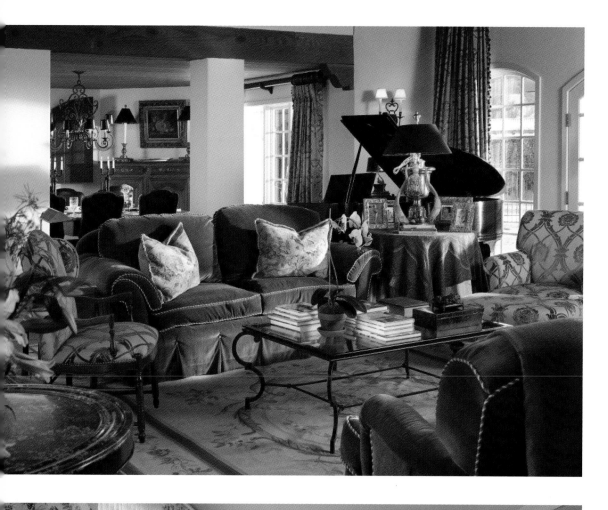

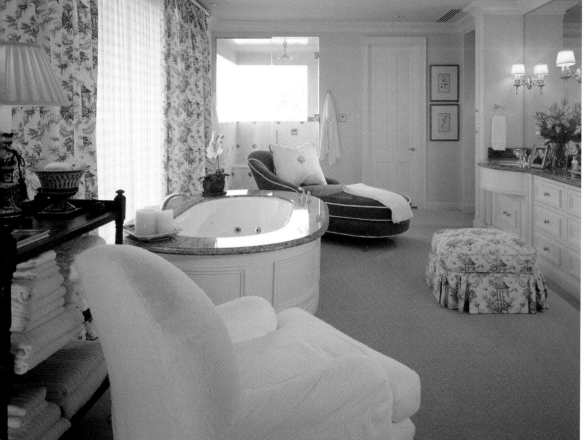

Through training and talent, each designer brings strengths to the business, which specializes in residential and high-end executive suites. Teresa's knowledge of art, architecture, and construction, with Kim's business perspective and design skills, create their distinctive style. Both agree that details make successful interiors. "Leave nothing to chance," Kim says. "The smallest details make all the difference in completing the finishing touches in a room, including the quality of materials, the use of appropriate size and scale, and the pure element of design."

The designers work with architects to create appropriate architectural elements for their clients' environments—features such as corbels, crown molding and wainscoting. In fact, in the historic Biltmore Estates they recently completed a 1940s home, maintaining its original elegance while including today's amenities.

"The most important detail is to reflect the tastes of the clients in their spaces," Teresa says. "Incorporating colors, styles, and collections and respecting the client's lifestyle should always be the starting point of a room." Recalling the design objectives of Nelson Barnum Interiors, Kim says that "for a beautiful home, it's really simple: Keep like items together and collect beautiful things that you love."

TOP LEFT
Inspired by the windows of Santa Barbara architecture, this refined yet comfortable space uses rich textures, needlepoint rugs and antiques.

BOTTOM LEFT
A nontraditional bathroom: Overscale upholstery and mixed beautiful fixtures create a spa-like atmosphere.

FACING PAGE
This room appears grand size but still maintains the warmth of texture and color that invites you in to gather with family and friends.

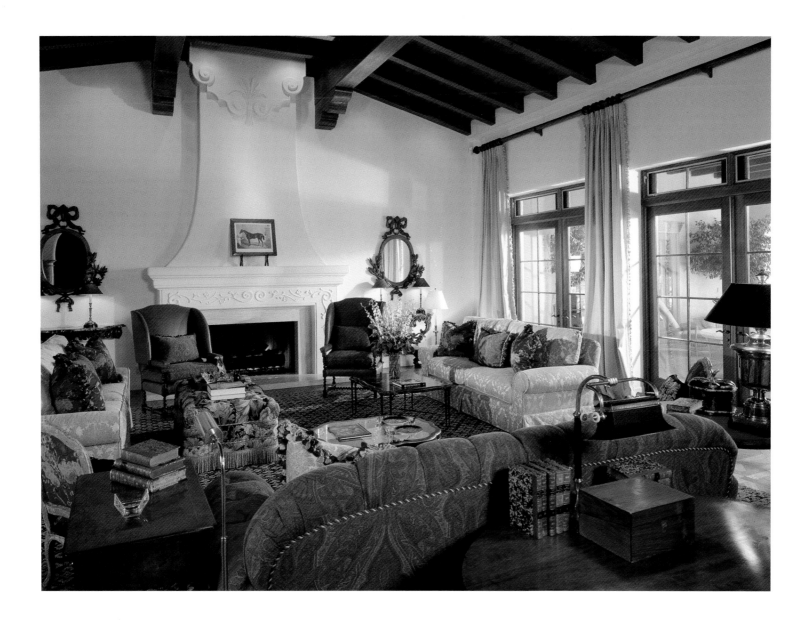

More about Teresa & Kim…

WHAT IS A SINGLE THING YOU WOULD DO TO BRING A DULL HOUSE TO LIFE?

Color, flowers, quality collections.

WHY DO YOU LIKE DOING BUSINESS IN THE SOUTHWEST?

Both of us being native Arizonans, this is home.

WHO HAS HAD THE BIGGEST INFLUENCE ON YOUR CAREER?

"Sister Parish" for her intuition, drive and motivation, and

Ralph Lauren for his style, presence and longevity.

IF YOU COULD ELIMINATE ONE DESIGN/ ARCHITECTURAL/BUILDING TECHNIQUE OR STYLE FROM THE WORLD, WHAT WOULD IT BE?

Bad interpretation of Tuscan and the stucco "McMansion."

Nelson Barnum Interiors
Teresa Nelson
Kim Barnum
7135 E. First Avenue
Scottsdale, AZ 85251
480.994.8919
www.nelsonbarnum.com

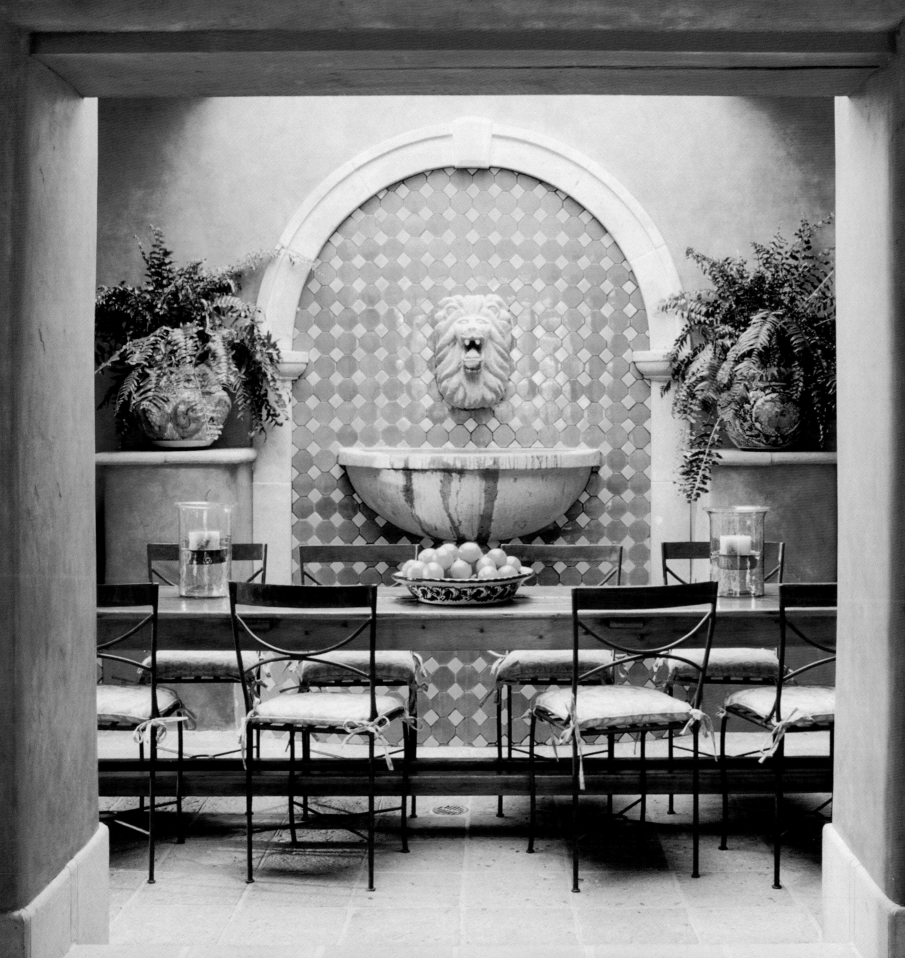

Deena Perry

Deena Perry Interiors & Collections

LEFT
Reminiscent of a Spanish town square, the dining room was created from the home's former patio. Just a few structural changes were needed: Deena removed the doors and added a roof (and a skylight) but kept the original tile floor. A dramatic fountain, surrounded by Mexican tiles, enhances the lively al fresco feel. Perry added the colorful walls for additional colonial appeal.

RIGHT
The Old World quality of this exquisite chest, with hand-inlaid details in contrasting wood tones, adds grace to any room.

Classic and no clutter: Deena Perry's interiors sit firmly between spare and sumptuous. "I strive for a strong sense of structured harmony and a restrained visual focus," says Deena, who has passionately designed interiors throughout the country for 25 years. "There is a fine line in design when less is too little and more is too much, where less is lacking and too much is diffused clutter and cacophony. Both create environments that leave people unnurtured and unsoothed." She adds, "The counterbalance and interplay of one item to the next creates the music, power, uniqueness and enjoyment that define our environment as they define and expand ourselves."

The Santa Monica, California, native, though, has distilled a lifetime of travel and professional experience worldwide. With an art degree, she started as a restorer of 19th-century and 20th-century American art. For three years, she was at the Dundee Museum in Scotland, working on its superb collection of 17th-century Flemish art. She followed this with a year in London. In both locations, collectors noted the quality of her work and invited Deena into their estates and castles.

"I would restore a painting for them—I even did a Caravaggio fragment once—and they wanted to feature it in their drawing rooms or dining rooms," Perry recalls. "Of course, it wasn't long before we were redecorating rooms and selecting antiques."

Transformed by this exposure to pre-industrial-age craftsmanship and age-old patinas, Deena established herself as an antiques dealer, which she eventually formalized by opening a store in Santa Fe.

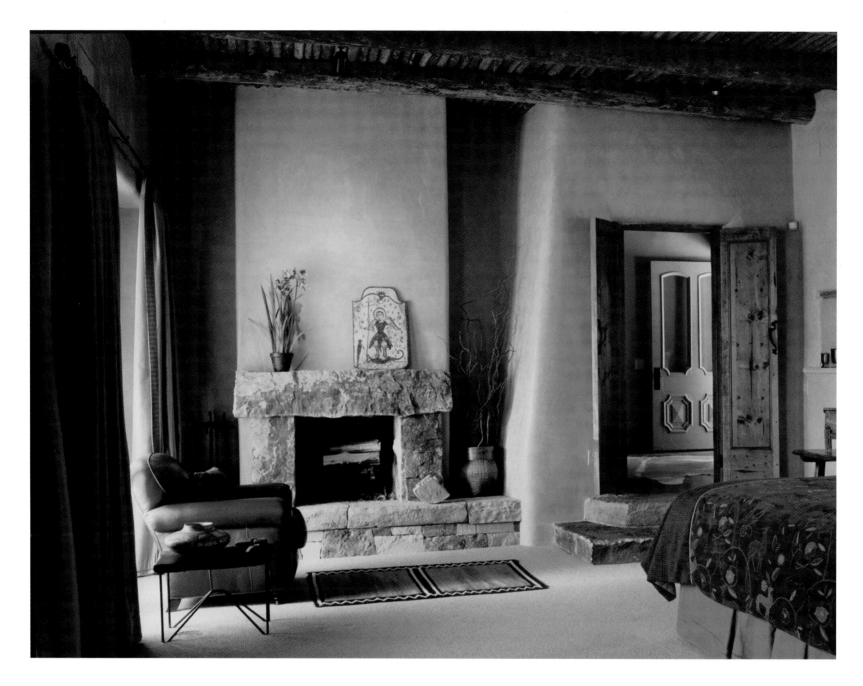

Making repeated trips to Europe, she would send back containers of Italian, Spanish, and English furniture from the Jacobean through the Georgian periods to her store—to be sold individually or to be incorporated into her interior design projects. "In my interior designs for homes and offices, I express this vitality of Old World aesthetics and my passions for antiques," says Deena, who is IIDA, state licensed, and widely published in books and national magazines. Developed with daughter Jamye Mannick, Deena's recently built web site is a resource for Old World, Tuscan and Mediterranean interiors—timeless environments with contemporary twists. "A life expanded by art, antiques, travel and education, has helped develop

my eye and my talents as I've built this new collection," she notes.

Because of the extensiveness of her travels, her mentors have not been designers but rather the designs in nature and the world, which continually provide her with new ideas. "Everything inspires me—whether it's the varied colors of a bird, the modeled patina of rusted metal or the gradient of colors on the wall of a canyon in Arizona, which I once used as a palette for wall colors in a client's home," she explains. "The exquisite interplay of light, texture and color that the world provides truly is my biggest influence."

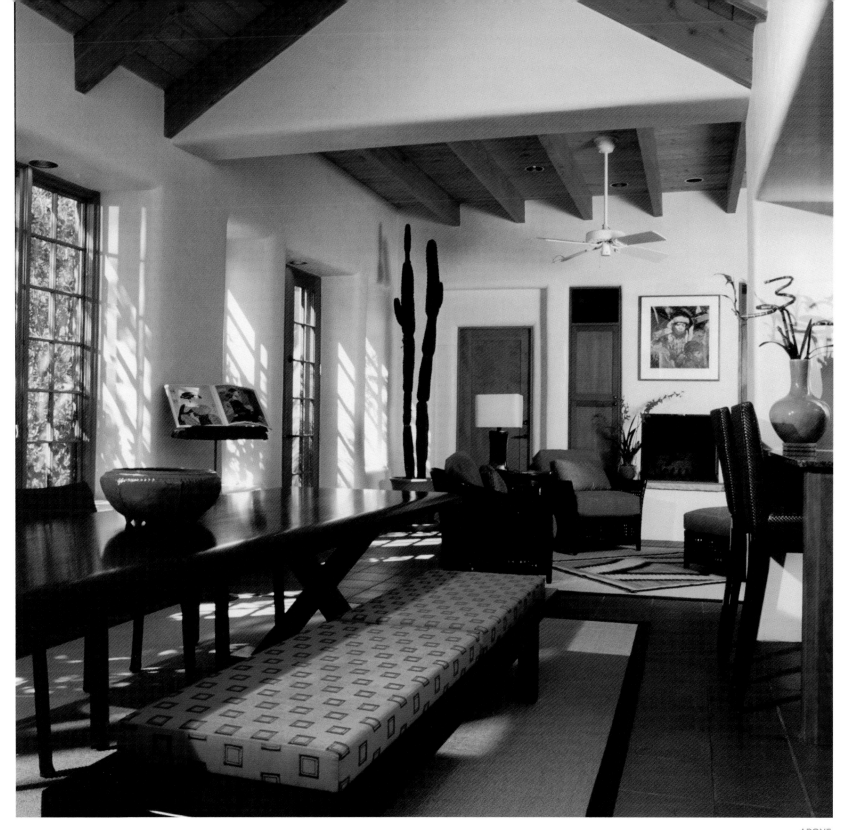

Deena has added colorful and bold fabrics to classic modern furniture in this dining/sitting area off the kitchen. Color keeps a modern approach from being too sterile or cold.

FACING PAGE LEFT
This interior clearly demonstrates Deena's design principles that a room should be made beautiful before anything goes in it. To provide an earthy serene environment, she designed the rustic fireplace out of a highly textured moss rock, which contrasts with the sensuously smooth colored plaster walls.

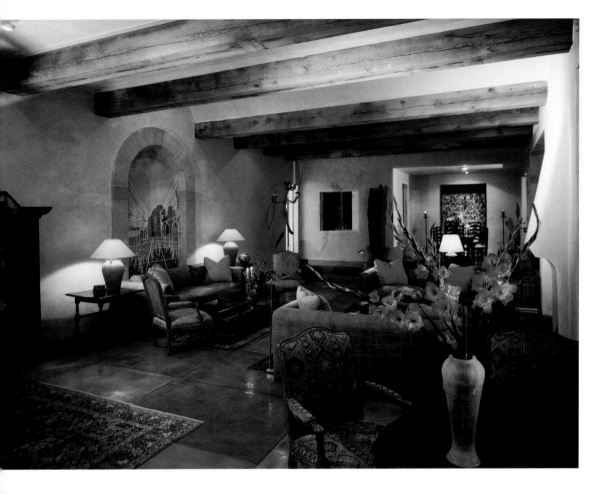

For Deena, one of the best ways to vivify a home is to add color. Color can enliven centuries-old or contemporary homes, muted and subtle interiors or bolder ones. "I sometimes use a full spectrum of color from light to dark, flowing from room to room as one walks through the home," she explains. Her travels, again, have been educative: "While in the colonial Mexican city of San Miguel de Allende, I became enchanted with the timeworn colors of the building facades. With no particular client in mind, I searched out the natural pigments that were used and later incorporated these pigments into a client's home in Santa Fe that was later featured on a magazine cover."

In addition to celebrating color, Deena encourages the dialogue between contrasting elements. In one home, she places a contemporary Holly Hunt dining table on a textured sisal rug; in another, she juxtaposes a moss-rock fireplace with a smooth, sensuous plaster wall. Integrating dualities, she mixes elements that are earthy versus urbane, warm yet restrained, contemporary versus Old World, charging her interiors with unexpected juxtapositions of materials and styles.

Her strong current of Old World inclinations are expressed in interiors of impressive variety as well as in her integration of scale and color with restrained dramatic accents. "Excellent design encompasses great taste and extends from many design styles," Deena says. Casual elegance, grace, wit, and charm can result from Bauhaus simplicity, Art Deco surprise or Palladian symmetry. "I strive to avoid trends and design for timelessness, to create interiors that will be as special and as successful 20 years from now as they are today."

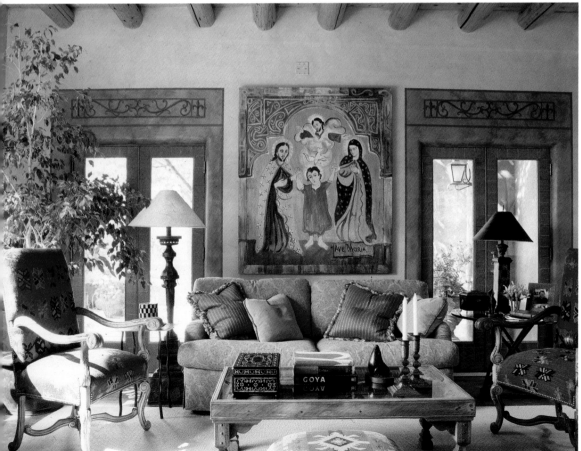

More about Deena...

DESCRIBE YOUR STYLE OR DESIGN PREFERENCES.

I am best known for my remarkable sense of color, along with a great sense of humor. I often laughingly quote an old Chinese proverb, "If you buy the best, you only cry once." I believe that my clients keep coming back to me because I have an innovative, timeless approach to design. The foundation for my design philosophy is classicism, whether the style is contemporary or traditional.

I try never to design a room that looks like it has been conceived at one point in time. It is too predictable and loses its humanity. Clients' homes should mirror their past travels, their family and friends as well as the interests they are passionate about. The homes I help to create become reflections of the multi-layered lives of my clients.

I believe that good design is that strange sophisticated blend of the varied aspects of a person's soul.

WHAT IS THE HIGHEST COMPLIMENT YOU HAVE RECEIVED PROFESSIONALLY?

The highest compliment I have ever received is that many designers look to my work for ideas and inspiration. I also feel that it is a very high compliment for my clients to continuously come back to work with me over the years as they have acquired new properties. One client commented, "Deena is delightful to work with. She has a talent for creating warm and inviting environments. She also elevates one's personal taste to a higher level. She works with you and teaches you along the way."

Deena Perry Interior & Collections
Deena Perry
256 La Marta Drive
Sante Fe, NM 87501
505.982.3722
www.deenaperry.com

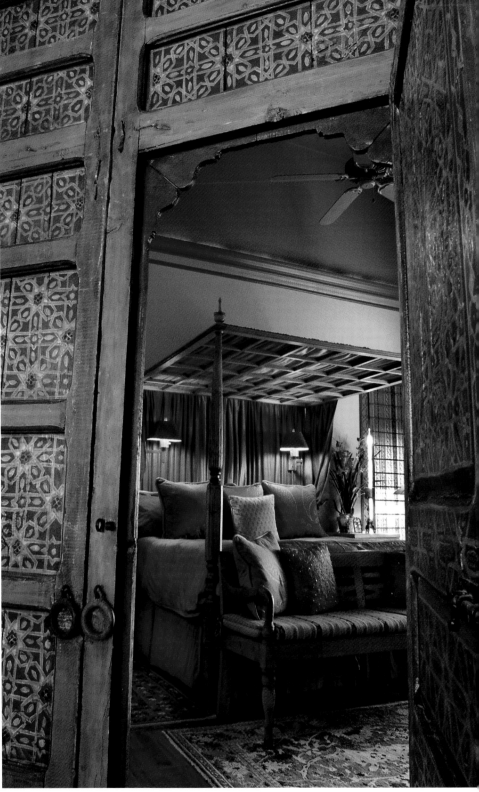

ABOVE
When the client wanted an 'exotic' bedroom, Deena found the antique Moroccan doors to frame the entrance into a room with silks, color, sexy lighting, and ethnic furniture.

TOP LEFT
Some interiors can exist anywhere or at anytime. The mixture of fine antiques with timeless upholstery and classic architectural elements provides the sanctuary the clients requested.

BOTTOM LEFT
Faux painting gives depth to the walls, tempering with bold colors. Over the living room couch, a vivid retablo, or religious painting on wood, is spotlighted. The upholstered chairs echo the deep reds and blues and add texture. The sofa is a softer contrasting touch.

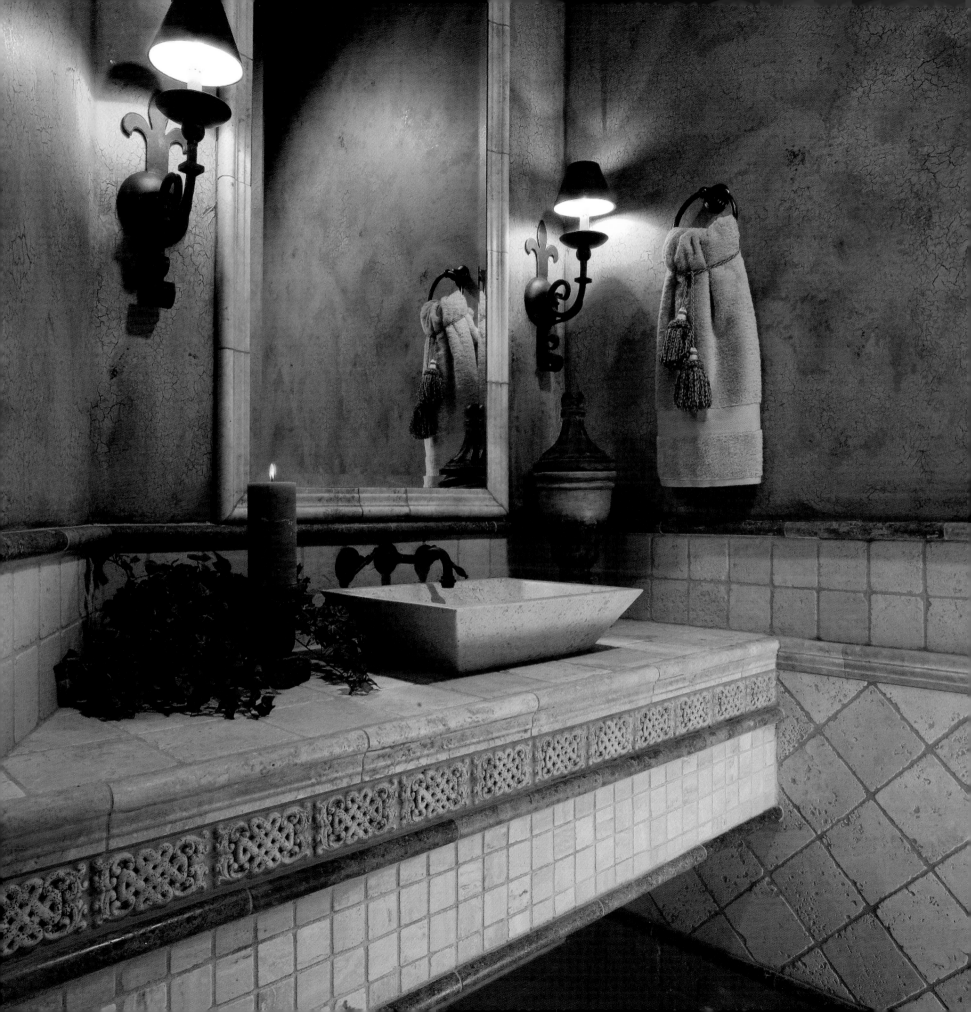

Robyn Randall

Robyn Randall Interior Design

LEFT
Interesting textures and patterns can be created simply by changing the size and position of the same materials in bathrooms.

RIGHT
Architectural embellishments can take an ordinary hallway and create drama such as when stone is applied to these archways.

Robyn Randall is quite an artist. However, she's not an ASID-credentialed interior designer simply because she is an artist. But those natural skills, and her architectural training, have helped to make her the well-regarded professional she has become.

For Robyn, now in her 23rd year as a designer and her 11th in the Valley, the process began in native Lansing, Michigan., when elementary school teachers recognized her artistic panache. While attending junior high and high schools, she trained in architectural designs and was awarded, but did not pursue, a scholarship to continue her architectural training.

She did pursue a retail fashion career. While the experience gave her an appreciation and love for fabrics, she realized that she wasn't satisfying her passion for art and design. So, after seeking the advice of her high school architecture teacher, she went on to a higher education to utilize those talents.

Today, that training tells: "I am able to do quick sketches as my client and I brainstorm ideas," she explains. "Being able to produce a visual drawing on-site is invaluable to my client relationships." Relatedly, she is proficient in AutoCAD, allowing her to quickly troubleshoot details on the front end—and save money for the client on the back end.

She's an artist, too, in staying small as a company and large as a communicator. "I work directly with my clients establishing personal relationships that continue long past the completion of the project. I want to focus on clients—not overhead," explains Robyn, a one woman firm since 2001.

Robyn Randall Interior Design
Robyn Randall, ASID
7904 E. Chaparral Road
Suite A110
Scottsdale, AZ 85250
480.213.9407
www.robynrandallinteriordesign.com

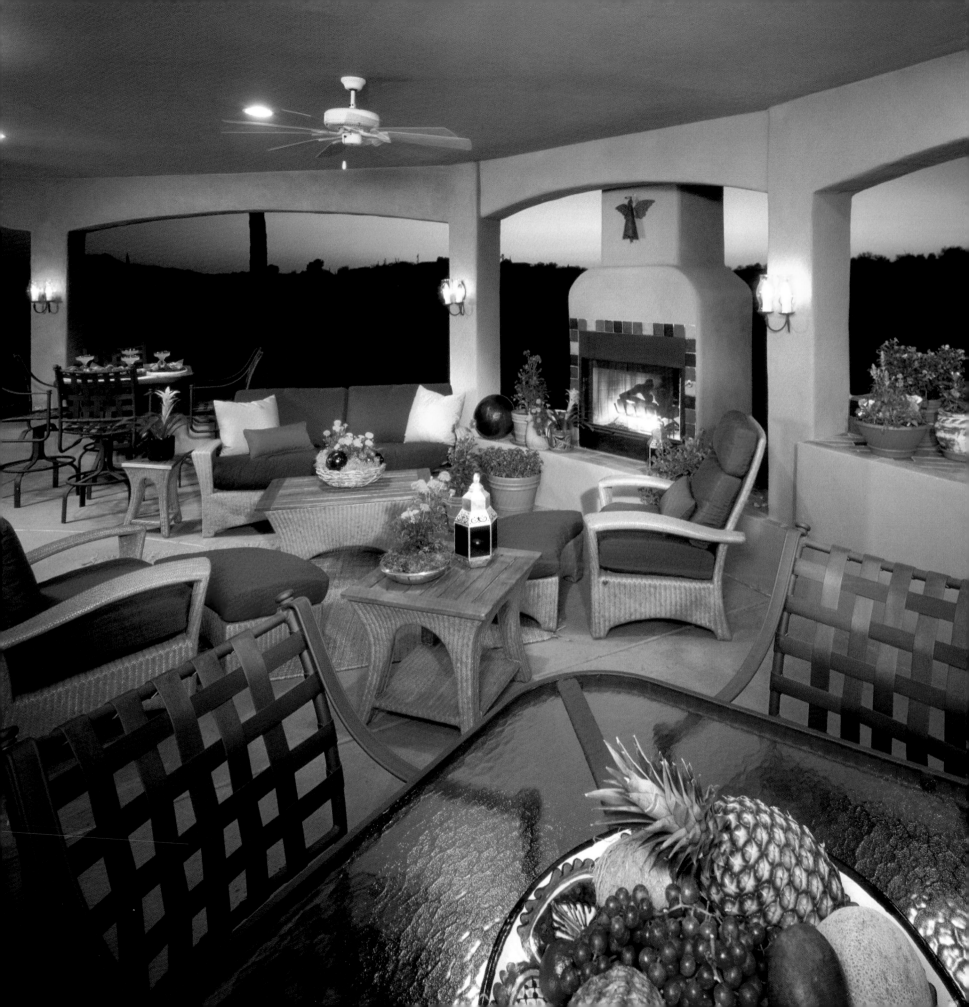

Liz Ryan
Liz Ryan Interior Design

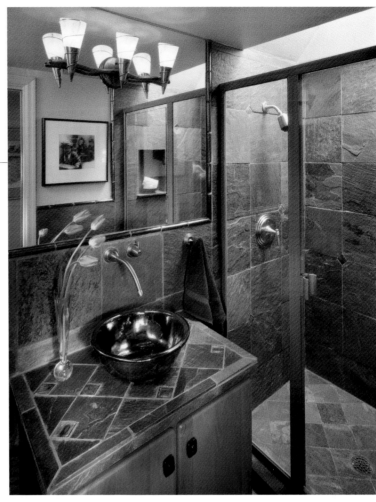

LEFT
Using a vivid color palette, Liz created a colorful and inviting outdoor area for entertaining that could focus around the homeowner's family and friends.

RIGHT
A symphony of textures, featuring slate, pewter, ceramics, elegant glass-tile accents and rich cherry wood, makes this small bathroom magical.

Liz Ryan has been an interior designer since 1989, when she and husband Dave moved from Telluride to Tucson. Here, Liz pursued her passion in Arizona, reschooling her design skills and assimilating the unique Southwest style. In the interim, she also picked up a commercial and residential contractors license—an invaluable asset in a profession that puts up as many walls as it tears down.

"I was born and raised in the South and have that ingrained on my soul," Liz says. Growing up in the South instilled in her respect for historical and family heritage—and for individual visions. "These early values," she recalls, "have been the structure for all aspects of my life and my professional career."

As a result, when she meets with clients, she welcomes them by banishing her ego. "I try to uncover unique and interesting aspects about the client's background, vision, passions and family life so that I can then interpret those into a personalized design." She adds: "I design for my clients, not for me."

Assiduously, but always with a smile, she and her staff then go to work. She is a University of Denver graduate with a creative, dedicated staff that includes a design assistant, who keeps projects organized and timely, and an administrative assistant, who keeps the business' wheels turning. "With the background laid I can begin infusing my design solutions into the project—whether it's contemporary, traditional, ethnic or regional," Liz says.

Looking at Liz's designs, you'll see a streamlined sunlit living room or a vibrantly colored outdoor entertainment area that picks up the palette of the desert sunset or two powder rooms, one crisp and minimal,

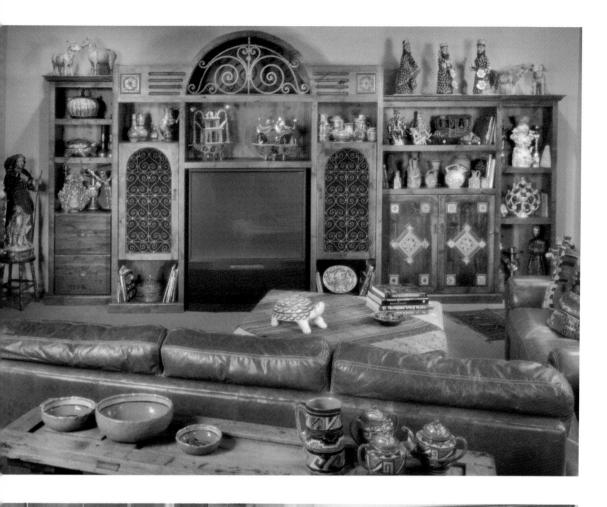

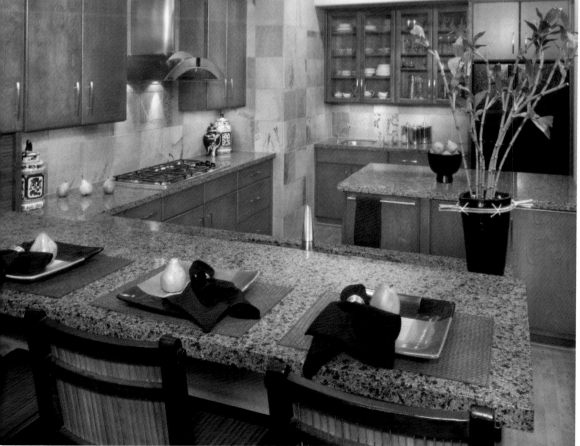

the other more textured and vibrantly colored. For these and other interiors, the ASID South Chapter has honored her with design awards, and local and national publications have featured her work.

Liz's well-choreographed interiors celebrate her clients' passions, collections and individuality. Accordingly, with fastidious attention to detail, she always stresses the importance of flexibility, of rolling with a project and adapting to its changing requirements and the importance of including the unexpected, so that interiors appear photogenic but not contrived.

These serendipitous elements may be an heirloom silver service on a contemporary tray or a piece of sculpture or a painting done by a family member. Liz explains: "We'll reframe it and adapt it. It becomes a wonderful focal point which the clients might not have thought appropriate but which carries so much special meaning." Similarly, she's creatively matted and framed art by children in the family. In each project, the result has been both sophisticated and personal. "If it's not warm and welcoming," she says, "it's not good design."

TOP LEFT
Liz designed a multi-functional wall unit to create the perfect backdrop, using antique metal grills and vintage tile for this eclectic collection of folk art.

BOTTOM LEFT
For a touch of drama, a contemporary stainless steel hood floats simply above the state-of-the-art countertop stove. Fossilized patterns within branched quartzite lend an intriguing backdrop to this kitchen focal point.

RIGHT
The leathered ochre finish of the walls, highlighted by a magnificent ceiling medallion, becomes the room's focal point.

More about Liz ...

WHAT EXCITES YOU ABOUT YOUR CAREER?

My career choice was a passionate decision. It has allowed me to push myself further and to blend my talents with my love of dealing with people. It has allowed me to become a more effective and positive role model for my 11-year-old daughter, Sidney.

WHAT PERSONAL INDULGENCES DO YOU SPEND THE MOST MONEY ON?

Travel: It inspires me and I learn from it.

WHAT COLOR BEST DESCRIBES YOU AND WHY?

I've often been accused of being a chameleon, and I consider that a compliment. One day I feel drawn to the rich yellow and amber tones, and the next day, for whatever reason, I can't live without red!

WHAT IS THE MOST UNUSUAL/EXPENSIVE/ DIFFICULT DESIGN OR TECHNIQUE YOU'VE USED IN ONE OF YOUR PROJECTS?

What began as a relatively simple kitchen remodel soon took on a life of its own. The kitchen expansion included extending one wall over a lower-level garage. When the walls came down, the most wonderful view of the mountains was revealed. The flood of natural light and this new view screamed "Roof Deck." The construction stopped, and we all scrambled to redesign the space, adding a stairway and deck, larger windows and completely reconfiguring the kitchen to accommodate these changes.

Liz Ryan Interior Design
Liz Ryan, Allied Member ASID
4525 E. Skyline Drive
Suite 117
Tucson, AZ 85718
520.299.2123
www.lizryandesign.com

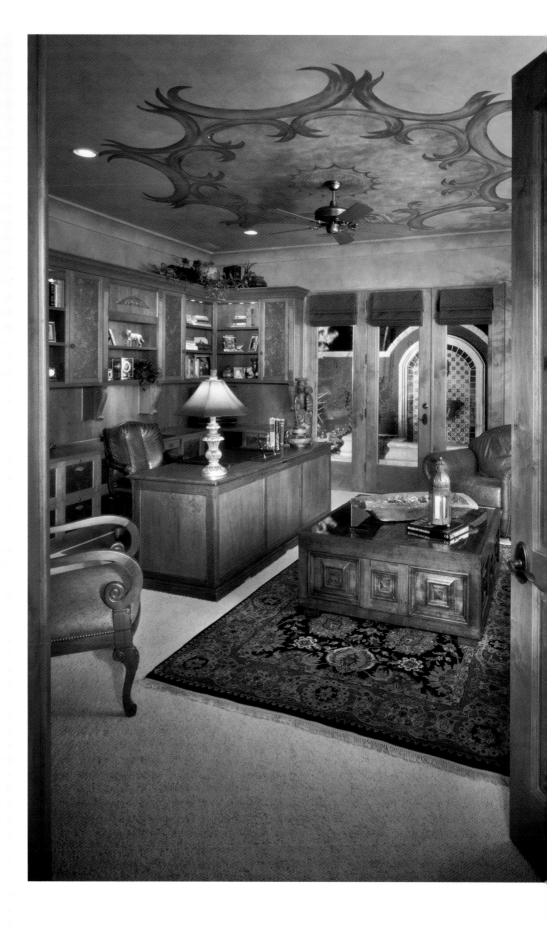

Carol Smith & Sandra Dana

Smith & Dana Associates, LLC

LEFT
The grandeur of this formal living room is highlighted by black-leather wing chairs and matching Chapman floor lamps. The desert comes inside as the large expanse of glass, which pockets into the walls.

RIGHT
This great room features the warmth of tooled-leather chenille chairs with custom woven bouillion trim and an antique reproduction of a Spanish bargueño, creating an inviting atmosphere.

When these partners look in the mirror, they often see a reflection of the other.

"It's almost scary," says a smiling Sandra Dana of herself and Carol Smith. "We're so much alike—in our values, our work ethic, and how we design—that sometimes we almost seem identical and joined at the hips." She adds: "We're able to sit down together and come up with a unified design—almost always without disagreement. With us, there's no ego. We're on the same wavelength." Together for the last five years, the two came from divergent backgrounds.

A Greeley, Colorado, native, Carol moved to Scottsdale in August 1988 with her husband Jim from Fort Collins, where she had begun her career as a designer a few years earlier. Prior, she was an accountant, trained at Colorado State University. "One day I said to myself that I no longer wanted to sit at a desk and push numbers around," she recalls. "It was boring and I wanted to be more creative." She had already been designing for friends, who were encouraging her to make the change—as was Jim. In 1990, she started a wholesale design business.

Sandra, on the other hand, started in commercial design in the late 1970s. A San Francisco native, she prepared for a career in psychology and art. The latter supplanted the former—although she says, chuckling, that many times the college training in human interaction has immeasurably helped in project maintenance. "My patience and intuitiveness have been great business tools: I can't tell you how much or how many times I've called on them." She and her husband were drawn to the peace and tranquility of the Arizona desert in 1993, and she continued her work in design.

Business, and destiny, united the women. "Sandra walked in one day and became a client," Carol recalls. Sandra also remembers the meeting fondly: "She was terrific, a pleasure to do business with." After Carol sold the business in 1995,

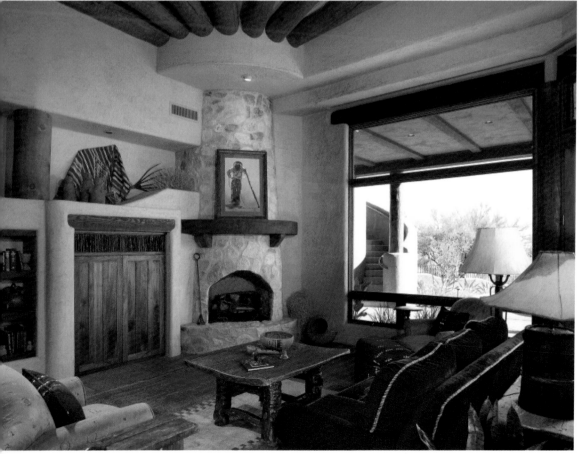

she remained working as a designer, and Sandra and Carol agreed to try some design projects together. After the success of these ventures, the two joined in 2000 to form Smith & Dana Associates.

Together and separately, it is not advertising but Carol's and Sandra's high energy and enthusiasm that inspire clients to work with them—and draws them back for repeat projects. Their one-on-one, hands-on relationships are built on a foundation of being quick studies of projects through visualization, communication and never passing off their work to assistants. "Many of our clients live out of state and remain comfortable with our making design decisions during their absence," Sandra says. "Because we are visual people, when we go into a home, we grasp an immediate concept of the space. For us, it's almost as if the room is talking to us." Both agree that they could not do without their design assistant Darcy Clement, who holds the office together.

From there, they strive to create a design complementary to the structure of the home, a design that will enhance its real assets. "The owners, after all, have bought the home for some reason, and we try to preserve the integrity of that environment," Sandra says.

If flexibility anchors their client relationships, versatility keys their design philosophy. Carol explains that they both enjoy the challenges of a variety of styles—from Spanish Hacienda to Contemporary Southwest. "If we had to pick one," she adds, "it would be combining a variety of elements toward an eclectic look that is casual and livable."

"Bottom line," says Carol, "we are a team. Some design partners work individually on their projects, but we bind together—on every project, every delivery, every installation. If we need to, we'll put on jeans and baseball caps and move furniture. We're not prima donnas."

More about Carol & Sandra...

WHAT COLOR BEST DESCRIBES YOU AND WHY?

Sandra—Yellow, because it denotes optimism.

Carol—Red, because it's vibrant and powerful, goes with any style and is never out of style.

IF YOU COULD ELIMINATE ONE DESIGN/ ARCHITECTURAL/BUILDING TECHNIQUE OR STYLE FROM THE WORLD, WHAT WOULD IT BE?

Sandra—The design style of superficially placing furniture or accents in a room because they appear to be the perfect design element for the space. An example is adding a piano when the client does not play.

Carol—Anything trendy.

WHAT IS THE MOST UNUSUAL/EXPENSIVE/DIFFICULT DESIGN OR TECHNIQUE YOU'VE USED IN ONE OF YOUR PROJECTS?

Sandra—We had to come up with a new design concept to renovate a private and established golf club. Satisfying the expectations of a large membership can present many challenges.

Carol—A 5-foot-round ottoman that separated into four individual ottomans on casters with pullout trays for drinks/snacks.

WHY DO YOU LIKE DOING BUSINESS IN THE SOUTHWEST?

Sandra—I have found that most people who transplant themselves from different areas of the country come to the Southwest anxious for change. That desire opens up new avenues for the client to break away from old traditions and allows the designer to be creative.

Carol—Desert sunset colors and casual lifestyle.

Smith & Dana Associates, LLC
Carol Smith
Sandra Dana
8711 E. Pinnacle Peak Road, #176
Suite D-102
Scottsdale, AZ 85255
480.585.5504

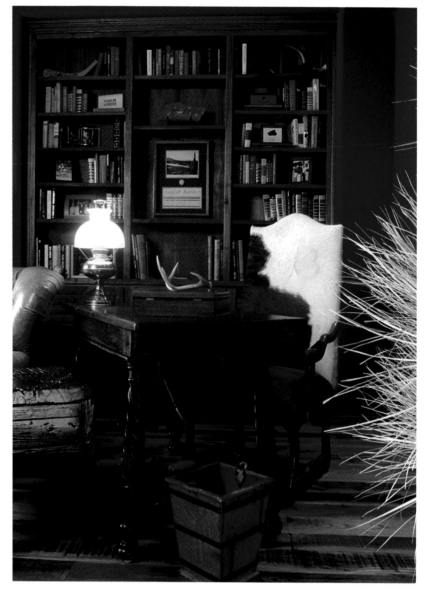

ABOVE
Cowboy charm completes the mood of the den/office, from the cowhide-upholstered desk chair to the very distressed antique mesquite floors.

FAR LEFT TOP
The charm of this Mexican hacienda kitchen began with the color palette on the old painted cabinet with the chickens. The kitchen features walnut cabinets, concrete countertops, an antique hanging chandelier and heavy-textured Venetian plaster walls.

FAR LEFT BOTTOM
Primary colors carry over into the great room starting with a one-of-a-kind Gabbeh rug placed on an upside-down saltillo tile floor. Note the use of an antique workbench with vise as an end table.

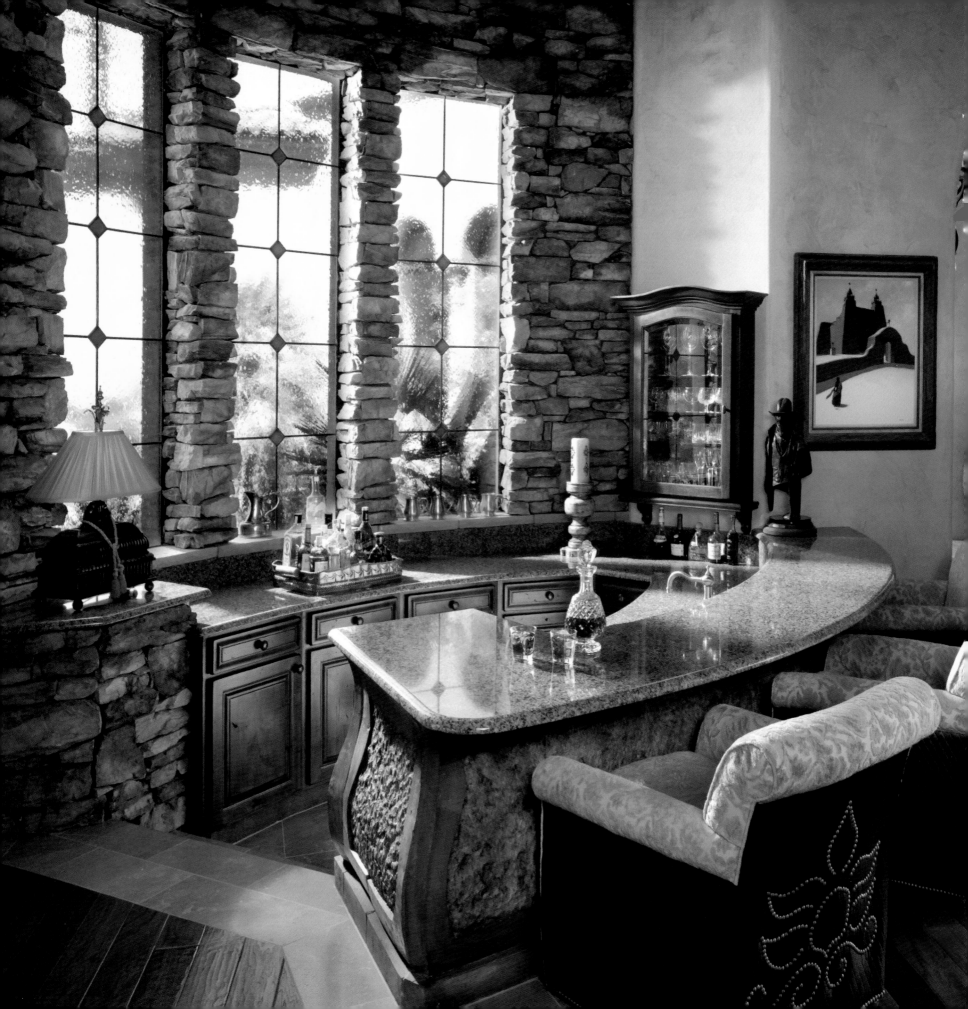

Tony Sutton
Est Est, Inc.

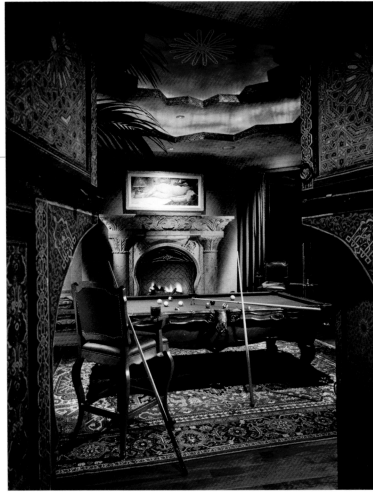

LEFT
The sunken wet bar of the great room has a carved Cantera base with a granite top and an inset sink that loosely forms an eclectic design with the curved bay windows. The custom windows have inset seeded-glass diamonds. The curved storage cabinet sits under the bay windows and holds a refrigerator and stock liquor. This area has an inserted wood floor with a travertine border. The bar stools are combination leather and fabric with a nail-head design.

RIGHT
The client found a pair of curved and painted antique doors in Morocco. They were hung as the 'entry gates' to the billiard room. To integrate the doors into this room, Tony floated a multi-tiered cut-out ceiling that repeats the design on the doors.

For almost three decades, Tony's Sutton's Est Est has made residential home design look as easy as "show and tell."

"At our studio, the client can see and touch most everything," says Sutton, Allied Member of ASID, who has been with or owned the distinguished company for 26 of his 27 years in the business. Est Est is the oldest interior design firm in Scottsdale—a significant attribute in a city well established as an important Southwest design center. And Tony, among his many honors, has received MAME Awards for Best Interior Design for custom and model homes and in March 2000 was named a "Master of the Southwest" by *Phoenix Home & Garden* magazine.

The expansive 12,000-square-foot facility in north Scottsdale includes a library, tile/wood sample departments, and a wide-ranging collection of high-end artifacts from around the world: English, French and Italian antiques, furniture and specialty pieces from Peru, Bolivia and Mexico, and Native American pottery.

Accessorizing to a regional style has always been a tradition at Est Est. Established in 1959 by William Benner and Patrick Maas, the firm worked closely with architect George Christensen to pioneer the Southwest style. "The true Southwest style is not a pure style at all," Tony explains. "It is an eclectic blend of traditions and crafts and handiwork that

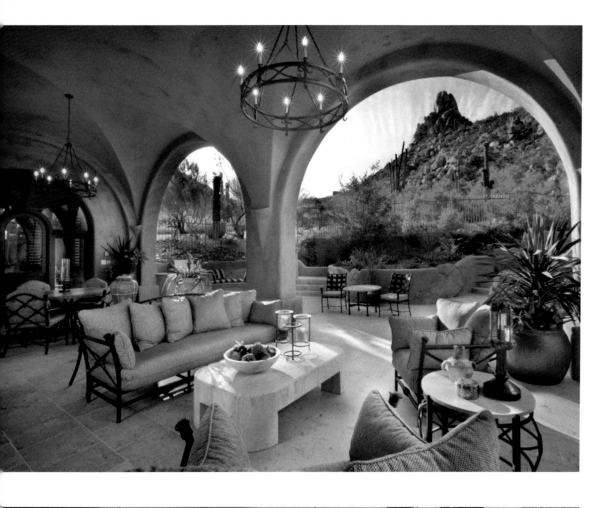

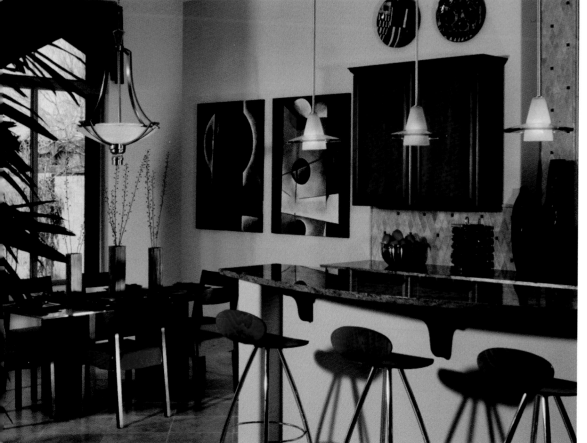

the early settlers, Spanish, English or others, brought with them." Hence, his and Est Est's regional celebration: "The Southwest is truly a melting pot of people from diverse backgrounds and design styles."

But, Tony cautions of historical treasures in general: "New isn't bad, and old isn't good just because it's old." Accordingly, he'll customize furniture to meet the needs of his clients—which are always paramount. "All of our designers create understated human-scaled atmospheres that reflect the clients' personalities and dreams," says Tony, a Champaigne, Illinois, native and Interior Design graduate of the University of Illinois. "We hope they don't scream, 'I am an Est Est design.'"

His staff of 30 includes 17 skilled professionals, some trained in CAD, others designers who work with the clients and even an in-house faux finisher. The firm involves itself in each residential project as an equal member of the client's design team—the architect, the lighting specialist, the graphics and artwork specialists, the landscaper, the electrical engineer, and the builder. In fact, because of its experience, Est Est is adept at coordinating the various disciplines and resolving concerns between them. "The power of intelligent design is evident in all of our projects," says Tony, who participated in an Arcosanti Workshop under Paolo Soleri in Arizona before joining Est Est in 1979.

In addition, as part of the firm's and wife Tracey's multi-faceted community involvement, Tony coordinates an Intern Scholarship Program with

ABOVE
The main patio off of the great room has an arch that frames Scottsdale's Pinnacle Peak. There is also access to the breakfast room to this patio. The patio has growing vaulted ceilings with Cantera flooring. The up-lighting is built into the plasterwork columns as is the built-in banco and outdoor grill. The chandelier illuminates the casual but comfortable outdoor furnishings.

LEFT
Pendant lights hang over this contemporary bar of amber fantasy granite with a simple plaster base. The bar stools are cherry wood with aluminum bases, and the table is a dark wenge table seating six.

Arizona State University and Scottsdale Community College. "Mentoring young designers is central to our tradition," Tony says. "This program helps the students learn what 'real life' design work is all about."

Personal attention, integrity, quality and skill are the principal components that make Est Est outstanding. Hence the name: The traveling monks of the Middle Ages would send scouts to reconnoiter towns for sleeping and dining accommodations. If the scout liked the opportunities, he scrawled on a building, wall, "Est"—"It is," "It'll do." But, if the scout thought the setting distinguished, he scrawled "Est Est"—"It is very good," "It is superb."

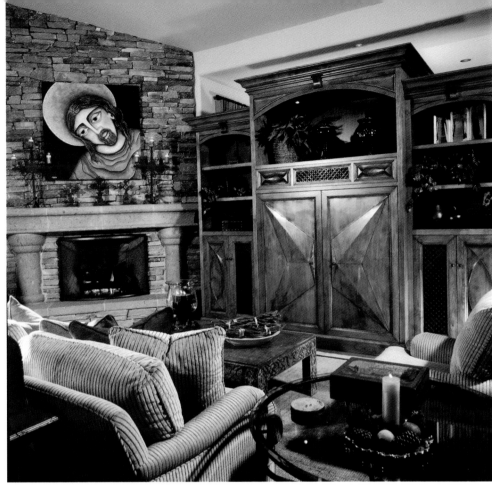

RIGHT
A segmented great room is divided by a custom wall that holds a two-sided fireplace and tandem storage units as well as a hidden entertainment unit, fronted by comfortable easy chairs for lounging, reading and watching television.

More about Tony ...

WHAT COLOR BEST DESCRIBES YOU AND WHY?

Black makes every color look better.

WHAT ONE ELEMENT OF STYLE OR PHILOSOPHY HAVE YOU STUCK WITH FOR YEARS THAT STILL WORKS FOR YOU TODAY?

The Est Est philosophy has always been to be fair and equitable to the client, to our vendors and to ourselves. This litmus test has served us well over the years. Another idea that we stress to our design team as well as to the clients is that there is more than one way to do a design and have it be a good design.

IF YOU COULD ELIMINATE ONE DESIGN/ARCHITECTURAL/ BUILDING TECHNIQUE OR STYLE FROM THE WORLD, WHAT WOULD IT BE?

As a competent, professional designer, you look to appreciate all styles; to

bring out the best in each design element; and, to avoid or diminish the negative aspects of any style or technique.

WHAT IS A SINGLE THING YOU WOULD DO TO BRING A DULL HOUSE TO LIFE?

The simplistic, most obvious, answer would be "color." However, in my opinion this answer is for the television or newspaper quick-fix article. Est Est has always found that to make a house come alive, we must focus on the client. It is the owners' personalities that will bring the house to life and make it sing. Therefore, we strive to infuse and integrate aspects of the clients' characters and lifestyles into the design theme.

Est Est, Inc.
Tony Sutton
17770 N. Pacesetter High Way
Scottsdale, AZ 85255
480.563.1555
www.estestinc.com

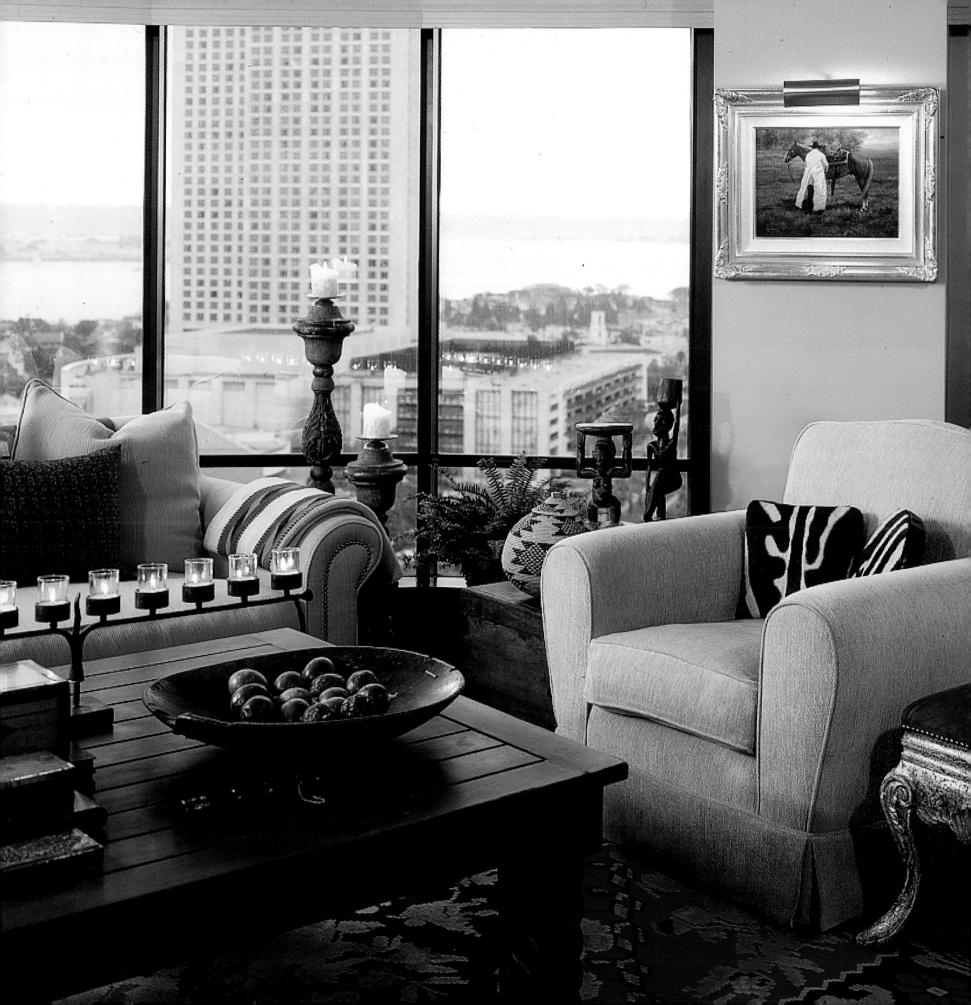

Jo Taulbee
Taulbee Design Group

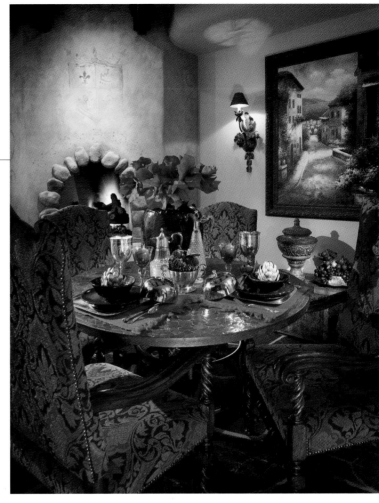

LEFT
One of Jo's urbane urban projects: a living room looking toward San Diego harbor.

RIGHT
This breakfast room includes a red-tile tabletop, a tapestry chair and antique accessories.

Let the imagination roam as a result of travel: That's how Jo Taulbee keeps her interior designs crisp and distinct, unique one to the next.

"Not everyone knows this about me, but I have a well-developed sense of adventure traveling to out-of-the-way places," says Jo, principal of Scottsdale's 18-year-old Taulbee Design Group.

No surprise, then that her favorite color is red, firing the spirit and the senses.

In life and practice, Jo is always racing to accomplish and to create. When she's not working on a home, she's leaving in search of new adventures. She sends back antique artwork, fossils, fabrics and other artifacts, which she either keeps or incorporates in plans for her clients. In addition, she purchases books from each area (though not always necessarily in English).

"In the past few years, I've brought back silver trays and fabrics from Morocco and artwork from Turkey," Jo says. With them, she is able to accessorize as well as create unique patterns and palettes for her interior designs.

While recently in France, she shipped back natural pigments. "I said to my clients, 'Let's use the colors from these pigments and translate them into color themes for interiors and fabrics.' They were very excited about the prospect."

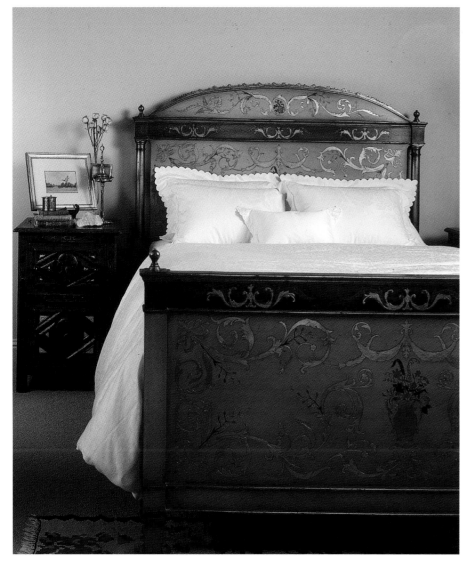

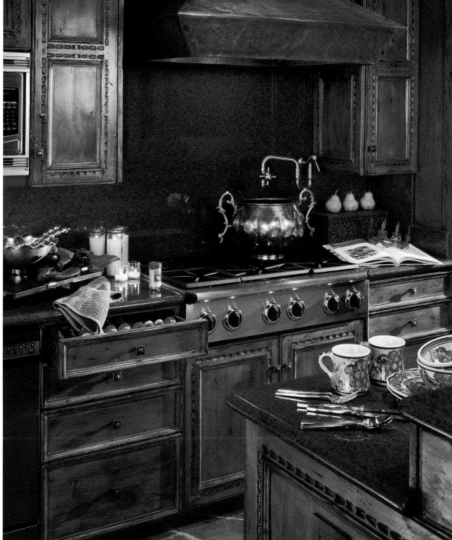

The Southwest provides a vibrant site for her work: Its diversity of people, styles and colors continually offers an expanding palette of opportunity. "The area seems to draw people with new skills and new ideas, who carry with them a promise for the future. It allows me to create fully and freely."

Two avocational passions ignite the passion that is her design career: photography and traveling. The latter is a continuing experience that expands her designs. While recently in Barcelona and Istanbul, she picked up various books on styles and the history of the areas. She also purchased a novel set in 19th-century Barcelona, which described the locations she had just visited.

The warmer, desert countries she has visited have influenced what she brings to her designs at home. "There people are so attuned to their environment," she says. "In Morocco, for instance, people dress appropriately for the desert and they design their homes to take advantage of air movements at different times of the day. Fountains and gardens also add a cooling effect." The Moroccan climate closely approximates our Arizona climate.

This sensitivity influences her designs—and her recommendation to clients is to build within the parameters of the desert, to accommodate design to its physical reality, its textures and colors.

Because of this expanding creative spirit, she maintains a nonformulaic approach: "I don't follow a 'set look' or a 'designer look,'" she says. "I don't want someone to walk into one of 'my homes,' and say, 'Oh, that's a Taulbee home,' because it accords with some formula," she adds. "Houses and people have their own personalities."

Keep it simple, too. "I don't believe that you go to a furniture store and purchase everything— and it's done. That's just filling space. What you want to do is to vitalize the space. And, if you're working with clients who have a sense of creativity, responsibility and trust you—and I've been very fortunate to have those kinds of clients—you really can't do it any other way."

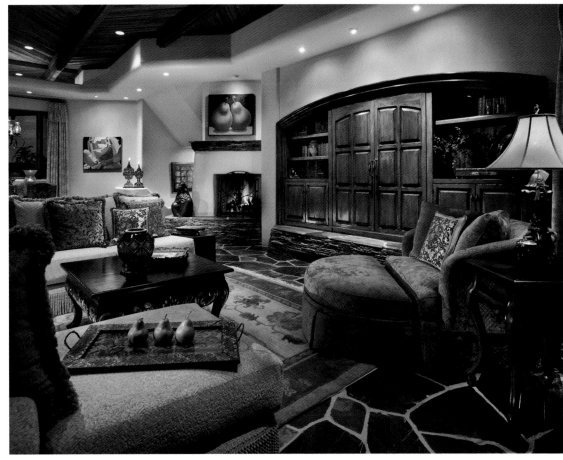

TOP LEFT
A hand-carved and -painted bed centers this master bedroom.

NEAR LEFT
Red granite, hand-rubbed cabinetry and a copper hood create sizzle in this kitchen. The silver pot is from Bolivia.

ABOVE
This living room features honey and ochre colors and a rug from Sante Fe.

More about Jo …

IF YOU COULD ELIMINATE ONE DESIGN/ARCHITECTURAL/ BUILDING TECHNIQUE OR STYLE FROM THE WORLD, WHAT WOULD IT BE?

Early American: It doesn't grow or change.

WHAT IS MOST UNUSUAL/EXPENSIVE/DIFFICULT DESIGN OR TECHNIQUE YOU'VE USED IN ONE OF YOUR PROJECTS?

Being the third designer on a job with difficult clients.

WHAT IS A SINGLE THING YOU WOULD DO TO BRING A DULL HOUSE TO LIFE?

Paint the walls.

WHAT IS THE HIGHEST COMPLIMENT YOU'VE RECEIVED PROFESSIONALLY?

On the following day after an installation, my client called and said that she couldn't believe the house was really hers and how happy it made her feel to be able to wake up every morning and know that it is hers.

Taulbee Design Group
Jo Taulbee
39919 N. 102nd Street
Scottsdale, AZ 85262
480.595.9189

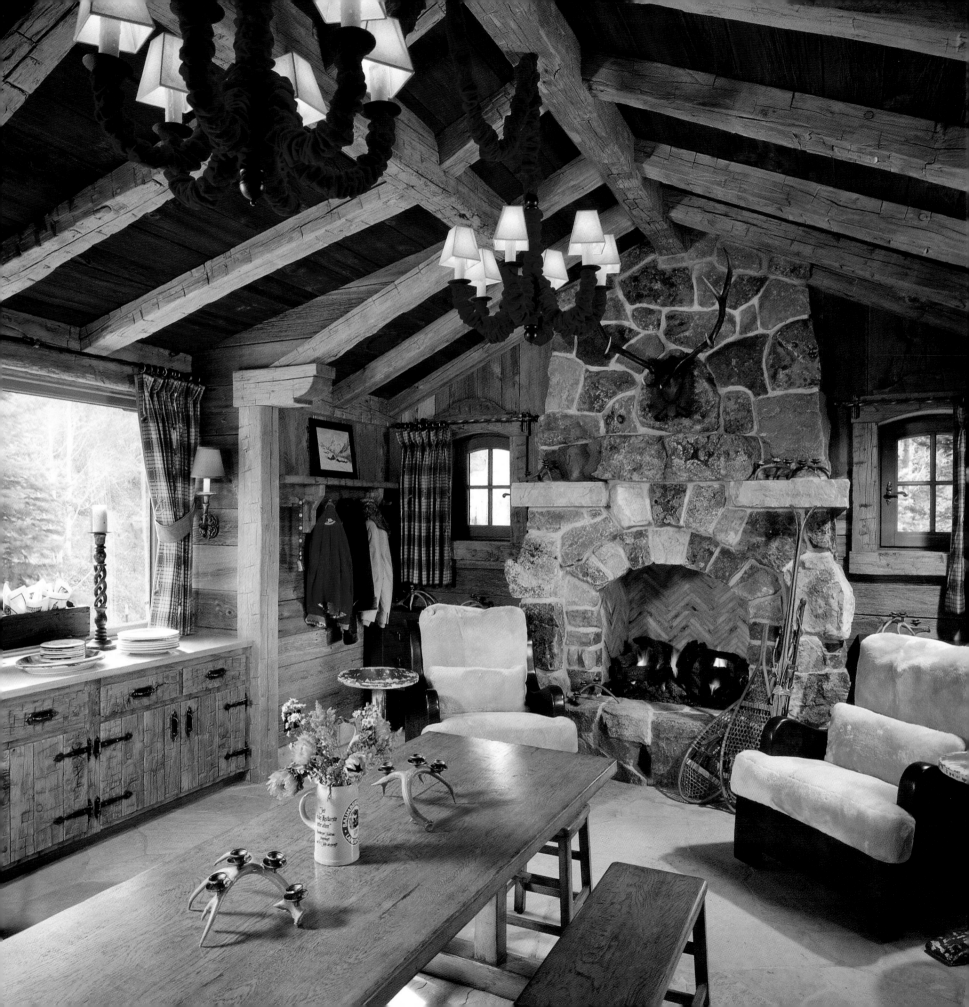

Donna S. Vallone
Vallone Design

LEFT
Ski right in to warm the toes by the fire and grab a bite to eat from the buffet in this Vail ski hut. The large picture window looks out to the ski slopes. All the wood is reclaimed.

RIGHT
For this Scottsdale family room remodel/update, the client wanted 'happy' colors, and Donna added the 'whimsy' with 'funky art.'

Donna Vallone has created not only some of the finest residential interiors in the Southwest but also some of its outstanding golf clubs and resorts. For the past 25 years, she has inspired her clients to create spaces that reflect their individual styles. "Our clients come to us because they don't want 'vanilla,'" she says. "They want color and excitement; they want warmth and welcome to their environments."

Donna is the lead for her team of 18, including designers as well as support staff. Her passion for designing luxurious residences led to a project in Scotland. In 1996/97, she completed her first major commercial work by doing a job that was basically residential: the Loch Lomond Golf Club. "The design of the 18th-century Georgian mansion, carriage house and garden cottages was like doing several grand residences," she recalls. The owners loved her conversion of the estate so much that she has been invited back annually for other projects. "Our commercial work carries a residential ambiance," Donna explains. "Our clubs look like homes."

Her reputation has brought other commissions: The Silverleaf Club at DC Ranch in North Scottsdale; the new Paradise Valley Country Club; the library, conference room and wine cellar addition at the Hermosa Inn, also in Paradise Valley; eight guest suites and reception lobby at the new Montelucia Resort in Paradise Valley (the former La Posada Resort); the Royal Palms Resorts new spa and guest room renovation; the Scottsdale Waterfront, adjoining the Arizona Canal across from Scottsdale Fashion Square; Glenwild Clubhouse in Park City, Utah; the

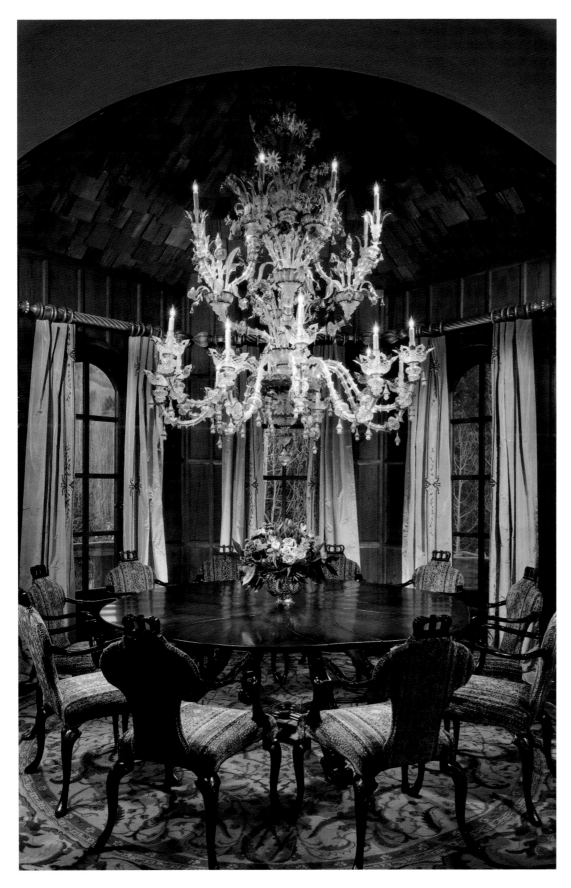

Las Campanas Clubhouse remodel in Santa Fe, New Mexico; and the Santaluz Clubhouse in San Diego, California. Currently, Vallone Design is working on projects in California, Colorado, Florida, Hawaii, Long Island, Manhattan, Utah, England and Scotland as well as in the Phoenix/Scottsdale area.

Many who experience Donna's commercial work call her to complete their home interiors as well, although she limits the number of projects for each. "I must admit to being somewhat of a control freak," she says, adding that a hands-on relationship with all projects is essential, even with the expertise of the firm's senior designers: Kim Anderson, Caroline Decesare, Marcie Englert, Jennifer Ferrandi, Kristine Mauer, Niki Scatena and daughter Berkley Vallone.

Published in a variety of local, national and international magazines and books, Donna's work is classic and traditional— "with a twist or kick. "My interiors are comfortable and charming with an approachable elegance, but I always add a bit of whimsy, a little humor, just to make sure that we're not taking ourselves too seriously," Donna says. The capricious and fun: a piece of art, some funky furniture, an unusual child's chair fitted comfortably into an elegant sitting room.

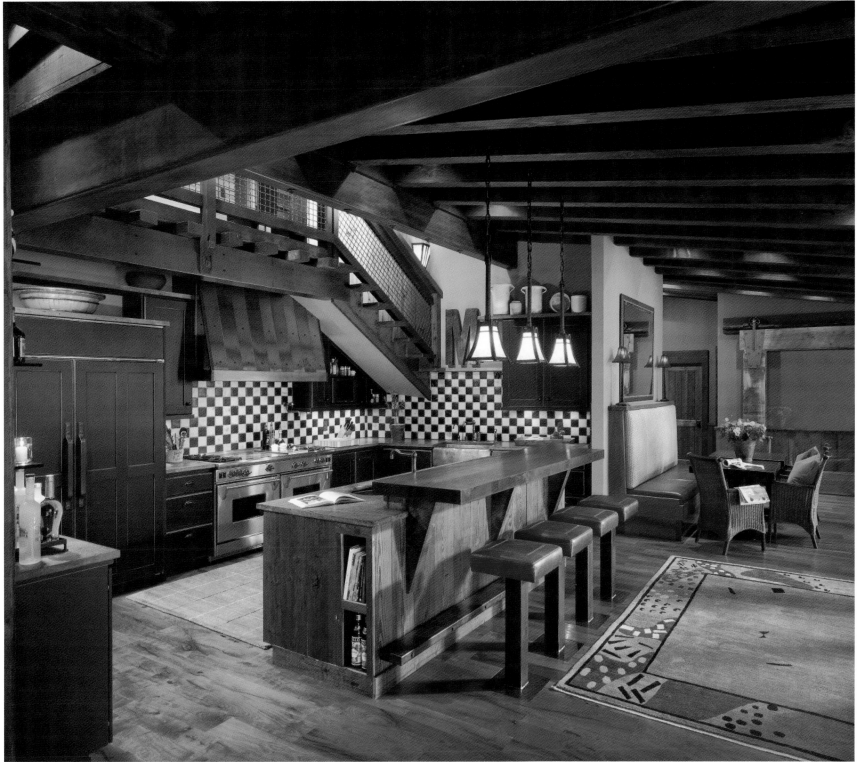

LEFT
'Ski Chalet' was the design concept for this Vail vacation home dining room. The architectural plans originally called for a flat-lid ceiling, but when Donna found the 7-foot-long chandelier, she took the peak to 14 feet and added the reverse shakes to juxtapose the formal and the rustic.

ABOVE
For this kitchen in Truckee, Calif., the inspiration for the color palette came from a knit stocking presented by the client at a first meeting with Donna. Their passion for folk art and rustic, old 'Tahoe' architecture inspired the design.

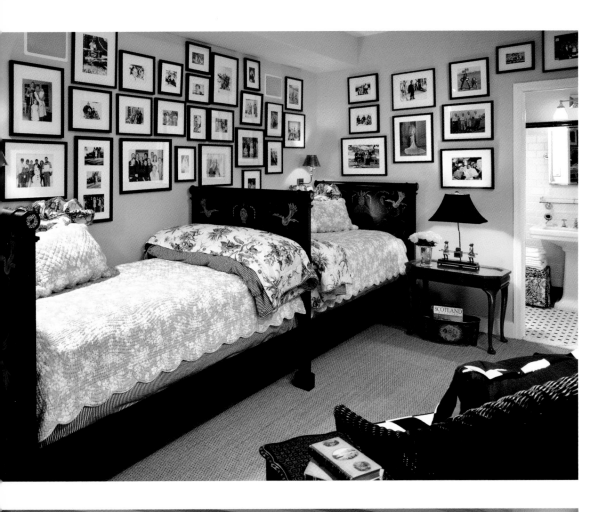

The entire process of design excites Donna. "I love it all: researching and sharing ideas with my staff; competing for a project; designing the job; working with clients; earning their trust; and seeing their reaction when a job is complete."

This is an intimate relationship, she emphasizes—with perils and pleasures. "The important point is to listen to clients, understand their lifestyles and find out which of their personal treasures they want to include. The key is to establish a look they want— not what I think they should have," Donna says. "But, talk about rewarding. When a job comes together and I see the delight on a client's face—that is absolutely the best!"

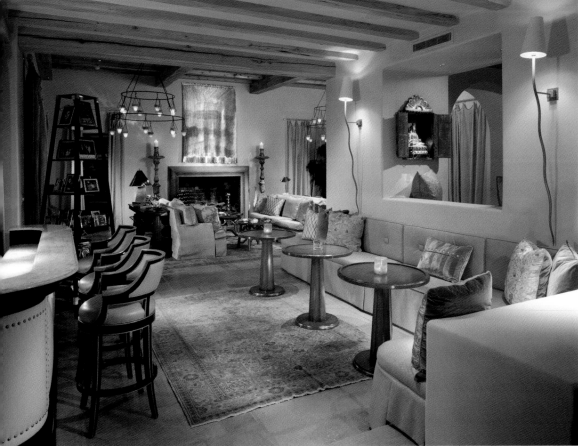

TOP
Space planning was key in designing a small room in Scottsdale to serve as a guest room and home office. Sunflower-yellow walls enhance the collection of 'treasured' family photos in contrasting black and white.

LEFT
In this Paradise Valley bar/lounge/living room, a client who frequently entertains wanted guests to flow into the living room. Donna and staff opened a wall and added the bar/lounge to encourage this.

More about Donna...

WHAT COLOR BEST DESCRIBES YOU AND WHY?

Red: I'm a Leo!

WHAT ONE ELEMENT OF STYLE OR PHILOSOPHY HAVE YOU STUCK WITH FOR YEARS THAT STILL WORKS FOR YOU TODAY?

Timeless, approachable elegance and to respect the client and the things they value. We strive to make it their home—not Vallone!

WHAT IS THE MOST UNUSUAL/EXPENSIVE/DIFFICULT DESIGN OR TECHNIQUE YOU'VE USED IN ONE OF YOUR PROJECTS?

A cable car.

WHAT IS THE SINGLE THING YOU WOULD DO TO BRING A DULL HOUSE TO LIFE?

Do a "white out!"

WHY DO YOU LIKE DOING BUSINESS IN THE SOUTHWEST?

I love the casual lifestyle and clients being relaxed and fun. Many times, it is a second or third home, which allows them to think more "out of the box!"

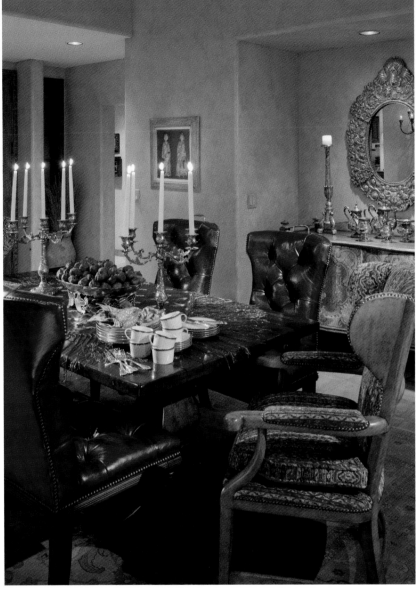

ABOVE
Dining room, Scottsdale, Arizona: What to do with an oversized foyer in a small patio home? Donna's solution: Turn it into a dining room. A silver mirror and candelabra complement Old World red-leather chairs and a trestle table. The custom hand-painted chest, designed by Vallone, was made to fit the niche.

Vallone Design
Donna S. Vallone
Allied Member, ASID
7007 E. Third Ave.
Scottsdale, AZ 85251
480.421.2799
www.vallonedesign.com

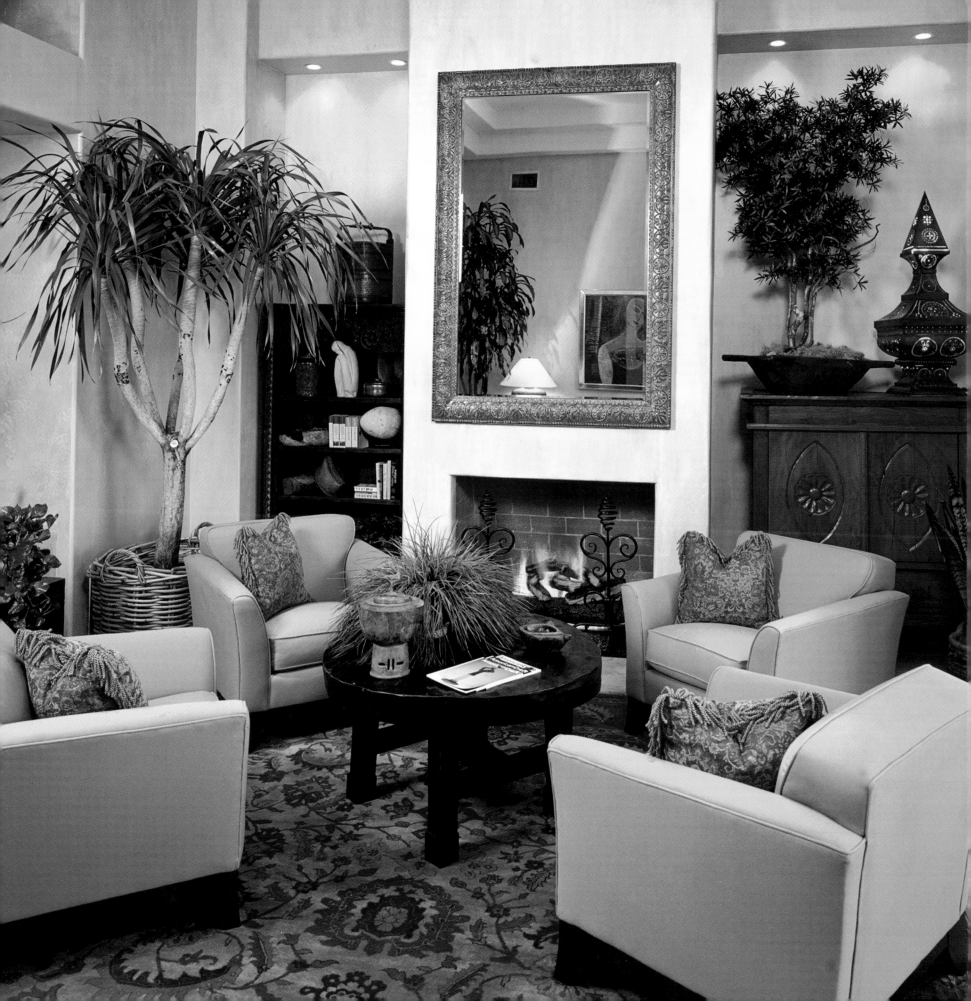

Gia Venturi

Gia Venturi Interiors

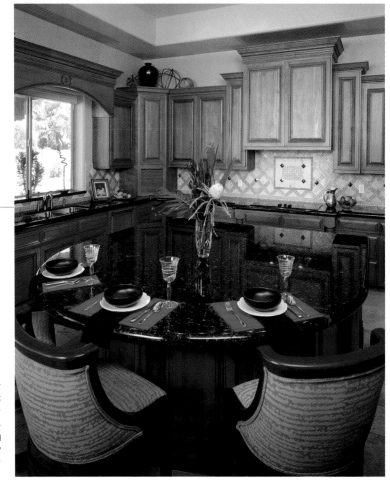

LEFT
Warm tones of camel and salmon help to create this perfect conversation area by the fireplace.

RIGHT
For this custom kitchen backsplash, iridescent mosaic glass and pewter and travertine tiles bridge traditional and contemporary elements seen throughout the home.

Gia Venturi is in the right vocation in the right location. "I love what I do," says Gia, with an Arizona design firm for the last eight years. "I have had a passion for interior design since I was a child."

Much of this inspiration derives from her parents. Her father was an engineer/inventor her mother is an artist. "They provided a foundation in which to explore creatively and learn to be resourceful, thoughtful and organized," she says.

This, in turn, allows her to innovate for clients. "I love working with each of them in helping them discern what it is that they love—and then creating it," she says. "It's a relationship that requires intimate trust and rapport."

Gia moved to the Valley from Ann Arbor, Michigan, 24 years ago— and isn't moving back. She loves the Southwest style and the Southwest style of living. The desert, with its subtle colors, large spaces, brazenness and high contrasts, brings inspiration to her work.

"We have a unique, evolving regional style that the rest of the country is taking notice of: our textures and materials, our architects and designers," she says. "We are an area that is a frontier for creativity and discovery."

While Gia loves the Southwest style, she is also innovative in mixing styles while respecting regional characteristics. "Because each client is unique, I will work with any of the traditional styles including Old World, French Provincial, Mexican Hacienda, Contemporary, Mid-century Modern, American Traditional or Tailored Modern."

Regardless of style, restraint connects all the strands—and the heart: "A designed space and its pieces must evoke emotion and tell a story my client can proudly call 'home.'"

Gia Venturi Interiors
Gia Venturi, Allied ASID
5129 E. Flower St.
Phoenix, AZ 85018
602.914.9223
www.giaventuriinteriors.com

THE PUBLISHING TEAM

Panache Partners LLC is in the business of creating spectacular publications for discerning readers. The company's hard cover division specializes in the development and production of upscale coffee table books showcasing world class travel, interior design, custom home building and architecture as well as a variety of other topics of interest. Supported by a strong senior management team, professional associate publishers, and a top notch creative team of photographers, writers, and graphic designers, the company produces only the very best quality of these keepsake publications. Look for our complete portfolio of books at www.panache.com.

We are proud to introduce to you the Panache Partners team below that made this publication possible.

Brian Carabet

Brian, co-founder and owner of Panache Partners , has more than 20 years of experience in the publishing industry. He has designed and produced more than 100 magazines and books. He is passionate about high quality design and applies his skill in leading the creative assets of the company. "A spectacular home is one built for entertaining friends and family because without either it's just a house... a boat in the backyard helps too.

John Shand

John is co-founder and owner of Panache Partners and applies his 25 years of sales and marketing experience in guiding the business development activities for the company. His passion toward the publishing business stems from the satisfaction derived from bringing ideas to reality. "My idea of a spectacular home includes an abundance of light, vibrant colors, state-of-the-art technology and beautiful views."

Kristine Currier

Kristine is the Associate Publisher for Arizona and New Mexico for Panache Partners. She and her husband are new residents to the Phoenix area and have really enjoyed setting up their new home and meeting the friendly people of the desert. "My idea of a spectacular home is one that has unlimited open space, an array of colors, and breathtaking views that can be shared with family and friends."

Rich Rayburn

Rich is the Executive Publisher of the Western Region for Panache Partners. He has over 15 years of sales leadership and marketing experience in publishing and advertising. His passion for Spectacular Homes comes from the energy and diversity he encounters in the design community everyday. "A spectacular home is one that from the moment you enter, draws you in and with proper use of form and function creates an environment that embodies the concept of home for those who live in it."

Dino Tonn

An attention to detail and true artistry in lighting has made Dino Tonn, the book's supporting photographer, one of the leading architectural photographers in the Southwest. For over 15 years, Dino's work has been featured in many regional, national and international magazines and publications. "What makes a home spectacular is the ever-changing artistic and creative use of non-traditional and natural materials. Especially when they are used to define a space with texture and color in a way you wouldn't expect."

David M. Brown

David M. Brown, editorial associate on this book, was born and educated in Philadelphia, Pennsylvania and migrated west about 25 years ago. He has been a publisher, reporter and editor but most enjoys the challenges of freelance writing—challenges he meets in a variety of subjects such as architecture, food and wine, and tourism. He is the father of two and is, in turn, mentored by a wise cockapoo and an exuberant border collie.

Additional Acknowledgements
Design—Mary Elizabeth Acree
Production Coordinator—Luanne Swisher Honea and Elizabeth Gionta
Project Management—Carol Kendall

PHOTOGRAPHY CREDITS

Pages	Design Firm	Photographers
17	Andrighetti Design Associates, Inc.	Dino Tonn
35	Carol Buto Designs	William Lesch
43-47	Christopher K. Coffin Design	Christian Blok
107-109	David Michael Miller Associates	Bill Timmerman
87-91	Debra May Himes Interior Design & Associates	Dino Tonn
123-127	Deena Perry Interiors & Collections	Christian Blok
		Clay Ellis
		Ala Gould
		Daniel Nadelbach
		Brad Simmons
99-101	Devon Design Ltd	Dino Tonn
53-57	DeWitt Designs	Rod Evans
		Mellsa McMunigal
11-15	Élan Interiors	Chad Deslatte
59-61	Eren Design & Remodeling Company	Robin Stancliff
69-71	Ernesto Garcia Interior Design	Mark Bosclair
		Philip Clayton Thomas
139-141	Est Est, Inc.	Mark Bosclair
111-113	European Traditions	Dino Tonn
153	Gia Venturi Interiors	DeLawn Hawkins
		Walt Saadus
83	Harper Studio of Interior Design	Raul J. Garcia
115-117	Interior Motives	Dino Tonn
93-95	Interiors By Design	Mark Bosclair
		Tony Hernandez
		Dino Tonn
25-27	Janet Brooks Design	Mark Bosclair
		Jerry Portelli
		Bill Timmerman
63-67	Judy Fox Interiors	Karen Shell
131-133	Liz Ryan Interior Design	William Lesch
37-41	Lori Carroll & Associates	William Lesch
77	Marieann Green Interior Design, Inc.	Dino Tonn
119-121	Nelson Barnum Interiors	Mark Bosclair
		Dino Tonn
79-81	Paradise Interiors, Inc	Dino Tonn
19-23	Paula Berg Design Associates	Lydia Cutler
		Ed Gohlich
		David Marlow
		Scott Zimmerman
73-75	Grant Design LLC	Richard Petrillo
		Scott Sandler
129	Robyn Randall Interior Design	Mark Bosclair
97	Room Service LLC	Steve Thompson
85	Sherry Hauser Designs	Dino Tonn
135-137	Smith & Dana Associates, LLC	Christian Blok
		Brian Smith
103-105	Studio Encanto	William Lesch
		Brion McCarthy
		James Yochum
143-145	Taulbee Design Group	Mark Bosclair
		Jim Brady
49-51	Tre'ken Interiors	Jackie Mercandet
		Dino Tonn
147-151	Vallone Design	Dino Tonn
29-33	Wiseman & Gale	Dino Tonn

INDEX OF DESIGNERS

BRENDA B. AGEE................................11
Élan Interiors Inc.

MARTHA ANDRIGHETTI................................17
Andrighetti Design Associates, Inc.

KIM BARNUM................................119
Nelson Barnum Interiors

PAULA BERG................................19
Paula Berg Design Associates

JANET BROOKS................................25
Janet Brooks Design

PATTY BURDICK................................135
Wiseman & Gale

CAROL BUTO................................35
Carol Buto Designs

SUE CALVIN................................135
Wiseman & Gale

LORI CARROLL................................37
Lori Carroll & Associates

CHRISTOPHER K. COFFIN................................43
Christopher K. Coffin Design

KIMBERLY COLLETTI................................49
Tre'ken Interiors

SANDRA DANA................................135
Smith & Dana Associates, LLC

SARAH DEWITT................................53
DeWitt Designs

JANICE DONALD................................59
Eren Design & Remodeling Company

SHARON FAIRCLOTH................................79
Paradise Interiors Inc.

JUDY FOX................................63
Judy Fox Interiors

ERNESTO GARCIA................................69
Ernesto Garcia Interior Design

ROBIN GRANT................................73
Grant Designs LLC

MARIEANN GREEN................................77
Marieann Green Interior Design, Inc.

RHONDA GREENBERG................................79
Paradise Interiors Inc.

ELLEN BETH HARPER................................83
Harper Studio of Interior Design

SHERRY HAUSER................................85
Sherry Hauser Designs

DEBRA MAY HIMES................................87
Debra May Himes Interior Design & Associates

BEVERLY S. HOGSHIRE................................93
Interiors By Design

MARY ANN HOPKINS................................97
Room Service LLC

SANDRA KUSH................................99
Devon Design Ltd.

JANA PARKER LEE................................135
Wiseman & Gale

CHRISTY MARTIN................................103
Studio Encanto

DAVID MICHAEL MILLER................................107
David Michael Miller Associates

CHARLEY MORROW................................111
European Traditions

ANITA LANG MUELLER................................115
Interior Motives

TERESA NELSON................................119
Nelson Barnum Interiors

DEENA PERRY................................123
Deena Perry Interiors & Collections

ROBYN RANDALL................................129
Robyn Randall Interior Design

LIZ RYAN................................131
Liz Ryan Interior Design

CAROL SMITH................................135
Smith & Dana Associates, LLC

TONY SUTTON................................139
Est Est, Inc.

JO TAULBEE................................143
Taulbee Design Group

DONNA S. VALLONE................................147
Vallone Design

GIA VENTURI................................153
Gia Venturi Interiors